Rendering with mental ray® & 3ds Max

Rendering with mental ray® & 3ds Max

Joep van der Steen

AMSTERDAM • BOSTON • HEIDELBERG • LONDON • NEW YORK • OXFORD
PARIS • SAN DIEGO • SAN FRANCISCO • SINGAPORE • SYDNEY • TOKYO

Focal Press is an imprint of Elsevier

Acquisitions Editor: Paul Temme
Publishing Services Manager: George Morrison
Project Manager: Kathryn Liston
Assistant Editor: Georgia Kennedy
Marketing Manager: Christine Degon Veroulis
Technical Reviewers: Ted Boardman and Steven D. Papke
Cover image credit: Joep van der Steen

Focal Press is an imprint of Elsevier
30 Corporate Drive, Suite 400, Burlington, MA 01803, USA
Linacre House, Jordan Hill, Oxford OX2 8DP, UK

∞ Recognizing the importance of preserving what has been written, Elsevier prints its books
on acid-free paper whenever possible.

Library of Congress Cataloging-in-Publication Data
Application submitted

British Library Cataloguing-in-Publication Data
A catalogue record for this book is available from the British Library.

ISBN: 978-0-240-80893-2

For information on all Focal Press publications
visit our website at www.books.elsevier.com

07 08 09 10 11 10 9 8 7 6 5 4 3 2 1

Typeset by Charon Tec Ltd (A Macmillan Company), Chennai, India
www.charontec.com
Printed in Canada

Working together to grow
libraries in developing countries

www.elsevier.com | www.bookaid.org | www.sabre.org

ELSEVIER BOOK AID
International Sabre Foundation

Contents

Contents

Acknowledgments

Creating this book would not have been possible without the help and support of numerous people who surround me, both in my private life and in my work environment.

From the private arena, a special thanks to my girlfriend, Ellen, for her support. Ellen put up with me during the creation of the book, and even took it upon herself to read through the whole thing, checking to see if it made any sense.

From the working environment, thanks to the guys who supplied some of the 3ds Max scenes, and to Gijs-Thijme who helped with the rendering of all the images. Also, thanks to Steven Papke and Ted Boardman who together checked my English for sense, and to the team at Focal Press who made it all happen. I would also like to send a big thank you to the people at mental images, who made sure that I wasn't introducing new, nonexisting features for mental ray.

Finally, my thanks to the people who have bought this book. For them, I have put together a support Web site: www.masteringmentalray.com. Visit this site if you have any additional questions concerning mental ray inside 3ds Max. I'll endeavor to ensure you receive answers.

I enjoyed creating this book, and I hope that you will find it useful.

So for now, enjoy and happy rendering.

Joep

Image created by Edwin Mens

Chapter 1

Getting Started with mental ray® in 3ds Max

1.1 Introduction

mental ray® is a render engine that comes standard with 3ds Max from Autodesk's Media and Entertainment division. It is an engine with enormous potential, possibly the best there is. Unfortunately, the documentation available for mental ray with 3ds Max is not really user friendly. Most people who start to work with it the first time, without going over the manual, experience difficulties. Even after reading the very technically oriented manual, the average user still is not able to produce consistent results.

However, there have been major improvements toward the user interface of mental ray with this new release, making it more intuitive. Major strides have been made in the use of materials and lighting of scenes. It is now actually possible to create stunning images with a few mouse clicks, just by using a very small portion of the capabilities that mental ray has as a whole and without any deep knowledge of what really happens and why things turn out the way they do.

This book is set up in the following manner. It introduces some basic concepts and rules that you will need to follow. The book then examines rendering with the mental ray. Step-by-step tutorials teach you how to render scenes with indirect light or with specific effects, such as depth of field and motion blur. The book also talks about contour line shading and various other mental ray features. Next, the book explains how to use the different light types of 3ds Max inside mental ray and how to use mental ray's own specific area lights and its new daylight system. Finally, the book reviews mental ray–specific materials and what effects can be obtained by using most of the specific mental ray shaders. In the end, you will really understand what you are doing so that your creativity can take over, rather than a lack of understanding of the software getting in your way.

This book is intended for the average 3ds Max user who is familiar with the program already but lacks the experience and doesn't want (or simply doesn't have the time) to spend hours trying to find out how everything works inside mental ray. The book starts working with mental ray in a procedural, step-by-step manner. It goes over the software by using a lot of example scenes, which have been organized in a logical way, taking one step at a time. Not every detail is discussed since they are too specific for the average user, who will rarely use them, if at all. This book is intended to be a practical guide.

mental ray as a render engine can give you lots of effects inside your end result, such as the following:

- Global illumination
- Reflection/refraction
- Ray-tracing
- Caustic light effects
- Realistic effects through different shaders
- Area lights
- Depth of field
- And much more

Since mental ray has been totally integrated inside the main user interface, you do not see any difference when you start rendering. All the differences are handled in the background. Actually, a scene that is made in 3ds Max is passed on to the mental ray rendering engine and then transformed and rebuilt inside mental ray. Finally, it is rendered and the end result is shown on your computer screen. Because of the mentioned integration inside the main software, you are never aware of this process.

When you start using mental ray, it is best that you keep working in the way you were accustomed when you were still using the scanline renderer. In this way, you can keep using the same types of materials and lights that you are familiar with. As you get more acquainted with the software, you can start using the specific effects, lights, materials, and shaders that are available in mental ray. All these options can be found in various locations throughout the user interface of 3ds Max. I have deliberately chosen not to go over the complete interface options because it would be easy for you to get lost, considering all the options, terms, and concepts needed to learn each function of the rendering engine.

1.2 Important Information before We Get Started

Before getting started, you will need to understand some important settings and concepts pertaining to the software driver and units.

1.2.1 Software Driver

A number of examples files are supplied on the CD that accompanies this book. If you open these files, you may get a picture that looks like this (Figure 1.1):

However, it is supposed to look like this (Figure 1.2):

Both of the images will render just fine, but the problem is caused by the type of graphics driver chosen. The

Figure 1.1 *Display with software driver*

first image uses the standard software driver. The proper image is displayed when you use Open GL or Direct3D. I have no real technical explanation for this except that it is caused by some accuracy settings inside 3ds Max; but, it is important to share this information with you before starting.

1.2.2 Units

mental ray is relative to the units you are using in your scenes. This is a critical point to understand and recognize. During the course of working with this book, you will use a number of practical exercises. Almost all are set to inches, for the System Unit Scale (Figure 1.3).

Figure 1.2 *Display with OpenGL or Direct3D*

The Display Unit Scale is set to generic units (Figure 1.4).

This setting can be accessed through Customize menu > Units setup. Make sure you respect these settings; otherwise, the adjustments made will have a different effect than the pictures provided in this guide during the course of the exercises. In some cases, your result could be totally different.

If the software displays the Units Mismatch message window when opening a scene, select the Adopt the File's Unit Scale before opening the sample file; there are some sample files that use different unit scales (Figure 1.5).

Figure 1.3

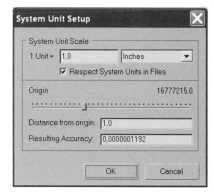

Figure 1.4

Figure 1.5

Finally, it is important to know that the notation of the numbers I use is European style, meaning that if I indicate one thousand, it reads 1.000 — not 1,000. Also, to indicate 1/10, I use 0,1 — not 0.1. Since this is also part of the computer settings used, the book presents the numbers in this way throughout the screenshots.

1.3 Concepts

When working with mental ray, you need to know some basic concepts. The book presents these basic concepts initially and explains them further in later chapters. The concepts outlined next are important for your understanding.

1.3.1 Shaders

A shader is a little software program that solves a specific piece of the rendering process. Basically, every shader function is based on input parameters that result in a certain output. For instance, if you use a distortion shader inside a camera, the result will be a distorted image based upon the settings you have entered (Figures 1.6 and 1.7).

mental ray, as a render engine, is extremely flexible in handling shaders. All shaders work together to translate the scene data into the final rendered image. Shaders can be applied to all sorts of scene objects, such as geometry, lights, and cameras. Depending on where you want to apply a shader, a list of available shaders is usually presented to you through the Material/Map Browser. The use of shaders can be compared with the mapping techniques you are familiar with in 3ds Max. In fact, mental ray can work with most of the existing mappings that are available inside 3ds Max. As an example, if you want to apply an image to texture an object, there is no need to use a specific mental ray shader. Simply use the bitmap map, as you are accustomed to doing.

mental ray looks at the scene from the camera's point of view. By sampling the scene, it establishes the color for each individual pixel that makes up the final image. Just imagine the following sequence — the whole process will become clear to you:

When a ray is shot into the scene, it eventually hits a surface of an object. Once this is done, the shader (or set of shaders) describing the characteristics of

Figures 1.6 & 1.7 *Different distortions by changing the input for the specific shader*

that surface is called and the calculation task is performed. The outcome is sent back and used as information for the final coloring of the pixel in the resulting image.

In the next set of images, a contour line shader is used to make the final rendering show a kind of "cartoon look." In shader terms, this means that once the ray hits the surface of one of the objects, it knows it has to process the input in such a way that the outcome should be converted to show the contour lines, instead of the real-life material (Figures 1.8 and 1.9).

Figures 1.8 & 1.9 *Moving from real-life to cartoon like images with the help of contour line shaders*

Shaders are not restricted to the control of materials; there are also shaders that control light objects, camera objects, and more. Shaders can be used for reflective rays, shadow computation, and special effects such as global illumination and caustics, among others. In other words, most of the things that go on inside the scene are controlled by shaders, which, in turn, are controlled by mental ray — the mastermind behind it all.

1.3.2 Global Illumination

Global illumination is a universal term for the description of a scene in which all aspects of light have been considered as bounced, reflected, and refracted light. Rendering algorithms that calculate the way light travels between surfaces of objects are called Global Illumination algorithms. The two most important Global Illumination algorithms are ray-tracing and radiosity. Radiosity is used by the scanlinerenderer, whereas mental ray uses ray-tracing.

Ray-tracing works like this: imagine a room with a single light source. From this light, tiny particles, called photons, leave the source. These photons hit somewhere in the room on a surface of one of the objects in the scene, such as a wall or ceiling. Depending on the material used, they are reflected or absorbed. Photons travel through the space with a certain color wavelength. This wavelength is responsible for the coloring of the surface of the object. Surfaces of objects that are extremely smooth reflect the ray of light in a direction that is the same as when it arrived at the surface (i.e., light hits the surface at a certain angle and then leaves it again with the same angle). These surfaces (e.g., a mirror) generate so-called specular reflections. The surfaces themselves are called specular surfaces. If the surface of the object is rough, the photons that arrive will be bounced back in different directions. These types of surfaces are called diffuse surfaces, and they generate diffuse reflections.

The final illumination of the room involves a combination of these two types of reflections, resulting from the millions of photons that have been emitted by the light source and the types of materials and surfaces inside the room. So, on each surface you can have direct illumination (from photons that have just left the light source) and indirect illumination (from photons that have been bouncing inside the room). In the end, a number of photons reach your eye and activate the rods and cones; based upon messages from the rods and cones, your brain creates the final image of the room.

In the computer graphics, conceptually speaking, the rods and cones of the eye are replaced by pixels on a screen in an attempt to achieve the closest possible result to reality. Using the photon map technique, among others, global illumination can be achieved. To this end, mental ray needs to be told which light source will create global illumination, as well as which objects in the scene are able to generate and receive this type of illumination.

Another technique that mental ray uses to reach a global illumination is the Final Gather technique. This also is a physically correct calculation method and is therefore a very good alternative to using the photon technique. Final Gather shoots rays into the scene, much in a way that photons are shot into the scene originating from light sources or that rays are shot from cameras. There is one fundamental difference, however. The rays used for Final Gather do not originate from light sources or cameras; they originate from the geometry itself.

In the following sections, global illumination is examined by its different components, which together make up the final image or reality as we perceive it.

1.3.2.1 Direct Light

Direct light is a pretty common term in the computer graphics environment. Basically, it is light that is present in the scene in which all the light rays stop when they hit a surface—there is no bouncing of light occurring. This becomes evident when you look at the following image, which shows the direct light component in the scene. In this scene, the only light source used is the sun; no materials and shadows were used intentionally (Figure 1.10).

There are no special calculations when using direct light as the lighting approach, which means that this is a way of rendering fast. As a result, direct illumination is created. mental ray can work with the standard light objects that come with 3ds Max, and it

Figure 1.10 *Only direct light inside the scene*

also can work with mental ray light objects. All these issues are discussed in subsequent chapters of this book.

1.3.2.2 Shadows

There are different types of shadows inside mental ray. Most of the normal 3ds Max shadow types are supported; but, if you happen to use one that is not supported, mental ray automatically switches to the ray trace type of

shadows and also provides a message that this is being done. In addition to the standard shadow types within 3ds Max, there is also the mental ray shadow type, for mental ray area shadows.

Figure 1.11 *Shadows added to the scene*

The most accurate shadow types are the ray-traced shadows. However, mental ray can still create soft shadows when using these types of shadows. Ray-traced shadows work by casting rays to every light in the scene from the point that is being rendered, and checking whether the rays intersect any of the objects from the scene. If this is the case, this ray is excluded so that a shadow is generated. Opaque objects create full shadows; transparent objects create density and colored shadows, based upon how much light travels through the object material definition. If you use area lights inside the scene, it is possible that part of the light will not be visible due to the position of the object. This difference in intensity of the light is then made visible inside the final image as a realistic, blurry, soft-edged shadow. There is no light behind any of the objects, just solid black shadows, which is the result of not using any kind of indirect light (Figure 1.11).

An alternative to ray-traced shadows is shadows maps. Shadow maps are less accurate but tend to be faster during the calculation time. To create a shadow map, a map is projected from the light onto the scene. Rays are cast from this map, and the distance to each object is calculated and stored in the map, which is created within the software

before rendering. Transparent objects do not create transparent shadows by default, but mental ray has the ability to do this. Even transparency, including color information, is possible when the appropriate shaders are used.

1.3.2.3 Bounced Light

Bounced light (or diffuse light) is added to the scene by adding bounces to the light rays. This means that the light ray doesn't stop when it hits a surface but is reused inside the scene. In order to use this functionality, specific methods must be set, which are discussed later in the book. In this sample image, the only light inside the scene is still the sunlight (Figure 1.12).

Figure 1.12 *Bounced light creates lighter shadows*

Figure 1.13 *The environment light introduced to the scene*

Figure 1.14 *Materials add an extra dimension to the scene*

1.3.2.4 Environment Light

The next lighting method available is environment light. Environment light is created for this outdoor scene by the sky and by other objects surrounding the scene (Figure 1.13).

1.3.2.5 Materials

Materials can be added to the scene to enhance the realism of the image. Materials can include everything from colors to textured materials such as wood or paintings, and also transparent and translucent materials. In everyday life, you can see all these different types of materials (Figure 1.14).

Materials interact with the light source. In real life, you have lighting phenomena such as color bleeding, reflection, refraction, and caustics. In mental ray terms, materials are a group of shaders that together describe the properties of a certain surface. Different material definitions need different shaders, but there always has to be a surface shader available. With more complex materials, shaders are available for material components such as Shadow, Volume, and Environment. mental ray works with most of the normal 3ds Max materials that are available, but it also comes with its own specific material type. These will be discussed later in this book.

1.3.2.6 Caustics

Caustics are created by light passing through transparent materials such as glass and water, and are based on properties of reflection or refraction. A good example of this is the reflection of light on the walls of a swimming pool, or the type of light reflection a glass of wine casts on a table. To be able to generate this lighting effect, a special calculation method is necessary. mental ray

uses the photon map technique. Ray-tracing is not accurate enough, and the scanline renderer isn't able to generate this effect at all. To work with caustics, you need to tell mental ray which light object will be responsible for the caustic effect and which objects in the scene will be able to generate or receive the caustics. After that, mental ray will calculate the caustics for you automatically (Figures 1.15 and 1.16).

Figures 1.15 & 1.16 *Caustics can come from reflection and refraction*

1.3.2.7 Volumetric Effect

Another special lighting effect is volumetric lighting. This effect can be added for a more realistic image. Volumetric effects are created when light travels through a medium such as air that is filled, for instance, with fog, dust, or smoke. Some examples of this effect are when a spotlight is used on a stage where a smoke machine is used, or when light shines inside the water creating some visible light beams (Figures 1.17 and 1.18).

Figures 1.17 & 1.18 *Volumetric effects can apply to the whole scene or objects and light beams*

1.3.3 Final Gather

How does mental ray create indirect illumination? There are two major methods available and a third that is less likely to be used. The first one is Final Gather, and the second is the photon map technique. Both techniques are physically correct calculation methods since the underlying algorithm is the same, but Final Gather tends to be better than the photon map technique in both performance and quality.

Final Gather shoots rays into the scene, much in a way that rays represented by photons are shot into the scene originating from light sources or cameras. There is, however, one fundamental difference. The rays used for Final Gather do not originate from light sources or a camera; they originate from the geometry itself. The Final Gather technique shoots rays into the surrounding environment of the scene to collect information from this environment. It then takes all the information from these rays and computes how much light gets to the point at which the final gather started, also taking into account the information from neighboring points and using the same process and averaging them. Final gather can be used without global illumination to create an indirect illumination effect throughout the scene. Although the images from both the Final Gather and the photon map techniques might show differences, they are both 100% correct physically. These differences are usually due to the shaders used inside the scene and not the underlying algorithms.

Final Gather is set by default to not calculate multiple bounces of the rays, so the end result tends to be a bit darker than the same image created with the photon map technique, which does calculate multiple bounces by default and holds the correct distribution of energy in them for the overall scene. It is important to note that the Final Gather technique can be set to calculate these bounces with changes in the settings.

Fortunately, the two techniques can be combined. Ideally, this can improve the overall quality of the image since Final Gather is better for small details and smoothing the colors inside the image. When used in combination, the Final Gather technique performs lookups into the indirect illumination photon solution to generate a rendered image that has both great light depth in the shadows and soft tonal variations in the lighted areas (Figure 1.19).

Figure 1.19 *Sample with combined Final Gather and Global Illumination*

1.3.4 Photons

mental ray can also create indirect illumination by using the photon map technique. Light sources emit rays of light, which can be considered under certain circumstances as small particles that are called photons. These photons can be traced inside the scene; this is how mental ray's algorithms work. Basically, a ray of light can be looked

at as a long line of individual photons. Photons in mental ray simulate the phenomena of real-world photons. Photons are reflected by mirrors, refracted through glass, or scattered by diffuse surfaces. The big advantage of photons is that they replicate what happens in nature. This can include reflections on metal and refraction through glass.

Each light carries an amount of energy that is divided over the number of photons the light is set to emit. When the photon starts to travel inside the scene, it has both energy and a color that is the same as the color of the light. The color and energy change when the photon bounces off colored surfaces or interacts in another way with objects inside the scene. When this process stops, the photon is left with a certain amount of energy and color, which can be completely different than when it started its route.

Photons are only used for indirect light, not for direct light. There is no need to use photons for direct light since it can be checked if the point of the object's surface is visible to the light. Although photons are emitted and hit the point of the surface that is visible for the light, this is not considered inside the calculation, meaning that this first pass is overlooked. Calculation starts from that first bounce, where the photon influences the final result of the next surface it hits because it is now part of the scene's bounced (diffuse) light.

In summary, the process is this: a photon is shot inside the scene and may or may not hit a surface on its path. If it does, mental ray looks at that surface and asks the surface shader what it should do with the photon. If the object is a mirror, the photon is not changed but is bounced directly back into the scene. If the surface is shiny blue, part of the energy is absorbed and the color of the photon changes into blue, and so on.

Photons themselves are not visible, but the result of the photons' travel is visible. If you are working with indirect illumination, the mental ray renderer follows the photons that are being transmitted by the light source. The photons are followed throughout the scene based upon reflection and refraction of the objects until a diffuse surface is hit, where the photon leaves an imprint that represents the contribution of the photon to the indirect illumination. At that point, the imprint is stored inside a photon map, which is a kind of three-dimensional data structure used by the software. The creation of photon maps can be time consuming depending on the number of photons used inside the scene.

Once this process has finished, the photon map is used when rendering the scene. As the scene is rendered, photon averaging takes place based on the user-defined radius to smooth the result of the photon map. Disadvantages of the photon map technique are both the time and computer memory consumption it requires. The Final Gather technique is probably the better choice since it gives you more details by default without the long rendering times associated with photon mapping.

Internally, photons are divided between photons for the global illumination and photons for the caustic effects. This provides the ability to render the two effects individually. Caustic effects are usually sharp, and global illumination effects are desired to be as smooth as possible, so they need a different radius in which the averaging of the photons takes place.

1.3.5 Ambient Occlusion

The third technique that mental ray can use for creating an indirect illumination effect is not physically correct. It is called ambient occlusion. Ambient occlusion is a technique that does not use a complex lighting setup, though it can still create a realistic image. It creates a grayscale map based upon how much of the environment can be seen from each surface point of the geometry. The grayscale map basically shows the amount of ambient light that a surface can receive.

The theory behind ambient occlusion is that there is an ever-present ambient light. Thus, a given surface receives a certain amount of this ambient light, but not a constant amount. The amount depends on how much the surface is occluded, or blocked, by other geometry. What happens internally is that the area above the point to be shaded is sampled for blocking geometry. If any is found, the percentage of blockage translates directly to an occlusion factor.

Figure 1.20 *Scene with only Ambient occlusion and no lights*

Occlusion has several uses. One of these is ambient occlusion, in which the shader is used to scale the contribution of ambient light. Another use of occlusion is reflective occlusion, in which the shader is used to scale the contribution from a reflection map. A third use is to create files for external compositing, in which the occlusion shader is assigned to every material in the scene. The output can be used to modulate other render passes to achieve proper compositing in postproduction (Figure 1.20).

Chapter 2

Rendering with mental ray inside 3ds Max

Now it is time to start rendering with mental ray. The easiest way to do this is to use the render presets that are available at the bottom of the Render Scene dialog box. There are three major groups to be discovered there. One is for rendering without any kind of indirect lights, just using mental ray as an alternative render engine. The second main group is for rendering specifically with the mr Daylight system, which uses indirect light rendering techniques. The last one is the hidden line contour rendering preset. The approach shows you how to activate the preset and use it. From there, we will leave the presets and go into detail by using the manual approach, giving you much more information on mental ray and how to set it up and control it to get the best possible results.

This chapter starts with using mental ray simply as an alternative render engine. Then, we will move on to the more important stuff, rendering with indirect illumination. All the different techniques and effects you can use, such as Final Gather, Caustics, and Global Illumination will be examined. Finally, we will evaluate specific rendering options such as Contour Line rendering, Camera Effects, Displacement, Depth of Field, and Motion Blur.

But, let's start at the beginning—switching on mental ray!

2.1 Switching on mental ray

To begin, start 3ds Max and load the file **mental-ray.max**. Once you have done this, make a quick render to see what you have inside the scene (Figure 2.1).

Just as might be expected, a normal scanline rendering appears. Inside the scene, only standard

Figure 2.1 *Default scanline rendering*

3ds Max materials have been used and there are some lights to get some lighting effect. This is as basic as a scene can be. There is no special rendering technique used for creating indirect light.

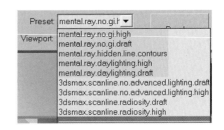

Next, open the Render Scene dialog and move all the way to the bottom, where you will find the Preset drop-down list. Open this list; you will see five mental ray specific presets (Figure 2.2).

Figure 2.2 *Render Presets overview*

There are three major groups inside the preset list. The first two ones are the *no.gi* type. This means "no global illumination," so the rendering will be without the indirect light, light bounces, and so on. The third one is for hidden line contour rendering, which is used to make a cartoon-like rendering and will be explained later.

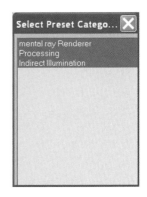

Following the contour preset are the day lighting types. These do have indirect lighting and are typically for rendering daylight scenes with the (mental ray) daylight system, regardless of whether they are indoors or outdoors. Since this is the first introduction to rendering with mental ray, let's start with the simplest rendering, the no.gi type.

Figure 2.3

Choose the mental.ray. no.gi.draft preset. Upon selection of the preset, the Select Preset Categories box appears (Figure 2.3).

There are three items highlighted. These three items are mental ray–specific panels that become available inside the Render Scene dialog after mental ray has been switched on. Inside each of these panels, options have been preset according to the mental. ray.no.gi. draft settings. Select them all, and press the Load button.

Figure 2.4 *New panels inside render scene dialog*

mental ray has now become active. The first thing we see is the mental ray–specific panels that have become available inside the Render Scene dialog, replacing the ones specific for the scanline renderer (Figure 2.4).

You now have the Processing, Indirect Illumination, and (mental ray) Renderer panels, which are different than the ones available when the scanline rendering engine is active. Render the image and see what happens using mental ray as a rendering engine (Figure 2.5).

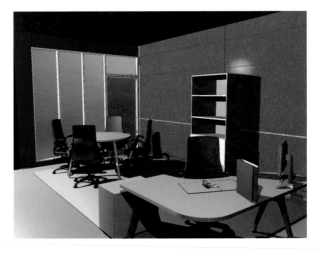

Figure 2.5 *Result with the mental ray draft preset*

Basically, the same result appears, except that there is a bigger staircase effect (antialiasing effect) than there was with the scanline renderer. It is important to note that mental ray works exactly the same way with standard materials as scanline does, giving more or less the same rendering result. However, one thing to notice is the time it takes to render this image. The mental ray engine is much faster than the scanline, meaning that this kind of setting is perfect for test renderings. Another thing that is readily apparent is that the horizontal progress line from the scanline rendering engine is replaced with small squares moving around the image while it is being calculated. This is the way mental ray works in creating an image. The small squares are called *buckets*.

Return to the presets and choose mentalray.no.gi.high from the list, load all the different panels, and render again (Figure 2.6).

Figure 2.6 *Result with the mental ray high preset*

Now, the image has much better quality, as might be expected by switching from draft to high quality. The rendering time is more or less the same as it was with the scanline rendering.

Presets are useful for starting off and experimenting, but when serious work needs to be done, understanding a lot of the settings that are available on the new panels in the Render Scene dialog is critical for predictability, speed, and fine-tuning. Numerous settings and options are available in the mental ray–specific panels, but let's start by focusing on the most important ones. The remaining options will be addressed later in the chapter.

There are two important settings that you should be able to do manually. The first, and most obvious, is switching on mental ray. The second is understanding how to increase the render quality by introducing a better sampling technique. So, here we go.

Reload the **mentalray.max** file, so that we can start from scratch. Say no to the prompt to save. When presets were used, mental ray was automatically turned on as the alternative render engine. This must be done manually inside Render Scene dialog. Switch to the Common panel, and open the Assign Renderer rollout (Figure 2.7).

Hit the Production Renderer button (Figure 2.8).

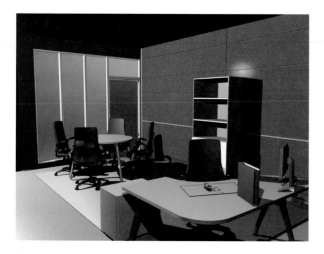

Figure 2.7 *Assign renderer rollout*

Figure 2.8

Select mental ray renderer in the Choose Renderer dialog box, and click OK (Figure 2.9).

Now mental ray is active. Render the scene to see what happens:

- The way the rendering presents itself has changed. A horizontal progress line no longer moves from top to bottom. Instead, small squares randomly complete the rendering. These small squares are called *buckets* in mental ray terms.
- The resolution that is used for the rendering is identical to the one we were using with the scanline renderer. This means that these settings are transferred directly between the two render engines. This characteristic applies to a lot of things when working with mental ray.
- The result is basically the same as before. However, there is a small difference in sharpness of the image. The antialiasing defaults show small staircase effects at the sides of the different objects. As demonstrated using the draft and high presets, this can be corrected.

Figure 2.9

mental ray in its most simple form is just another render engine. There is no need to change your existing workflow with specific mental ray materials or lights; you can still continue working like you used to. The only thing that has changed at this point is the internal process of generating the final rendered image. Since mental ray has been totally integrated inside the main user interface, you will not be able to notice the difference until you start rendering. All the differences are handled in the background. What actually happens is the following: a scene that was made in 3ds Max is passed on and then transformed and rebuilt inside mental ray. Finally, it is rendered and the end result is displayed on the computer screen. Because of the mentioned integration inside the main software, you are never aware of this process.

Now, let's talk about the improvement of the quality between when we used the presets and this last rendering. The main responsible setting found at Renderer panel > Sampling Quality rollout. The quality is controlled (among other things) by the Samples per Pixel group (Figure 2.10).

The default settings for the Samples per Pixel are ¼ as minimum and 4 as maximum. These settings are responsible for the poor aliasing effect seen with the draft presets. We have created two images: one with a minimum value of 0,015625 and maximum of ¹⁄₁₆, and one with a minimum value of 1 and a maximum of 256.

Never give the minimum and maximum the same values. A value bigger than 1 indicates the number of samples taken to create the pixel. Values smaller than 1 mean that samples are taken every fourth (or 16th or 64th) pixel (Figures 2.11 and 2.12).

Figure 2.10 *Sampling Quality rollout*

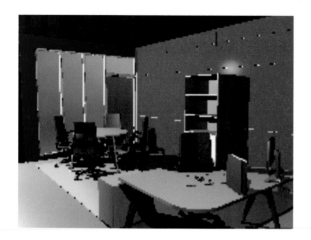

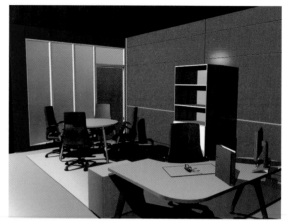

Figure 2.11 *Min = 0,015625 and Max = ⅟₁₆* **Figure 2.12** *Min = 1 and Max = 256*

Sampling itself is an antialiasing technique. It gives the best guess for the color of each rendered pixel. mental ray first samples the scene color at locations within the pixel or along the pixel's edge; it then uses a filter to combine the samples into a single pixel color. This technique is also used inside the normal scanline renderer and is called super sampling. When using mental ray, there is no need to use super sampling for standard materials because it is done in any case.

For now, this is more than enough to get started. Other settings of the different panels will be discussed as they are used. Let's move on to more complex and intriguing renderings, instead of going over little details (no matter how important they are). In order to start making beautiful renderings, settings with indirect light and other special effects will now be explained.

2.2 mental ray and Indirect Illumination
2.2.1 Introduction
The first steps have been made — we are rendering with mental ray. Up to this point, mental ray was used simply as an alternative render engine. The renderings made so far have been simple: just direct lighting. There is more though. Just imagine, dancing light reflecting from the water surface to the ceiling, a dimly lit room with just the light from a candle or fireplace, or the morning sun falling into your window, giving the room the most fantastic kind of light, both in color and in atmosphere.

The Indirect Illumination panel is the place in the interface that generates these types of effects. They all involve the reflection or refraction of light bouncing through the room and objects, creating effects such as global illumination and caustics. mental ray can generate these special light effects for you.

Lighting phenomena such as global illumination, caustics, and photons were mentioned in Chapter 1, where we first introduced these concepts. Now it is time to bring them to life. This is the part of the book where these kinds of things are used both as terminology and as options. Open the Render Scene dialog > Indirect Illumination panel, and let's explore the options.

2.2.2 Indirect Illumination

The Indirect Illumination panel has two rollouts: Caustics and Global Illumination, and Final Gather. We will first explore the Final Gather rollout, using different examples, both interior and exterior, to learn how to use these techniques in your work. After that, we will explore the Caustics and Global Illumination rollout to make this part complete. So, let's get started with the Final Gather, the first rollout inside the Indirect Illumination panel.

2.2.2.1 Final Gather (Exterior)

Model provided by Aydin Uluc

Open the file **final_gather_preset.max** and render the scene, just to get an idea of what we have inside it (Figure 2.13).

mental ray is already assigned as the active render engine, and there are no special lighting techniques active. The scene uses the mr Daylight system as the only light source, so we can use a rendering preset.

Use the presets that activate the Final Gather options: the mental.ray.daylighting presets. Select the mental.ray.daylighting.draft preset. Remember, Final Gather in Version 3.5 of mental ray inside 3ds Max shows enormous improvements in both speed and ease of use over the previous versions. And, just to reiterate a point previously made, Final Gather shoots rays from points on the geometry; it does not use light rays.

Open the Render Scene dialog and select from the Preset options the mental. ray.daylighting.draft (Figure 2.14).

The Select Preset Categories dialog will open again (Figure 2.15).

Compared with the previous Preset
options we used (no.gi.draft and no.gi.high), there is one extra panel that will be
adjusted automatically — the Environment panel. Just select all the panels and click the Load option. The Environment panel needs to be adjusted when we use an mr Daylight system. To be honest, we have already prepared the scene a little bit, but we will talk in detail about how exactly an mr Daylight system needs to be set up when we go over all the light options for mental ray in Chapter 3. For now, it is just important to experience the Final Gather render technique; this is what we will focus on.

Figure 2.13 *No indirect illumination yet applied*

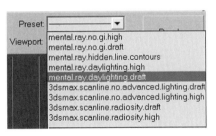

Figure 2.14

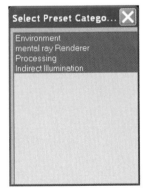

Figure 2.15

Start rendering the image and check what happens. You can see that the scene is first built up in a very crude way. This is normal. There is no need to stop the rendering. There will come another pass once this one is finished, to create the final image. The first pass is really a draft version; it gives you an idea of what will be created. If you look at the process, you can see that even the way the buckets are created is different. This involves the way that the final gathering is calculated. Actually, what you see is a dump of the output of the surface shader with the lowest possible sampling quality (Figure 2.16).

The quality is not that good upon completion of the first pass, but the general idea is there and, most importantly, the rendering time is short.

The final image is created during the second pass. We have now created an image with a daylight system that uses indirect light. It is easy to see the differences in the tonal values and variations of the shadows, as it would be in reality (Figure 2.17).

Now render using the mental.ray.daylighting.high for even a higher-quality image (Figure 2.18).

Select the preset as shown above, load all the panels, and render the scene again. In this regard, any of the "high" presets will be computationally intensive and will increase rendering times significantly. Unfortunately, there is a price for quality . . . and that is time (Figure 2.19).

The quality of the image has been improved enormously, and more detail has become visible.

Now let's discuss the most important things that have actually happened inside the settings of mental ray. Reset everything by reloading the **final_gather_preset.max**

Figure 2.16 *The first final gather rendering pass*

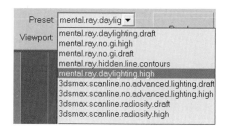

Figure 2.18

Figure 2.17 *Final gather draft preset rendering completed*

file so that the changed settings can be examined. It is readily apparent from the opening of the Render Scene dialog that mental ray has been switched on and the Sampling quality has been set to specific levels by using the daylighting presets. But since we have discussed this already with the no.gi preset, we will skip this part.

The most important thing that has happened is that we have created indirect illumination, with the use of a special rendering technique called Final Gather (FG). This option was switched on when we started using the presets. This can also be done manually inside Render Scene dialog > Indirect Illumination panel > Final Gather rollout (Figure 2.20).

Figure 2.19 *Final gather high preset rendering completed*

Enable the Final Gather option by clicking on the checkbox just below the preset drop-down menu; all the grayed-out options will become usable. The interface is presented in three different sections: Basic, Final Gather map, and Advanced group. Let's start with Basic.

Basic Group

First, there is a drop-down list with presets, which fill the settings inside the Basic group (Figure 2.21).

Note that the list of presets changes. The draft and high presets are the ones that are actually activated when the render preset for daylighting is selected. There are some additional presets, offering a range of quality defaults as well as the ability to create and save custom settings

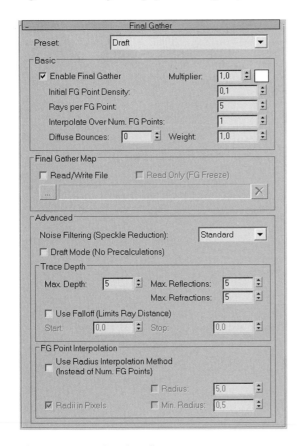

Figure 2.20 *Final Gather rollout*

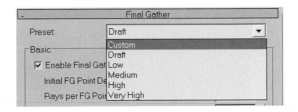

Figure 2.21 *Final Gather presets overview*

fine-tuned to your preferences. All of the presets affect various settings in the Basic group in some way or another. A comparison of all the preset variations is presented in the table that follows.

	Initial FG Point Density	Rays per FG Point	Interpolate over Number of FG Points
Draft	0,1	50	30
Low	0,4	150	30
Medium	0,8	250	30
High	1,5	500	30
Very high	4	10.000	100

It is apparent from the table that with the improvement in quality, the initial FG point and rays per FG point are increased, which is in direct proportion to rendering times. So, what do these headings mean?

In order to explain this more clearly, let's render with the Diagnostic settings turned on, which will display the actual FG points in the scene. A visual display of the setting will better explain what these different presets are doing relative to the table above. Activate the diagnostic setting inside Render Scene dialog > Processing panel > Diagnostics rollout (Figure 2.22).

Click the radio button for the Final Gather option. Rendering the scene will display a similar image (*Note*: The dots inside the diagnostics rendering are green; a simple gray material for all objects was applied in the scene to make the dots more evident.) (Figure 2.23).

The tiny green dots are the actual Final Gather points that are being used inside the calculation. When switching between presets, the initial FG point density changes. This multiplier controls the actual amount of FG points inside the scene, from where rays are cast into the scene starting from the geometry. The diagnostic rendering was made with an Initial FG Point density of 1. So, what happens with the presets

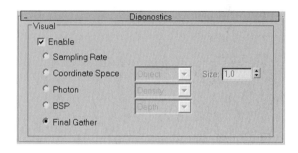

Figure 2.22 *Diagnostics rollout*

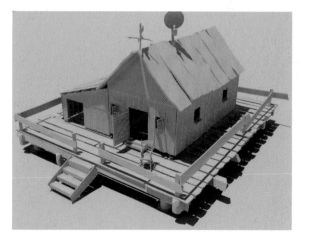

Figure 2.23 *FG diagnostics rendering*

is that the number of actual points that are used for the calculation is being varied.

The next setting that varies with the presets is Rays per FG Point. This setting increases the number of rays that are shot from the FG points. Logically, if you define more FG points and more rays to leave from these FG points, the total amount of information that can be collected will go up, and thus the quality of the image will increase.

To explain what happens with the Interpolate over Number of FG Points setting, we need to zoom in a bit on our diagnostic rendering (Figure 2.24).

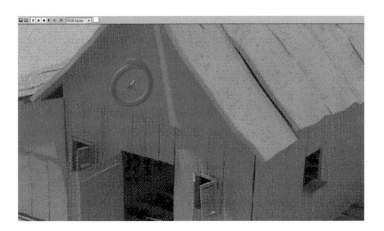

Figure 2.24

Let's say the red cross shown above represents the actual pixel you would like to calculate inside the image. mental ray now starts looking to the surrounding area of this pixel until it has found 30 Final Gather points to average the rendered pixel. This is what the Interpolate setting controls: the number of FG points that need to be considered prior to rendering the pixel.

Note from the table above that this value remains constant between presets until the last preset (very high) quality. Only with the last option does this amount increase, meaning that more FG points will be used to create the pixel sample. It should be reiterated that these extra calculations are directionally proportional to the quality of the image and, of course, increased rendering times.

The last setting in the Basic group is the number of Diffuse bounces. This setting increases the number of times diffuse light bounces are calculated for a single diffuse ray. The default of this setting is 0, with no bouncing rays calculated. The weight factor determines the relative contribution of the diffuse bounces to the final gathering solution. We will not use this option inside the exterior scene since the scene is brightly lit already.

In summary, the Basic group parameters change when using different presets. I explained briefly what these settings were. Essentially, remember that more FG points, more rays, and a larger number of FG points over which to interpolate create a better quality. There is hardly any reason to use the custom settings when rendering exterior scenes like the one in the example. The different presets can be readily used to create stunning images.

The next Final Gather rendering exercise will evaluate these same settings relative to an interior scene. An interior scene is much more complicated computationally since just a small portion of the scene, such as a window that lets the sunlight in, is responsible for illuminating the entire scene. Changes in the presets are much more evident than in the exterior scene.

Final Gather Map

The second group contains the Final Gather map settings, which are incredibly useful, especially for animations. They also allow for fine-tuning an image, as is shown later in this chapter. Settings in this group provide the ability to save the Final Gather map as a file that can be reused for all the next frames inside your animation, thus saving an enormous amount of rendering time. The final gathering solution is calculated only for the

first frame; provided that no objects or lights move inside your animation, there is no need to calculate this for each individual frame. This option is great for walk-through and fly-by animations, where usually only the camera position changes.

Open the file **final_gather_animat.max**. The file contains a simple animation sequence for this scene. Check the Render Scene dialog > Indirect Illumination panel > Final Gather rollout (Figure 2.25).

Figure 2.25

In order to generate a Final Gather map, 3ds Max needs a file name and a location to store and retrieve the map. Make sure that the Read/Write file option is checked when the file is generated. Once this is done, render the scene. *Do not render the whole animation*, just the first frame. The final gathering solution is generated for the image just as we expect, and the Final Gather map is created and stored on disk and as a separate file.

Now, in order to start reusing this file, make sure that both options Read/Write file and Read-Only are switched on. Also, remember to switch the setting inside the Common panel to render the whole animation, and click Render. By using the Final Gather map, just the final image is rendered, not the preview. This feature saves time on each individual frame that is processed since a Final Gather map no longer has to be generated for each. If you want to simply look at the animation demonstrated in the exercise without waiting, just check the DVD and look for the final_gather_animat movie.

In the next section, we will render an interior scene. We will create an image by building on the Basic group settings learned in the previous exercise. Then, we will use the same file; however, this time creating a final image with the Advanced setting group. In this way, you will have an overview of both options and will be able to use the one you prefer (although the Advanced group is a bit trickier to set up).

To show you how these two Final Gather techniques work, a different scene is used. This scene presents a challenge for final gathering since it is an inside a small space where the scene is lit by one window.

It is important to note that the preferred method to manually set up scenes for use of final gathering should be done using the presets inside the Basic group and adjusting the settings beyond that, as needed.

2.2.2.2 Final Gather (Interior)

Model provided by Richard Böck, www.macrocad.nl, based upon a magazine picture of this bathroom by the Czech architect Petr Sulc.

It is finally time to do the interior scene in detail. First, open the **fg_interior.max** file and render the scene (Figure 2.26).

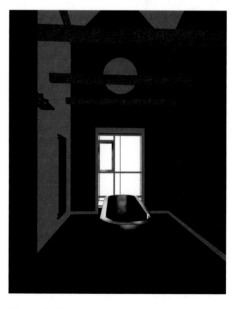

Figure 2.26

Inside the image, there is a small bathroom with just one window that lets light come into the room from the mr Daylight system. Not an impressive image, true, but there are still some things we need to do. We have created this scene already with an mr Daylight system in place. The mr Physical Sky shader has been applied inside the environment, and the Logarithmic exposure has already been assigned. We just "forgot" to turn on the Final Gather option during rendering. This kind of setting is typically hard for Final Gather since there is just a small portion of the scene that supplies the light for the scene as a whole, but I will show you that it works — both with the Basic and the Advanced settings.

We will start with the Basic options. Go to the Indirect Illumination rollout, switch on the Final Gather option, and select the Draft preset and start rendering (Figure 2.27).

The good news is that we have indirect illumination since the scene is more or less lit all over just by the daylight from outside. The quality is not good yet, but we will start improving this one. First, let's discuss what we are seeing at present. For this, we need to create a diagnostic rendering of this scene.

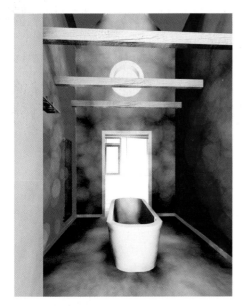

Final Gather shoots rays inside the scene, which originate from the geometry. These rays collect the brightness information of the scene so that the system can determine the actual color of the pixels in the rendering.

There is a way to make the actual FG points visible inside the rendering. You can find this inside Processing panel > Diagnostics rollout. Switch on he Final Gather option, and the points will become visible as tiny green spots over the rendering (Figure 2.28).

Render the scene again to get the following image (Figure 2.29).

The green dots are the actual Final Gather points, so these shoot the rays into the scene. If we now check the Basic settings group, we spot directly the

Figure 2.27 *Final Gather draft preset rendering*

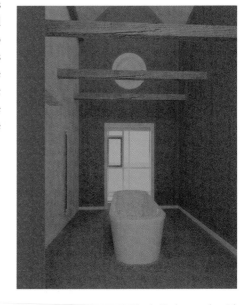

Figure 2.29 *Diagnostic Final Gather result with FG density of 1*

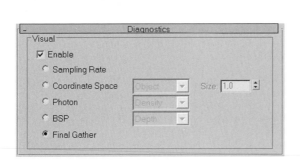

Figure 2.28

option that is responsible for the number of Final Gather points inside the scene (We actually adjusted this value to 1 get the previous rendering to show more FG green dots.) (Figure 2.30).

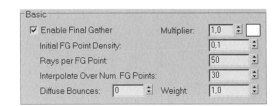

Figure 2.30

The option responsible is the Initial FG Point Density option. The amount of rays that are shot from these points are obviously controlled by the Rays per FG Point option; at present, we are using just 0,1 of the default amount that mental ray would create. Each point shoots 50 rays into the scene to gather the information needed, as you can see from the Rays per FG Point setting.

Now let's look closer at the Interpolate over Number of FG Points. For this, we have used the diagnostic rendering, but we zoomed in a lot into one of the corners (Figure 2.31).

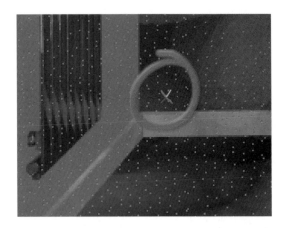

The small red cross stands for the actual pixel we want to create inside the image. There is a circular shape around this pixel. Inside this circle, there are 30 Final Gather points, and this is exactly what happens internally when the value for Interpolate over Number of FG Points is set to 30, as we are using now. For each pixel that needs to be defined, mental ray looks for 30 FG points surrounding it, and then averages out all their information into the color to be displayed.

Figure 2.31

So, if we would increase this number for our scene, we would get a smoother result in our final image because we would use more FG points to create the final pixel. Let's test this by increasing this number, and see what happens (If you want to render, don't forget to turn off the Diagnostic option at this point.) (Figures 2.32 and 2.33).

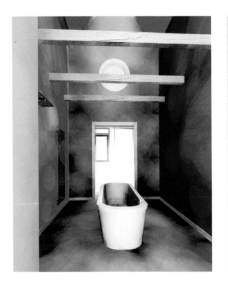

Figure 2.32 *Interpolate over Number of FG Points = 30*

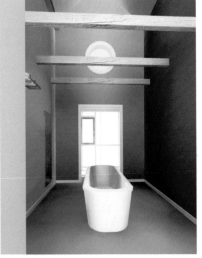

Figures 2.33 *Interpolate over Number of FG Points = 250*

What an improvement! But there are both good and bad aspects to this option. The good news is the improvement of the overall quality. Also, increasing this number does add some rendering time, but not dramatically since this option is independent of the size of the scene. The downside is that it has not resolved all the problems since the red wall is still incorrect and the image is too flat at present; there is no color variation on the wooden beams, for instance. But remember that increasing the interpolate option is best to create noiseless images, with a minimum of rendering time involved.

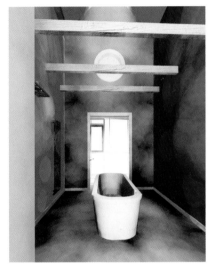

Figure 2.34 *Initial FG Density = 0,1*

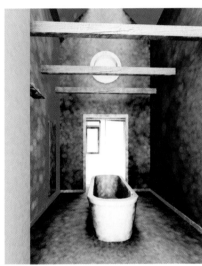

Figure 2.35 *Initial FG Density = 4*

Now let's try another approach to make this image better. First, put the interpolation back to 30. We will start increasing the density of the Final Gather points, and see what this option will do for us. We have created one image with a density of 0,1 and one with a value of 4. (Figures 2.34 and 2.35).

For both, we also created a diagnostic rendering, so you can see visually how much extra information is added with this option (40 times) (Figures 2.36 and 2.37).

Obviously, this is not the complete solution to our problem, although the overall quality has become better. We have more details inside our scene but still a lot of noise. So, remember that increasing the density will give you more details.

One way to solve the noise would be to increase the interpolation again, but there is an alternative, which happens to be the one option we have not yet used: increasing the number of rays per point.

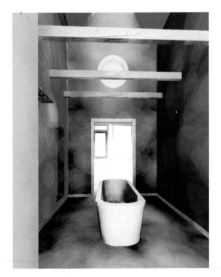

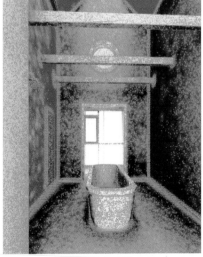

Figures 2.36 & 2.37 *Diagnostic showing the difference between 0,1 and 4 Initial FG density*

Load the preset draft again and change the interpolate number to 1 (which is the same as turning it off). After this, we have created two renderings again, but one with the number of rays set to 50 and another one with the number of rays set to 10.000. We turned off the interpolate option on purpose so that you could see the influence of more rays in the best possible way (Figures 2.38 and 2.39).

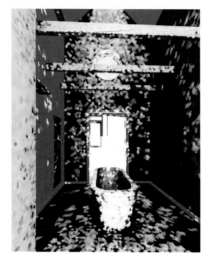

The image with the 10.000 rays is getting close to perfect. It might just need some interpolation to make it complete.

So, to resume the settings part: we have three variables, which all have their specific influence. Depending on the scene you are working on, you need to play with one of the three options. A scene like ours, with a high contrast (a small window for the overall lighting of the scene), needs more rays than scenes that are more evenly lit. High-contrast scenes can easily need between

Figures 2.38 & 2.39 *The result of increasing the number of rays from 50 to 10.000*

1.000 and 10.000 rays. Simple scenes can do with as few as 50.

A bigger density for FG points will increase the level of detail in your scene. Increasing the interpolation will result in less noise inside the rendering.

One final note about our scene involves the bounce option, which we have not touched on yet. There are still some dark areas inside our image. The reason is that it is hard for the sunlight to reach these points, for instance, the corners behind the inside wall. Remember that by default we are using just one bounce, so just one pass is used to transport the light from one object to the other. So, we need to increase this number to get the correct light distribution in our bathroom. We increase the value to 5, which is a normal value for this option. A good range is anywhere between 3 and 10, where 3 is for darker walls and 10 is for lighter walls. Remember that adding bounces will add render time (almost multiplying the previous render time with the number of bounces you add). We will use the bounce option within the next section so that you can see what happens.

Alright, we have covered the options and their influences. Now let's reset everything and make it our goal to create a great image as fast as we can. Since we already know that we are dealing with a tough scene, we start by adding bounces directly. So change the bounces to 5 and load the Draft preset as a first step (Figure 2.40).

Now render the scene to see what we get (Figure 2.41).

Let's tackle the problems we see. The first problem is the overall brightness. Part of this has to do with the tone mapping, which can be adjusted within the Logarithmic exposure control of the Environment panel. Remember that this problem has nothing to do with the final gathering solution itself; it is just the way that the *computer-generated color data* are changed into *monitor colors*. We changed the brightness to 35 and the contrast to 30. The other reason for the overbright image might be that we have used too many bounces, but we will leave this for now (Figure 2.42).

Next, we need to solve the noise (more interpolation and more rays per FG point) and we need more details (increased density of FG points), so select the medium preset and adjust the initial FG density to 2, the interpolation to 50, and render again. At this point, it is a good habit to save the Final Gather map. This gives you the flexibility to test even higher interpolation values if you still have some smoothing problems left, without doing the whole calculation process again. The map gets saved to disk, and by

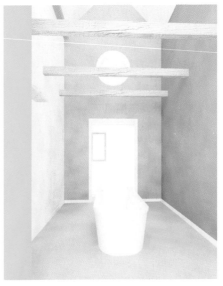

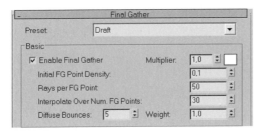

Figure 2.40 & 2.41 *First result with increased number of bounces*

reusing it you can quickly try out different values until you have reached your preferred look in the final image (Figure 2.43).

For final fine-tuning, let's use the Final Gather map and increase the interpolation to 100. Make sure the Read-Only option is switched on within the Final Gather map group (Figure 2.44).

Render the image again, saving a tremendous amount of time (Figure 2.45).

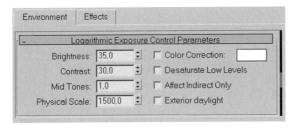

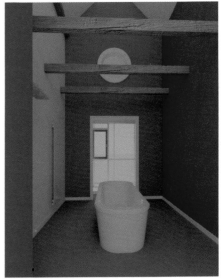

Figure 2.42 & 43 *Logarithmic Exposure Control Parameters rollout*

Advanced Group

Now let's try to get the same result using the Advanced settings. Reload the **fg_interior.max** file so that we can start from scratch. Now go to Render Scene dialog > Indirect

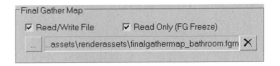

Figure 2.44

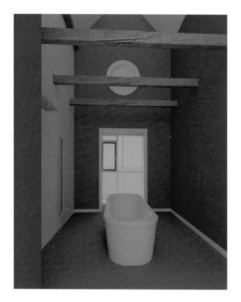

Figure 2.45 *Final result of interior scene*

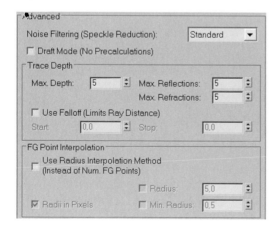

Figure 2.46

Figure 2.47 *Advanced group for Final Gather*

Illumination rollout and turn on the Final Gather option. Just leave the settings as they are for now. We will adjust them later on (Figure 2.46).

Move on to the Advanced option group and check the options we have there (Figure 2.47).

The funny thing about these Advanced options is that they are not actually *advanced* — they are just the way that the previous version of 3ds Max and mental ray worked. So, actually the options are just a bit different, but they will give you the same result as with the Basic options. The most important group for us is the FG Point Interpolation.

The main difference is the way the FG interpolation works for these advanced settings. If you just turn on Use Radius Interpolation Method (instead of Number of FG Points), you introduce the major difference. As the full name of this option states, we now overrule the interpolation method by a radius inter-polation method. We have selected the way final gather worked inside the previous version of 3ds Max. Once you have done this, the option Interpolate over Number of FG Points in the Basic group becomes unavailable, which means we will be rendering with a radius setting. So, inter-nally mental ray is no longer looking for a fixed number of Final Gather points; instead, it looks for the Final Gather points that are inside this radius. Therefore, inside the Advanced options, you need to play with the radius to get a smoother result, in combination with the number of rays per FG point, of course. For the rest, the same rules apply, like increasing the number of rays and the number of Final Gather points to increase quality.

So, instead of going over all the different steps we did when using the Basic group of options, we just put the final image in directly. You might think we could more or less use the same settings as we had before, as long as we know the radius we need, to get the same number of FG points to be considered during the averaging process, but, unfortunately, this is not possible — you need to find the proper settings for this through trial and error, and waiting.

To make your life easy, these are the settings we used to get the final image: For the Logarithmic exposure, we used the same settings as with the Basic group; so, Brightness = 35 and Contrast = 30. We used 5 bounces for the rays, which is also the same as before. The Initial Density was set to

1 and the Rays per FG Point at 1.000, and we used a radius of 50. Therefore, what actually happens is that for a given number of FG points, 1.000 rays leave from each point. The only difference is that we are now looking inside a radius of 50 and averaging the information that the FG points inside this radius will give us. This means that your radius has to be big enough to catch sufficient FG points to make the image smooth but not too many, which will make the image loose details (Figure 2.48).

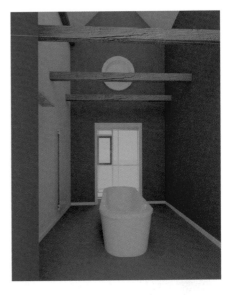

The result looks great, but there is no real difference between the quality of the "advanced" and "basic" final images. This is normal. As I mentioned, there is not much advanced about these options; they are just the old way of working in the previous 3ds Max and mental ray release. We will leave the other options, such as minimum radius and radii in pixels, as they are since the best way to go from now on is to use the Basic options. They are easier to control and set up, and they give the same result. The Advanced group is still important for solving problems such as color leaks (with Render to Texture) and for use in animations, although most of these problems can be solved by the new Basic method.

Figure 2.48 *Final result with advance group settings*

Now that we have the Final Gather Advanced group working, we have a few things still to be resolved and discussed in terms of the untouched options. So, have a look at the user interface again (Figure 2.49).

The first option is Noise Filtering. This option applies a median filter using neighboring Final Gather rays that are shot from the same point. This results in an even smoother solution, but as a side effect, it tends to make the scene darker. In our case, this is not a good option. In fact, if we were to use it in this scene, it would have a bad quality again, so we won't use this one.

The Draft Mode option is another we have not used. This one takes away the precalculation for final gathering, which results in a lower-quality rendering but a quicker result. It is perfect for test renderings, where the overall quality is not the main interest.

Figure 2.49

The Trace Depth group sets the limits for the reflection and refraction that occur inside the scene. Final Gather needs some basic light information about the scene before it can start shooting rays from the geometry, and that is what the Trace Depth group controls. The maximum depth stands for the maximum amount of both reflections and refractions. For instance, if there were two reflections and three refractions, the total would be five; this would equal the maximum depth setting, so it would stop once these numbers were reached.

The Falloff option can be used to limit the length of the rays, which is useful to exclude light sources that are to close to the geometry. Alternatively, when there is no geometry all around the scene, rendering will stop at this value, thereby saving time.

Final Gather and Ambient Occlusion

How does one decrease rendering times and maintain the quality? This one of the questions everyone would like answered. It is entirely possible to create beautiful images with Final Gather, but the fine-tuning part adds significant times to the rendering.

Remember the image from the beginning, when we used the Draft preset? The only modified setting was an increase in the Interpolate option from 30 to 250. The rendering was rather good. To refresh your memory here is the result from that rendering (Figure 2.50).

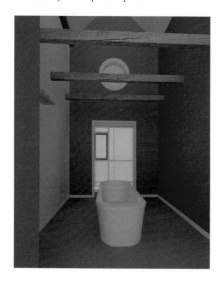

Fortunately, there is a way to add details without any kind of adjustment to the Final Gather settings. It is a setting that is specific for the new Arch & Design material, which was introduced with this release of mental ray 3.5. Now, open the scene **FGandAO.max**, but don't render it yet. This material was intentionally used inside this scene already. In order for it to work, Ambient Occlusion must be turned on inside the materials themselves. To do this, open the Material Editor and select one of the materials.

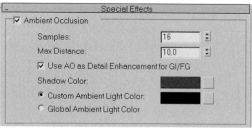

In the Special Effects rollout, you will find the Arch & Design option (Figure 2.51).

Figure 2.50 *Result with FG at draft preset and 250 value for interpolate option*

Figure 2.51 *Special Effects rollout of Arch & Design material*

As you can see, we have already turned on this option, but now you know where to look for it. We have turned on ambient occlusion for all the materials already, so just hit render to see how the result will look (Figures 2.52 and 2.53).

The difference is obvious; the right-hand image has more depth. Ambient occlusion has added details into the scene. More on this subject is provided in Chapter 4, where the Arch & Design material is discussed.

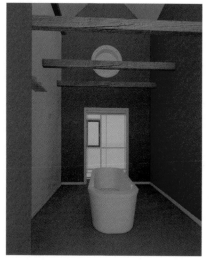

Figures 2.52 & 2.53 *FG at draft without (left) and with (right) ambient occlusion turned on for the materials*

2.2.2.3 Caustics

There is no preset available for the creation of caustics, so you always have to set this up manually. Caustics are the effect that light creates through an object on another object, via light reflection or refraction. Good examples of this are the reflection of sunlight on the walls surrounding a swimming pool, and the light reflection a glass of wine causes on a table. To be able to generate this effect, mental ray uses the photon map technique. Ray-tracing is not accurate enough, and the scanline renderer is not able to generate this effect at all.

It is important to note that lights and the object(s) in the scene that are to generate the caustics must be told to do so. By default, Generate Caustics setting is off for every object created, but the Receive Caustics setting is on for every object created.

Caustics come in two distinct functions of nature, one based upon reflections and the other upon refractions. The first exercise will demonstrate caustics based on reflections. A point of interest is that the photons used to calculate caustics are different than the ones used to calculate global illumination. By default, photons used in the calculation of caustics are 0,01 of the maximum size of the scene, compared with 0,1 for the photons for the global illumination.

We will first start with the generation of caustics through reflection. Open the file **causticreflections.max** and render the scene (Figure 2.54).

The reflection of the light in the water is shown, but in reality this light would reflect on the ceiling of this wooden structure. These are the caustics this exercise will demonstrate. For this to happen, there are some rules to follow. First, and most logical, the scene needs a light source. Without a light source, caustics will not show. We are using an mr Daylight system for this part. Second, there must be at least one object in the scene that is able to generate and/or receive the caustics. In this case, the generator is the water surface. Receiving Caustics is on by default, so there is no real need to check this. Generate Caustics is activated in the object's properties. Select the water surface and check the properties of this object by right clicking the mouse to bring up the Quad menu and then selecting the Properties option. The Object Properties dialog box will appear. Open the mental ray panel and turn on the option Generate Caustics; again, remember it is only for this object. The mr Daylight system also has to activate the Generate Caustics option, so do the same process again (Figure 2.55).

Figure 2.54 *No caustics introduced yet*

Figure 2.55 *mental ray specific Object Properties dialog*

The last setting that informs mental ray to calculate caustics must be activated prior to rendering, or all other settings do nothing. Open Render Scene dialog > Indirect Illumination panel and enable the Caustics option inside the Caustics group (Figure 2.56).

Now render the scene and see what we get (Figure 2.57).

Unfortunately, not that much is different from what we had originally. There is a small amount of light reflecting on the ceiling of the wooden structure. These are actually the caustics. The position of the photons that generate the caustic effect is defined by the angle the light source has toward the water surface, taking into account the normal direction of the surface. Now let's start fine-tuning this image by going over the different options we have for caustics.

Return to Render Scene dialog > Indirect Illumination panel. In the caustics group is the Multiplier setting and color swatch. The intensity and color of the caustics effect are controlled with these options. Change the value of the Multiplier to 2, and leave the color as it is for now. Technically, the default values should produce a physically correct rendering. In order to achieve a better-defined caustic reflection, simply adjust the overall contribution; this improves the believability of the image (Figure 2.58).

There is some improvement in the amount of indirect light shown on the ceiling. It is possible to achieve a similar result by increasing the Energy level of the daylight system. With the daylight system selected, switch to the Modify panel. In the mental ray indirect illumination rollout, increase the energy value and render. The results should be very similar.

The next adjustment is inside the Maximum Number of Photons per Sample. This one sets how many photons are used to compute the intensity of the caustic. Increasing this value makes the caustics less noisy but more blurry (Figure 2.59).

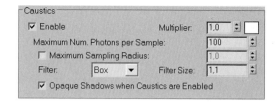

Figure 2.56 *Caustics group*

Figure 2.57 *Default settings showing almost no caustics yet*

Figure 2.58 *Increased multiplier*

Figure 2.59 *Caustics settings*

Figure 2.60

Decreasing this value does the opposite: it makes caustics more noisy but less blurry. More samples means a bigger rendering time, of course. The number of photons used to compute the intensity of the caustics is not the same as the total number of photons that are being shot inside the scene. This is just the number of photons that

is referenced for sampling purposes in a specific area. The total number of photons that are being shot inside the scene can be confirmed at the bottom of our caustics and Indirect illumination rollout in the Light Properties group. By default, the value is set at 10.000 photons (Figure 2.60).

Reduce the Maximum Number of Photons value, for starters, to 20; this should demonstrate more noisy and less blurry caustics, as shown in the next image (Figure 2.61).

The next option is the Maximum Sampling Radius. By default, mental ray uses photons that are 0,01 of the radius of the full scene, and that is the result we are seeing now. It is normal that you would want to adjust the default size. Let's try adjusting this one manually to see if we can get a more pleasing result. Activate this option and adjust the value to 2.5 (Figure 2.62).

Figure 2.61 *Less samples give more noise and less blurry caustics*

The caustics are becoming more splotchy, and it appears there are more of them. This splotchy effect would be further enhanced by shooting more photons inside the scene than the 10.000 currently being used. The reason that it appears to have more reflection involves the sampling and the size of the photons used. Where photon reflections overlap, the mental ray renderer uses sampling to smooth them together. Increasing the number of samples increases the amount of smoothing. Photons with a small radius don't overlap, so the samples setting has no effect.

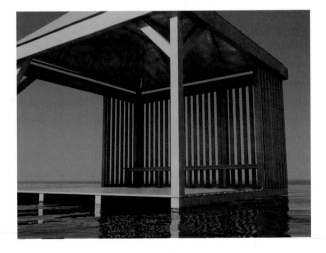

Figure 2.62 *Result of radius adjustment*

Next, we need to sharpen the caustics a bit more. This is the function of the Filter option. Various types can be selected within the drop-down including Box, Cone, and Gauss filter types. Box is the one currently being used, and it is the fastest. Cone creates the sharpest caustics, while the Gauss option makes them a bit smoother by using a Gaussian curve for smoothing. In conjunction with the filter type is the filter size. With the Cone option, values less than 1.1 make the caustics sharper (but noisier). Select Cone as the filter, and set the size to 1 (which is the smallest possible value) and render again (Figure 2.63).

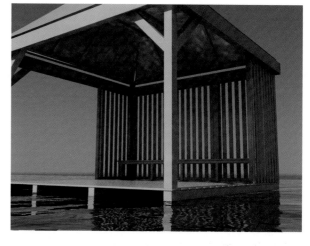

Figure 2.63 *Result of changed filter type*

The caustics are beginning to become more believable. The last option in the Caustics group is the Opaque Shadows option. When caustics are enabled, this option can be a great time saver. When enabled, the shadows are opaque, and when disabled, they are partially transparent. Opaque shadows render faster.

For the final image, all the settings will be considered together in a final pass. Increase the number of photons inside the scene to 100.000, which should produce a more splotchy effect. Increase the Maximum Number of Photons per Sample to 100. This will compute more photons for the intensity of the caustics, making them less noisy but more blurry. In summary, the settings will produce an image that is more splotchy, less noisy, and more blurry (Figure 2.64).

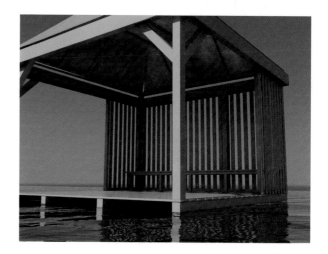

Figure 2.64 *Final result after fine-tuning caustics effect*

Just the way we wanted it for this scene!

In conclusion, caustic reflections are a powerful effect to use inside mental ray to enhance the realism of a scene. With a number of options, it should be noted that mental ray relies on energy and photon values depending on the units and size of the scene. In most cases, experimentation with the settings will help achieve the best result.

With the caustics based upon reflections completed, we will now demonstrate one based upon refractions. We won't review all the different steps for refinement since the procedure is exactly the same as for caustics based upon reflections.

Caustic Refractions

In the next exercise, we will demonstrate how to create caustics that originate from refraction, in this case through a glass bottle. Open the file **causticrefractions.max** and render the scene (Figure 2.65).

Inside the scene there are three bottles, all made of glass, using the Arch & Design material with the Glass Physical preset. Each has a different color, to demonstrate that it is possible to generate colored caustics.

As mentioned previously, it is important to verify all the rules of caustic generation. Select the bottle objects and check whether they are set to generate caustics by using the right mouse button and selecting the Properties option inside the Quad menu. Make sure they are set to Generate Caustics inside the Object Properties dialog box > mental ray panel (Figure 2.66).

Do the same thing with the lights in the scene and make sure they are also set to generate caustics. The final step is to tell mental ray to calculate the caustics. Open Render Scene dialog > Indirect Illumination panel, and check the Enable option inside the Caustics Group (Figure 2.67).

Next, render the scene (Figure 2.68).

The colored caustics do appear, though faintly. It is possible to achieve a better result. The previous exercise reviewed the different options, so they are not explained again here. Instead, the settings used will be shown in the following images (Figure 2.69).

As you can see, we used the standard size (0,01 of the scene) but pumped up the Multiplier value. By using the cone and the smallest filter size, we have achieved sharp caustics (Figure 2.70).

It is important to note that a lot of photons were used and the default value of Trace Depth was increased to 12. This is also reflected for the individual settings of the maximum reflections and refractions. This

Figure 2.65 *No caustics introduced yet*

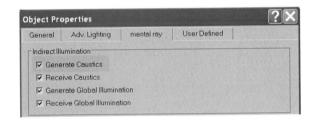

Figure 2.66

Figure 2.67

Figure 2.68 *First generated caustics using default settings*

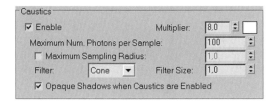

Figure 2.69

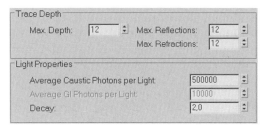

Figure 2.70

Figure 2.71 *Final result of manually adjusted caustics*

means that a maximum of 12 bounces for either reflection or refraction or a combination of both will be calculated.

The following image was the result from these settings. This image demonstrates what is possible by playing around with the settings, although it maybe a bit over the top (Figure 2.71).

2.2.2.4 Global Illumination

The next group inside the Indirect Illumination panel is the Global Illumination group, which will be reviewed now. Open the file **GI-interior.max** and render the scene. The same bathroom scene as used in the final gathering exercise will be used for comparison (Figure 2.72).

The rendering result is a very dark bathroom, which is lit by the mr Daylight system.

Figure 2.72

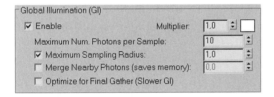

Figure 2.73

Figure 2.74

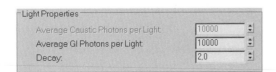

Figure 2.75

What the rendering lacks is obvious — indirect light. Using mental ray, this can be achieved with Global Illumination, which means that photons will be used in the rendering. Photons in mental ray simulate the photons that are present in reality. The photons in our scene will be refracted through the glass window and scattered around the bathroom by all the diffuse surfaces of the different materials we have applied. The photons are shot inside the bathroom directly from the Daylight system, and will start bouncing in the room, making sure that indirect light will be present. Let's start with showing the photons, and then move onto the step-by-step procedures of how to use photons when rendering with mental ray.

Turn on the Global Illumination option. You can do this by following this route: Render Scene dialog > Indirect Illumination panel > Global Illumination group. Since we started by showing you the actual photons inside the scene, we have already prepared the settings for the Global Illumination so that they will show. The settings we are using now are not the default settings, but they will give you the best possible understanding of what happens inside the scene now that we have turned on Global Illumination (Figure 2.73).

To be able to render with global illumination, you need objects that can generate and receive global illumination. For this scene, we have made things easy by turning this option on for all objects in the geometry properties group in the Render Scene dialog > Indirect Illumination panel > Caustic and Global Illumination rollout (Figure 2.74).

Now it is time to render the scene. We will be rendering with 10 photons per sample, and the sample radius is fixed to 1. We are shooting 10.000 photons in the scene. This value is set in the Light Properties group in the Caustics and Indirect Illumination rollout (Figure 2.75).

The maximum sampling range option isn't on by default, so mental ray will take a size of 0,1 of the maximum size of the scene. This is almost never the right setting, simply because mental ray is not able to

determine the actual size of the scene; it just makes an edu-
cated guess. If you are lucky, this might be OK, but you will
always need adjustments to get the best result. However,
since I want to show you step by step how you can set this
kind of rendering up manually in a normal workflow to
achieve the best result, we have already turned on the radius
option (Figure 2.76).

In this image you can see the photons. But, they are much
too small at present, so the first thing to do is to increase the
Maximum Sampling Radius (the size of the photons) from
1 to 25. Before rendering the scene again, let's look at the
next image, which explains better what is actually happen-
ing when we start altering the settings (Figure 2.77).

What this image shows is the radius, which can be adjusted
by the user. The spheres inside the image represent the
actual photons; of course, they can have different colors,
depending upon the surface they have been interacting
with. The transparent spheres are photons that are in the
scene but are not going to be included in the sample since we
have set a limit to the maximum numbers of photons per
sample.

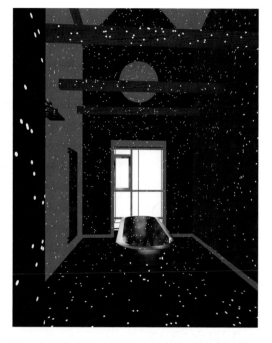

Figure 2.76 *First rendering with very small and low number of photons*

Inside the given radius, we are allowed to look
up a fixed number of photons. Therefore, we
could find all these photons inside our radius, or
fewer due to the limit of the radius. If there are
more photons inside the radius than the limit
allows, the ones closest to the centre will be
used and the others will be ignored. In any case,
the result will be averaged and displayed inside
the rendered image.

Now you can render the scene (Figure 2.78).

We're not getting a smooth image yet, but we
are getting photons over the entire scene now

Figure 2.77

and colors are starting to show. Areas that have a higher density of photons will be lighter in the final rendering.
Photons are simulating what happens in reality, which is why the photons in our scene have different colors; they
are influenced by the material they have been interacting with inside the scene.

Now make a bigger sampling radius (use 50) to see if we can get a smoother image (Figure 2.79).

The image has improved since the brightness is now better averaged out, but the image still isn't smooth. The rea-
son for this is simple: we need to look up more than 10 photons inside the radius we have set. mental ray simply

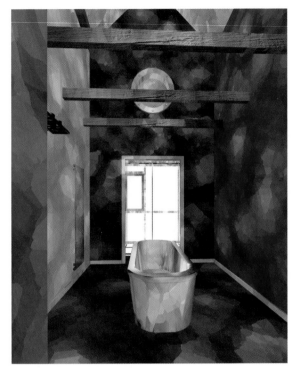

Figure 2.78 *Radius set to 25* **Figure 2.79** *Radius set to 50*

isn't allowed to look up more photons than this setting, even though the photons might be present. Let's increase the maximum number of photons per sample to 100. This will give mental ray the opportunity to look up 100 photons inside the given radius.

Render the scene again (Figure 2.80).

I'm sure you noticed that the rendering time decreased between this and the previous image. This is simply because the image is smoother, so less oversampling has to be performed. When photons overlap, the mental ray renderer uses sampling to blend them together. Increasing the number of samples increases the amount of smoothing. For global illumination, photons should overlap.

Let's look up more photons by increasing the number to 1.000. This is a normal value when you are rendering good-quality images (Figure 2.81).

That's strange — even though we have increased the number of photons to be looked up, the quality of the image has not increased as much as we would expect. Why? In the total scene, we are just using 10.000 photons, of which we are now trying to look up 1.000 inside a radius of 50. Quality doesn't become better simply because there aren't anymore photons to be looked up inside this radius, so increasing the number of photons will never result in a better image than this. Increase the radius to 150 and render again to look up more photons (Figure 2.82).

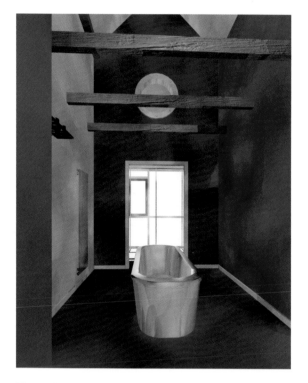

Figure 2.80 *Increased lookup to 100 photons* **Figure 2.81** *Increased lookup to 1000 photons*

The result is a nice smooth image that's as good as it gets for now. The only thing lacking is detail, which makes the image look a bit flat. To adjust the level of detail, we have a number of options. The first is to increase the number of photons that are shot in the scene. By doing this, we can decrease the radius again, which will give us more detail.

The second option is to use a combination of Global Illumination and Final Gather, which we discussed earlier. We will use this option in the next part of this chapter.

The third option is to use ambient occlusion. But to do this we would have to composite the images we get with the Global Illumination and the Ambient Occlusion passes, or we would have to start using the new Arch & Design material, which has ambient occlusion for detail enhancement built in. We have shown you how this works in combination with Final Gather, so we will not use the Arch & Design material solution again. Ambient occlusion itself will be discussed in Chapters 3 and 5.

So, let's concentrate first on shooting more photons inside the scene. The people from mental images (the company that makes mental ray) taught me a rule: "Shoot 4 times as many photons in the scene from the light source, and then decrease the radius by a factor of 2." By doing this, you will keep roughly the same amount of photons inside the radius.

Let's apply this rule. Increase the photons to 40.000, decrease the radius to 75, and render away (Figure 2.83).

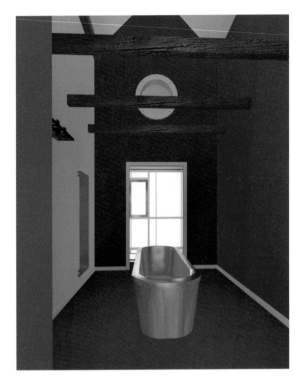

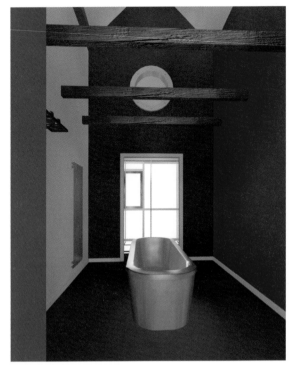

Figure 2.82 *Increased radius to 150* **Figure 2.83**

There is already a bit more detail around the bathtub and the beams, so apply the rule again and again, if needed, until you get details inside the scene. Don't worry about the noise that will be introduced by the process; we will solve that problem after we have sufficient details. I did some tests and ended up with 2.560.000 photons and a radius of 5 (Figure 2.84).

You can see the increased detail level on the beams. They now actually have a color change where they are attached at the walls and the middle. The disadvantage is that by increasing the level of detail, we have also increased the low-frequency noise. We should actually have applied a slightly different rule than just shoot 4 times the number of photons and divide the radius by 2. We should have done the following: divide the radius by 2, multiply the number of photons by 8, and multiply the number on the lookup by 2; this is courtesy, again, of the people from mental images.

Now we need to eliminate this low-frequency noise. For this, we just need to enlarge the number of photons to be looked up to, let's say, 10.000. Then, slowly start increasing the radius. Keep your eye on the rendering time of the image. Once it doesn't increase anymore, you know that you have reached the point where there are no more photons to be looked up.

I have tested this with different settings and found that the render time kept going up until a radius of about 35. Then the rendering stabilized. Finally, I decided that I liked the rendering with radius 37 the best, so this is the result for this rendering (Figure 2.85).

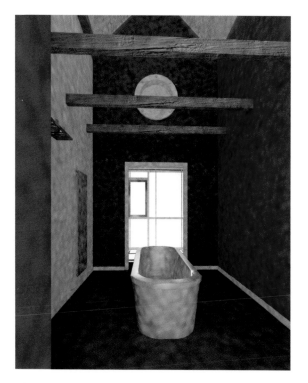

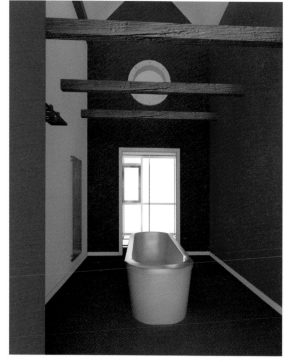

Figure 2.84

Figure 2.85 *Final result with fine-tuned photon solution*

As you can see, the image has become much more alive and now gives a sense of depth because more subtle details have been added.

So what have we learned? Photons distribute the energy in a scene — even a small number can produce a good result for the overall illumination. The photon maps that are used should increase if you want to add details to your final image. The limiting select factor for the quality you can get with photons is actually the amount of memory in the computer. This has now been improved, of course, with the availability of the 64-bit version of mental ray inside Max; nevertheless, the statement is still valid: the limit to the quality with photon maps is memory, so keep this in mind when you start using this technique.

Also, have a look at the next exercises for global illumination, where we combine Global Illumination and Final Gather, and where we will show you how you can add detail by taking advantage of the Final Gather technique.

2.2.2.5 Global Illumination and Final Gather Combination

Final Gather and Global Illumination can be combined. Global Illumination, with its photons, is used for the correct distribution of the energy inside the scene. Final Gather is used to fine-tune the Global Illumination solution and generate the details. This is good news since it means that you can use a lower Global Illumination solution than you would need if you used that technique exclusively. This stores the big photon map to refine it and reproduce the details in the rendering we saw in the last exercise. We can use Final Gather to do this.

The following is a sample of a low-level Global Illumination solution and Final Gather combined, in which the photons create the correct physical light distribution and the Final Gather creates the details, thus saving rendering time. However, the result looks similar to the final image we created during the last rendering with the high-solution photon map, except that the rendering time has decreased by more than 80%! We have used the Low Final Gather preset in combination with Global Illumination with 1.000 photons in the lookup and a radius of 150, which was the setting we used just before we started adding the details with increasing photons and decreasing the radius in the last exercise. If you want to experience it yourself, open the file **fg_and_gi.max** (Figure 2.86).

There can be some problems introduced with this method, so we will demonstrate this by creating the problem first. Just use the **fg_and_gi_bad.max** file; let's suppose we want to make a rough rendering. We suspect that if we use the default settings with a higher number of photons plus a Final Gather pass to add details, this will give us a good result. So, we turn on Global Illumination with the default settings from this file (100.000 photons from the light source and a lookup of 1.000 within a radius of 10) and Final Gather (low preset, just to save some rendering time), and start rendering (Figure 2.87).

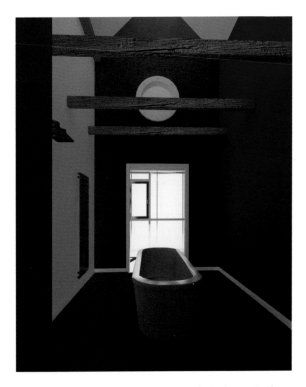

Figure 2.86 *Result of combining Final Gather and Photon techniques*

Some problems are introduced at the front of the bath tub, behind the radiator, behind the circular window, and on the right side of the floor close to the skirting board. The most common mistake made to solve the problem is to raise the quality of the Final Gather pass and to add photons to the rendering, which only result in adding a lot of render time to the scene. The reason for these problems is embedded in the quality of the Global Illumination solution. Switch off the Final Gather option and render again (Figure 2.88).

Since we are using a fairly low-quality Global Illumination solution (even though we are shooting lots of photons and have a large lookup), this is the information that will be used for the Final Gather calculation. Remember that Final Gather shoots rays from the geometry, which means, for instance, that the rays leaving the brighter spots at the bottom of the tub will hit mostly bright spots around that area. The resulting color will be much lighter than a darker point in a dark area nearby will generate. (The same applies for the points on the skirting board and behind to the radiator.) This is, in fact, what created the problems in the previous image. If we don't adjust our Global Illumination to smooth the result, we will never get a good final image and a low rendering time, and we will keep the artifacts seen earlier. A seemingly logical approach would be to increase the number of photons to get more quality; but, even if we increase this to 1.000.000 (and in the process introduce high render times), some

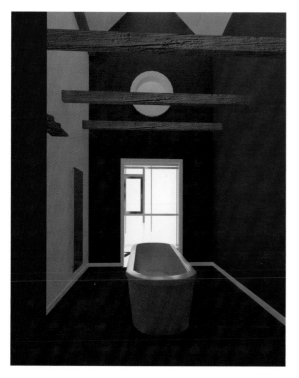

Figure 2.87 *Render artifacts when combining FG and Photons*

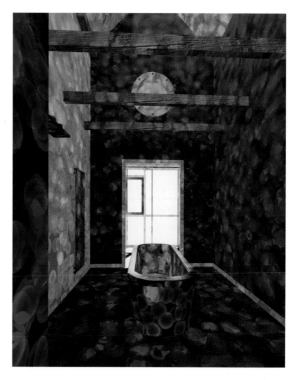

Figure 2.88 *Photon solution to rough*

of the problems might disappear but just by luck. So, make sure your Global Illumination solution is smooth before you start combining Global Illumination with the Final Gather technique.

2.3 mental ray and Hidden Lines Contour Rendering
2.3.1 Introduction

One of the things that mental ray can do for you is create contour shaded renderings. This technique becomes available as soon as mental ray is the active render engine. We will now use the preset option to get started with contour line rendering,

Figure 2.89 *Sample scene with contour lines*

and then we will move on with a discussion of everything you need to know about hidden line rendering with mental ray. This is a long chapter, but the good news is that all you need to know is revealed here.

To create hidden line rendering, you must apply a number of rules. Once you have done this, the final result can be amazing and just what you need to get a pen-like drawing for your presentation. It might give you something like the next image (Figure 2.89).

You are able to create contours in several different ways, for example, at the boundary of different materials or in places with high color contrasts and even contours created by reflections or through semitransparent materials. The final output can be anything ranging from a pure contour image to a contour image composited into a photograph to a PostScript file used inside a technical drawing that is based on your model (Figure 2.90).

Although the possibilities seem endless, you cannot render contour lines in a scene with motion blur, and contour rendering doesn't work with distributed bucket rendering — although it supports multithreading.

Figure 2.90 *Sample scene of contour line rendering*

2.3.1.1 Setting Up mental ray for Contour Line Rendering
Model provided by Frans Hessels, Almere, the Netherlands, at www.fhessels.nl

When you want to start creating contour line renderings, you need to make some adjustments to the default settings of mental ray to prepare the render engine for this special effect. The simplest method is to use the available preset inside the Render Scene dialog. Open the file **hiddenlines_contour.max** and render the scene (Figure 2.91).

Now, we want contour lines to be rendered, and for this to happen, we need to tell mental ray two important things: (1) we have to make mental ray aware of the fact that we want to render contour lines so that the render engine knows where contour lines need to be placed and how they should look; and (2) we need to tell the material that we want contour lines in the material. In this first sample, we will use the available render preset. So, open Render Scene dialog, move to the presets drop-down list, and then choose mental.ray.hidden.line.contours (Figure 2.92).

When the Select Preset Categories dialog shows up, be sure to select both categories and then click the Load button. (Figure 2.93)

Now render the scene and watch what happens (Figure 2.94).

Figure 2.91

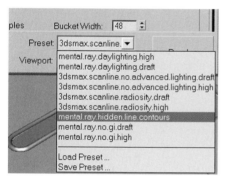

Figure 2.92

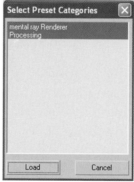

Figure 2.93

Figure 2.94 *Reasonable result of contour line rendering using the Preset*

During the rendering process, a gray-colored image is calculated, followed by some extra processing, and, finally, this hidden line image is created, which replaces the gray image with the hidden line image. So, by using the preset for the rendering, the two demands for creating contour line rendering (initialize mental ray and prepare the material) have been met. The overall quality is a bit poor at the moment, but during the course of this chapter, you will learn how the quality can be improved by using different shaders and settings.

The first part, preparing mental ray, is done inside Render Scene dialog > Renderer panel > Camera Effects rollout > Contours group > Contour Output option. You can see that the Contours option has been enabled. Inside the different Contour components, shaders have been placed automatically. The Contour Output component now holds the Contour Only shader, which is actually responsible for the replacement of the colored image into a contour-lines-only image. The contour lines themselves are defined in the material (Figure 2.95).

The material is also assigned automatically when we use the render preset. You can find this material inside Render Scene dialog > Processing panel > Translator Options rollout > Material Override Group. The name for the material is override.Std.Mtl (Figure 2.96).

If you now drag and drop this material from the Render Scene dialog into an empty material slot of the Material Editor, you can examine this material (Figure 2.97).

Figure 2.95

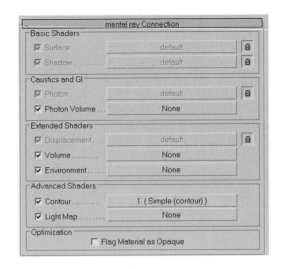

Figure 2.97

Figure 2.96

If you expand the mental ray Connection rollout of the material, you will see that inside the Contour component, a Simple Contour shader is used. Click on this field to view the options that are now available (Figure 2.98).

The black color swatch is responsible for the color of the contour lines, and the Width option is responsible for their thickness.

Figure 2.98

In the next exercise, I will show you how to adjust the settings and create a much better quality than with the render preset option. Your image can look like the one that follows (Figure 2.99).

Figure 2.99

I will show you exactly how you can achieve this result, plus more, so let's get started with the in-depth contour line rendering.

2.3.2 Contour Component Shaders
2.3.2.1 Introduction

Now that we have seen the basics of creating contour line renderings, it is time to get more detail. As we know, the way to make mental ray aware that it has to start creating contour lines consists of two major parts, enabling the contour option and making the material aware of the contour type. We will now go deeper into mental ray to start processing and generating contour lines. We will

actually start influencing the way that mental ray handles the basic information needed to calculate contours, and then define the position and the way this information is eventually used for the output.

As I mentioned earlier, you tell mental ray that we want to start rendering contour lines in the Contour group of the Renderer panel in the Render Scene dialog (Figure 2.100).

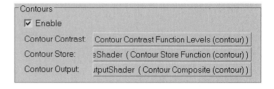

By default, a number of shaders have been assigned for the contours. The main responsibility for each of these shaders is as follows:

Figure 2.100

- The shader in the Contrast component defines the position of the contours.
- The shader in the Store component is the one that calculates the actual contours.
- The shader in the Output component defines the color and thickness of the contours.

Given their function, it is quite obvious that these type of shaders must be there; otherwise, mental ray would lack its most basic information to calculate the contour lines We will now discuss the different components (Contrast, Store, Output) and the shader options used in each specific component.

2.3.2.2 Contour Contrast Component

Start by opening the file **Shader_contourcontrast.max** and have a look at the Contour Contrast component, which can be found in Render Scene dialog > Renderer panel > Camera Effects Rollout > Contours group. Once the Contours option is enabled, there is always the Contour Contrast Function Levels shader, simply because it is the only one available for this component (Figure 2.101).

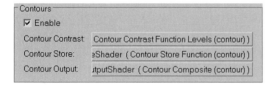

Figure 2.101

The Contour Contrast Function Levels shader is responsible for where a contour is going to be positioned. Now, render the scene and then we will discuss the possibilities of this shader (Figure 2.102).

In this example, we have already assigned materials using a Simple Contour shader, which is responsible for the small black contour lines in the render-

Figure 2.102

ing. (I will show you later on how you can do this yourself.) We have also dragged the Contour Contrast shader to an empty slot in the Material Editor, so the parameters have become available and are ready to be adjusted (Figure 2.103).

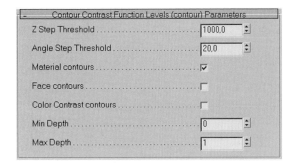

Figure 2.103

Figure 2.104

These are the default settings that are used by the Contour Contrast component to define where a contour needs to be made.

The Z Step Threshold stands for the minimum difference in the depth, which is needed to create a contour, measured in the coordinate units. The default setting is relatively high, so normally you will hardly notice the effect of this component. For this example, change the value to 0,3 and render once more (Figure 2.104).

The results can be seen in our last rendering. Use Z Step Threshold option whenever you want to add contour lines that show a depth difference that is not displayed with the high Z Step default value — in other words, when two objects are very close to each other in the Z direction.

Put the Z Depth back to 1.000. The Angle Step Threshold option defines the minimum difference in the angle between normals to start creating a contour line. Adjust the Angle Step Threshold from 20 to 5 and render the scene (Figures 2.105 and 2.106).

Extra contour lines are created where the difference in angle between the normals is bigger than 5. In this example, it puts emphasis on the curvature shapes of this model. Change the Angle Step value back to 20 before moving on.

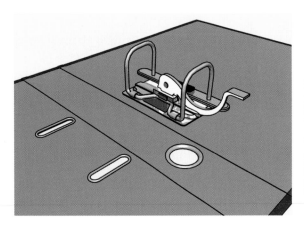

Figure 2.105 *Angle Step = 20*

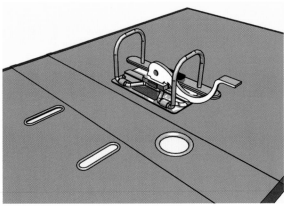

Figure 2.106 *Angle Step = 5*

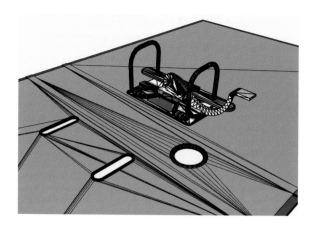

Figure 2.107

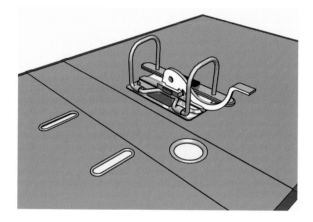

Figure 2.108 *Color Contrast option = off*

Figure 2.109 *Color Contrast option = on*

Figure 2.110

The Material Contours option speaks for itself. By checking this option, you will get contour lines at the boundaries of different materials, regardless of a difference in geometry. By default, this option is turned on.

The Face Contour option gives you the ability to make the faces visible and creates a nice special effect. By enabling this option, you get a wire frame–like rendering in which every face gets a contour line. Just enable it and render to get the result shown (Figure 2.107).

The Color Contrast Contour option creates contour lines at the point where a given threshold has been reached in the contrast of the colors. In the next image, you can see the difference between Color Contrast on and off for this specific example (Figures 2.108 and 2.109).

The Minimum and Maximum Depth give you the ability to create contour lines around reflections. Just change the value of Maximum Depth to 2 and render again (Figure 2.110).

Contour lines appear around the areas where there is a reflection in the material. The Maximum Depth can also reveal objects with contour lines visible that are inside or behind other objects that are semitransparent. We will talk more about this option later with the Layer Thinner shader.

2.3.2.3 Contour Store Component

The Contour Store Function shader is the simplest to discuss since it is the only shader available for the Store component and it has no parameters that can be adjusted by the end user. You can verify this by dragging and dropping the shader from the Render Scene dialog into an empty slot of the Material Editor (Figure 2.111).

Figure 2.111

The Contour Store Function Shader determines which information is being stored on the Image Sample location. It then checks whether there is enough difference between two samples to place a contour line.

2.3.2.4 Contour Output Component

The shader used in the Output component defines the color and thickness of the contours. In this component, three different Output shaders are available; as you can see in Render Scene dialog > Renderer panel > Camera Effect rollout > Contours group, the Contour Composite shader is the default shader used (Figure 2.112).

Figure 2.112

If you click on the Contour Composite shader, the Material Map Browser will open and you will see that you can choose from three shaders for this component (Figure 2.113).

The default shader, Contour Composite, enables you to store contour lines and display them over the original image. The Contour Only shader stores and generates an image without any materials but strictly with contour lines. (This shader was used with the preset we used at the beginning.) Finally, there is the Contour PS option, which lets you store a PostScript file from your contour line rendering.

Figure 2.113

We will go over the different shaders for this component one by one, discussing the most important options that are available for each of them.

2.3.2.5 Contour Composite Shader

We'll start by discussing the default shader: the Contour Composite shader. For this exercise, open the file **Shader_contourcomposite.max** and render the scene (Figure 2.114).

This shader is responsible for how contour lines are stored and finally displayed, and this typically shows you the original materials assigned to the model with

Figure 2.114

Figure 2.115

contour lines around it. The shader has already been dragged and dropped into the Material Editor as an Instance from the Render Scene dialog, making the parameters available for the user (Figure 2.115).

The Glowing Contours option will make the contour line darker and increase the transparency toward the edges. This will give you a "glowing look" for the lines. Check Glowing Contours and render again, and you will get the following result. You will notice that the lines look thinner and more vague (Figure 2.116).

The Composite Using Maximum Color option makes mental ray aware of the fact that where contour lines overlap, the maximum of the two colors has to be used. We have not included a sample image since this option is not evident in this example.

2.3.2.6 Contour Only Shader

With the Contour Only shader, you will get only the contour lines visible, without the original material that was used for the model. Open the file **Shader_contouronly.max** and render the scene (Figure 2.117).

In this file, we have used simple Contour shaders for the materials. We will now change the way the rendering looks so that the original material will disappear and only the contour lines will remain.

Open the Render Scene dialog and find the Contour Output options in the contour group (Render Scene dialog > Renderer panel > Camera Effects rollout) (Figure 2.118).

Click on the name of the shader that is present at the moment (Contour Composite); the Material/Map Browser will open where you should choose the Contour Only Shader (Figure 2.119).

Figure 2.116

Figure 2.117

Figure 2.118

Figure 2.119

To be able to influence the parameters of this shader, you need to drag and drop it to an empty sample slot inside the Material Editor (Figure 2.120).

Figure 2.120

Figure 2.121

Make sure you select the Instance option so that you will be able to adjust the parameters to have an effect in the final rendering. You will now get the parameters available in the Material Editor (Figure 2.121).

Render the scene again (Figure 2.122).

The background and the materials have now been replaced by the color that is set in the option Background Color, which was white. (Now you can see clearly that the quality we had when we first rendered hidden lines with the presets was very poor. This latest image is how your design can look if you know which aspects to fine-tune.)

Enabling the Glowing Contours option will make the contour lines darker toward the inside and more transparent toward the outside, giving them a kind of glowing effect when rendered (Figure 2.123).

Figure 2.122

The Composite Using Maximum Color indicates that if contour lines overlap each other, the maximum of the two colors should be used. However, in this model nothing special happens, so we have not included the result of this rendering.

Figure 2.123

2.3.2.7 Contour PS (PostScript) Shader

With the Contour PS (PostScript) shader, you will be able to generate a PostScript file as output. The contour lines will be black by default, but they will not display anymore in the rendering.

Open the file **Shader_contourps.max**. There is no need to render the scene since we have already made the Contour PS shader active in this file and, thus, the contour lines won't become visible even though we have used a Simple Contour line shader for all materials in this scene. The following image is the result of the rendering (Figure 2.124).

Figure 2.124

Open the Material Editor and have a look at the first Material Slot. We have made the Contour PS shader already available by a drag-and-drop action from Renderer panel in the Render Scene dialog. The parameters are shown in the following image (Figure 2.125).

Here is a short explanation of the different options:

- **Paper Size**. This is a numerical value for the paper size; 3 through 6 are for European sizes, whereas others are US sizes.
- **Scale**. This indicates the scaling.
- Transform B and Transform D. These transforms are for adjustments needed for specific printers (with a skew).
- **Title**. When Title is on, the name, frame number, and a borderline will be printed.
- **Landscape**. This option enables you to print in landscape.

Figure 2.125

- **Stoke Dir**. Here you define that every contour line needs to look like a pencil line, with variable thicknesses based upon the direction.
- **Min Frac**. This option defines the minimum thickness of a contour line in relation to the maximum thickness.
- **Filename**. This option refers to the name of the file.

Because all the options are only visible in printed images, we will leave them as they are.

2.3.3 Contour Line Shaders

For creating the actual contour lines, there are a number of different shaders available inside 3ds Max. Each shader will create different contour lines based upon the settings chosen for the material they are applied to. This is the overview of all the different shaders that are available (Figure 2.126):

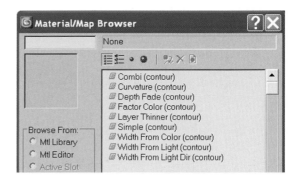

Figure 2.126

We will now start by going over all of these shaders in separate small examples. Each shader will give you the opportunity to create different shapes and colors of the contour lines, based upon variables such as lights, colors, and shape of the model.

2.3.3.1 Simple Contour Shader

With the Simple Contour shader, you will create contour lines of a given thickness and color for the entire object. Open the file **Shader_simple.max** and render the scene to see what we have (Figure 2.127).

First, make mental ray aware of the fact that we want to create a contour rendering. Open the Render Scene dialog > Renderer panel and enable the Contours option in the Contours group (Figure 2.128).

Figure 2.127

Next, you need to make the material aware of the fact that it has to create contour lines. For this, we need to select the material (train) in the Material Editor and open the mental ray Connection rollout. Find the Contour option and click on the gray None button to the right of it, and the Material/Map Browser will open (Figure 2.129).

Figure 2.128

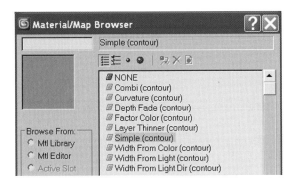

Figure 2.129

Figure 2.130

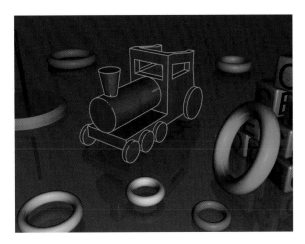

Figure 2.131

Choose the Simple shader, and the parameters will become available in the Material Editor (Figure 2.130).

The Color option involves the color of the contour lines that will be created. The Width (%) option is the thickness of the contour lines. Change the color to orange and change the width to 0,3. We will leave all other materials as they are for now. You only need to render the scene again (Figure 2.131).

The result is beautiful orange contour lines for the train with one universal thickness. Notice that the original material is still intact when we apply contour lines in this way. For creating different type of contour lines, there are many different possibilities. This Simple shader is exactly what is says, the simplest one—just one color and one overall thickness for each material it is applied to .

2.3.3.2 Width from Color Contour Shader

With the Width from Color Contour shader, contour lines are created based upon the color of the material. A bright color results in no contour line, and a dark color generates a contour line with a certain thickness. Open the file **Shader_widthfromcolor.max** and render the scene (Figure 2.132).

First, make mental ray aware of the fact that we want to generate output with contour lines. Do this by opening Render Scene dialog > Renderer panel and enabling the option in the Contour group (Figure 2.133).

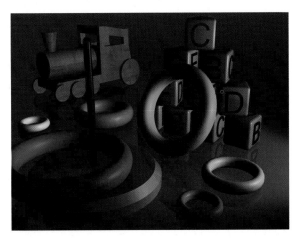

Figure 2.132

Figure 2.133

Figure 2.135

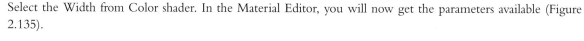

Figure 2.134

Figure 2.136

Next, make the material aware of the fact that it has to generate contour lines. Select the material in the Material Editor, and open the mental ray Connection rollout. Click the gray None button to the right of the Contour option; the Material/Map Browser will open (Figure 2.134).

Select the Width from Color shader. In the Material Editor, you will now get the parameters available (Figure 2.135).

Adjust the color to red and adjust the minimum width value to 0,01 and the maximum width to 1. Now render the scene again. As you will see, there are now contour lines visible with different thicknesses over the color, based upon the object's color at that point (Figure 2.136).

2.3.3.3 Width from Light Shader

By using the Width from Light shader, you will create contour lines based upon the angle between the face normal and the direction of the light source. Open the file **Shader_widthfromlight.max** and render the scene (Figure 2.137).

We will use this shader now to create contour lines with variable line thicknesses based upon the light

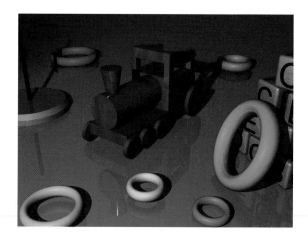

Figure 2.137

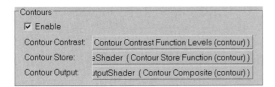

Figure 2.138

direction in the scene. First, we need to tell mental ray that we want to make contour lines, so enable this option by Render Scene dialog > Renderer panel > Contours group (Figure 2.138).

Next, make the material aware of the fact that it has to generate contour lines: select the material Train in the Material Editor and open the mental ray Connection rollout. Click the None button to the right of the Contour option, and the Material/Map Browser will open (Figure 2.139).

Select the Width from Light shader. In the Material Editor, you will now have the parameters of this shader available (Figure 2.140).

Change the color to yellow, and make the minimum width value 0,05 and the maximum width value 0,5. Finally, click on the None button to the right of the Light option and select the light that you want the shader to take into account. You will now get thicker and thinner lines on the object. The thickness depends on difference between the direction of the normal from the object and the light source. You can see a number of the thinner lines in front of the train (Figure 2.141).

2.3.3.4 Width from Light Dir Shader

The Width from Light Dir shader is a variation of the Width from Light shader. The difference is that you are now able to simulate a direction to a light without the light being present in the scene (Figure 2.142).

You just need to add values to the Light Dir option. The results are almost the same as the Width from Light shader, so we will leave this shader as it is for now.

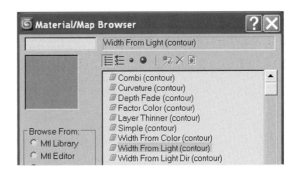

Figure 2.139

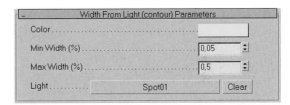

Figure 2.140

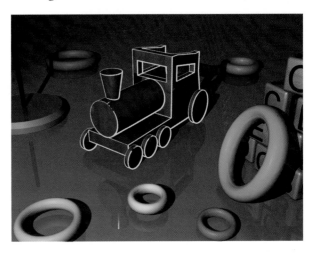

Figure 2.141

Figure 2.142

Figure 2.143

Figure 2.144

Figure 2.145

Figure 2.146

2.3.3.5 Curvature Contour Shader

The Curvature Contour shader creates contour lines based upon the curvatures of the surface (in other words, the differences in surface orientation). Open the file **Shader_curvature.max** and render the scene (Figure 2.143).

We can now create contour lines whose thickness varies based on the curvature of the surface. For this we need to use the Curvature Contour shader. The first step is to tell mental ray that we want to render contour lines. So, open Render Scene dialog > Renderer panel and enable the Contours option (Figure 2.144).

The next step is to make the material aware of the fact that it has to display contour lines. So, select the metal material and open the mental ray Connection rollout in the Material Editor. Now click on the gray None button to the right of the Contour option. The Material/Map Browser will open (Figure 2.145).

Select the Curvature shader. In the Material Editor, you will see the parameters of this shader (Figure 2.146).

Adjust the color to a bright orange, and set the minimum width to 0,05 and the maximum width to 0,7. Follow the same procedure for the black material, and then render the scene. The rendering will now display thicker and thinner contour lines based upon the curvature of the surface (Figure 2.147).

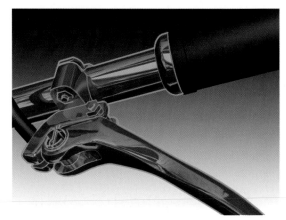

Figure 2.147

2.3.3.6 Depth Fade Contour Shader

With the Depth Fade Contour shader, you can create color and thickness differences in the contour lines based upon the Near and Far settings. Open the file **Shader_depthfade.max** and render the scene (Figure 2.148).

The first thing to do is to make mental ray aware that we want to make a rendering with contour lines that vary in thickness and color. Open Render Scene dialog > Renderer panel and enable the Contours option (Figure 2.149).

Next we will make the material aware of the fact that it has to generate contour lines. Select the metal material and open the mental ray Connection rollout. Click on the gray None button to the right of the Contour option. The Material/Map Browser will open (Figure 2.150).

Select the Depth Fade shader. In the Material Editor, you will now see the parameters of this shader (Figure 2.151).

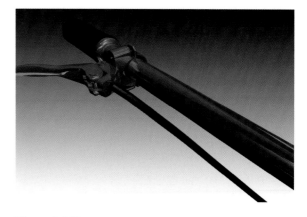

Figure 2.148

Figure 2.149

Change the Near Color to red and the Far Color to yellow, and then make the Near Width value 0,3, the Far Z value 15, and the Far Width 0,6. Render the scene. You will get a rendering with contour lines whose colors and thicknesses are based upon the settings we have just made (Figure 2.152).

Figure 2.150

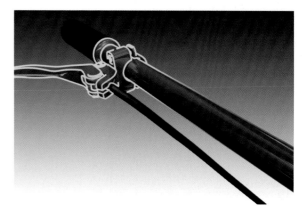

Figure 2.151

Figure 2.152

There is now a clearly visible mixing of the red and yellow but also changing of the thicknesses from the front to the back of the image. So, the result is a mixture of yellow and red and with thickness variation based on the settings we just adjusted.

2.3.3.7 Factor Color Contour Shader

With the Factor Color Contour shader, you are able to generate contour lines with the same color as the object but with a different brightness (usually darker). Open the file **Shader_factorcolor.max** and render the scene (Figure 2.153).

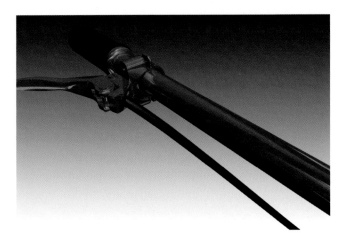

First, make mental ray aware of the fact that we want to make a rendering with contour lines: open Render Scene dialog > Renderer panel and enable the Contours option (Figure 2.154).

Figure 2.153

Next, make the material aware of the fact that it also has to display contour lines in the final rendering. Select the metal handlebar material and open the mental ray Connection rollout. Click the gray None button to the right of the contour option. The Material/Map Browser will open (Figure 2.155).

Figure 2.154

Select the Factor Color shader. You will now see the parameters inside the Material Editor (Figure 2.156).

Change the width (%) value to 1 and follow the same procedure for the black material, and render the scene (Figure 2.157).

Figure 2.155

The Factor value is responsible for the contour line being exactly the same color as the object itself, so look closely at the rendering because the contour lines are really there. Values between 0 and 1 will create a darker color (0 will be black, and 1 is the color of the material). Set the Factor value at 0,5 for both materials and render the scene again (Figure 2.158).

The width value defines the thickness of the contour line.

Figure 2.156

Figure 2.157

Figure 2.158

2.3.3.8 Layer Thinner Shader

With the Layer Thinner shader, you can create contour lines whose thickness is dependent on the position of the material. The material that is on top will have the thickest contour line, and the lines will decrease as you enter the model. Open the file **Shader_layerthinner.max** and render the scene (Figure 2.159).

This is a detail of a motorcycle handlebar. As you can see, we have prepared the scene a little bit. If you analyze the material we are using, you can see that we have already applied a Layer Thinner shader but that it is not working yet since we see only the lines of the outer objects and not the contours inside the handlebar. Another thing we have done is make the material semitransparent because this is mandatory for this shader to work. The settings for the Layer Thinner shader have been set as shown in the following image (Figure 2.160).

We have made the contour line colors black, as you can see. Width (%) stands for the width of the lines on the top. Depth Factor defines the amount that the lines become thinner for each of the layers. The settings indicate that black contour lines will be made with a thickness of 0,7 when they are on top, 40% less wide when the material is behind the next material, and

Figure 2.159

Figure 2.160

Figure 2.161

Figure 2.162

Figure 2.163

another 40% less wide when it is behind two materials, and so on.

Now we need to get it working, and for this we must adjust the Contour Contrast shader. Open Render Scene dialog > Renderer panel > Contour group and drag and drop the Contour Contrast Function Level shader into an empty sample slot in the Material Editor (Figure 2.161).

Make sure you choose the Instance option so that you are able to adjust the settings. Look in the Material Editor for these settings and find the Maximum Depth option (Figure 2.162).

Maximum Depth is responsible for the number of overlaps that you will be able to see in the rendering. Change it to 2 and render again (Figure 2.163).

Figure 2.164

As you can see, the second layer now becomes visible with a decreased thickness (Figure 2.164).

This is the result of the value of Maximum Depth at 6, which is the maximum amount of layers we have in this test scene. You can see all the different thicknesses of the lines very well.

2.3.3.9 Combi Contour Shader

The Combi Contour shader combines the Depth Fade, Layer Thinner, and Width from Light Contour shaders. For individual effects, use these particular shaders (Figure 2.165).

Figure 2.165

2.4 mental ray and Camera Shaders
2.4.1 Introduction

Just as with contour line rendering, the options you have with camera shaders are available directly after you enable mental ray as the active renderer. With the camera shaders, you can achieve different kind of effects that apply to different components of the camera. There are three major components available: Lens, Output, and Volume. For each of these components, different shaders and thus different special effects are available. In the next exercise, I have grouped all these different shaders so that you will have almost a complete overview of all the different camera shader options. Camera shaders have one thing in common—they manipulate the rendered image in a certain way depending on the camera shader applied.

So, if you open Render Scene dialog > Renderer panel > Camera Effects rollout > Camera Shaders group, you will get to the place where the shaders can be enabled (Figure 2.166).

Figure 2.166

By default, they are not used. You can see there are three different groups available, which we will now start discussing in detail.

2.4.2 Camera Lens Shaders

The first group is the Lens shaders. These shaders actually have an influence on the lens of the camera and change the direction of rays from the camera in how sample the scene. With this shader, mental ray switches to only raytracing because scanline rendering won't work anymore since the rays need to be bent (Figure 2.167).

We will now go over the different shaders with separate samples. We will not discuss the mr Physical Sky and the Shader List shaders since they are covered in Chapters 3 and 5, respectively.

Figure 2.167

2.4.2.1 Distortion Shader

When using a large-angle or fish-eye lens on a camera, obvious distortions are introduced. We have all seen pictures that look like they are pulled in or pushed out because the normally straight lines are bent. This is the effect that Distortion shader mimics for you.

Open the file **Shader_distortion. max** and make a quick render to find out what we have in the scene (Figure 2.168).

The next thing we will do is apply the Distortion shader to the proper camera component, which is the Lens. Just move to Render Scene dialog > Renderer panel > Camera Effects rollout > Camera Shaders group and click the gray None button to the right of the Camera Lens option (Figure 2.169).

The Material/Map Browser will open, and you can choose from the different shaders available for this component. Select the Distortion shader (Figure 2.170).

The shader will now be placed inside the Camera Lens component (Figure 2.171).

To be able to change the parameters of this shader, you need to drag and drop the shader from this component into an empty material slot in the Material Editor (Figure 2.172).

Make sure you choose the Instance option in the dialog so that you will be able to modify the parameters and see the result in the rendering. Once this has been done, you can see the available parameters of the Distortion shader in the Material Editor (Figure 2.173).

Figure 2.168

Figure 2.169

Figure 2.170

Figure 2.171

Figure 2.172

Figure 2.173

You can apply a Pin Cushion or a Barrel effect to the output. With the Amount value you can influence how strong the selected effect needs to be. Change the value into 2,5, just to be able to see the effect clearly, and leave the Pin Cushion option checked on. Now render the scene (Figure 2.174).

If you look at the books and the screen inside the image, the effect is obvious. It looks like they are being bent outward toward the corners of the image.

Now check the Barrel option and make sure you uncheck the Pin Cushion effect; then render again (Figure 2.175).

Now you can see the opposite effect; the books and the screen are being bent inward away from the corners.

Figure 2.174 *Pin cushion effect with a strength of 2,5*

Figure 2.175 *Barrel effect with a strength of 2,5*

2.4.2.2 Night Shader

At night and in the late evening, colors change; for example, bright red changes into a more purple color, and bright blue gets washed out (desaturated). This is exactly what the Night shader does. In fact, the Night shader simulates the way the human eye works in real life. Inside the eye, there are cones and rods. The

cones are sensitive to colors and are more active during daytime. At night and evening, the influence of the cones decreases and the rods take over. Since they are less sensitive to color, the result is that colors get washed out.

Open the file **Shader_night. max** and render the scene (Figure 2.176).

In this scene, we have tried to simulate night by using a Spot light with low intensity. As you can see, the red of the carpet is still too bright red to simulate realistic color. We will now use the Night shader to simulate the right effect, a desaturated red. First, open Render Scene dialog > Renderer panel > Camera Effects rollout and hit the None button to the right of the Lens option in the Camera Shader group (Figure 2.177).

Now the Material/Map Browser will open where you need to select the Night shader (Figure 2.178).

Drag and drop the Night shader from the Render Scene dialog to an empty slot of the Material Editor. By doing this, you will get the parameters available in the Material Editor. Make sure you select the Instance option when prompted so that the changes of parameters will be active for the final result (Figure 2.179).

Don't change anything yet; just render the scene again (Figure 2.180).

The Night shader works by boosting dim lighting and keeping colors desaturated, as is evident in the last rendering. This is why the lighting of the scene has changed somewhat when rendering with the Night shader. This is normal! What looks good before activating the Night shader needs to be adjusted after applying the shader. So, if you want to use the Night shader, make sure you set up the lighting of the entire scene before you start using it and

Figure 2.176

Figure 2.177

Figure 2.178

Figure 2.179

not afterward, as we did here, because the overall lighting affects the scene.

Now, back to the settings where you can choose how much to boost the dim light with the Multiplier value. This is, in fact, what is causing the brighter light settings from the previous rendering. If you set the Multiplier value back to 0, the overall brightness of the scene would return to the state we had before we applied the Night shader, both for the overall light intensity and for the colors. If you were to change the value to 2, the overall brightness would increase as well as the influence on the desaturation of the colors (Figure 2.181).

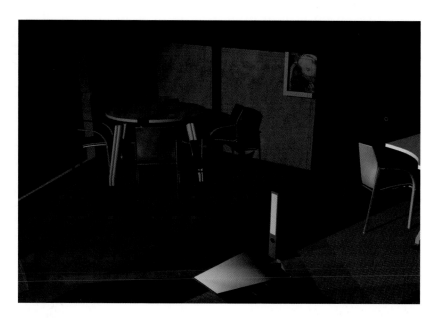

Figure 2.180

The Cutoff value defines the light level at which the Night effect should start decreasing the colors. Leave the Multiplier value at 2, but change the Cutoff value to 0,1 and render the scene (Figure 2.182).

As you can see, there is less desaturation of the colors. A value of 0 would give a completely black image, and a value of 1 would give the maximum amount of washing out of the colors in relation to the current Multiplier setting.

To conclude, there are two things of importance:

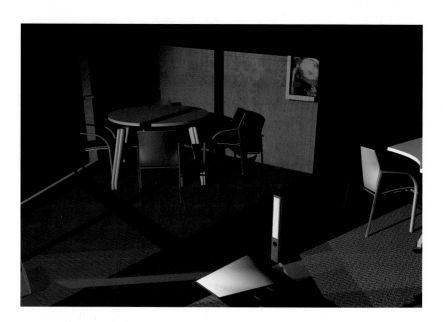

Figure 2.181 *Multiplier value at 2*

1. Remember to set up the overall lighting of the scene before you apply the Night shader; do not wait until after you have added the shader.

2. Remember that the Night shader mimics the way the human eye works when there is dim light, not the way a camera works with dim light.

2.4.2.3 WrapAround Shader

The WrapAround shader creates a 360-degree picture of the surroundings as seen from the camera's standpoint. This image can be reused for environment mapping, for example. Open the file **Shader_wraparound.max** and render the scene (Figure 2.183).

We will now apply the WrapAround shader. Open Render Scene dialog > Renderer panel > Camera Effects rollout and click the gray None button to the right of the Camera Lens option (Figure 2.184).

The Material/Map Browser will open where you need to select the WrapAround shader (Figure 2.185).

The WrapAround shader has no parameters; so you don't need to make any kind of adjustments. Just render the scene again (Figure 2.186).

The WrapAround shader creates a picture of the scene surrounding the camera. You could reuse this result as an environment or reflectivity map on a dome, for example.

Figure 2.182 *Multiplier value at 2 and Cutoff at 0,1*

Figure 2.183

Figure 2.184

Figure 2.185

Figure 2.186

The shaders in the Output component are two hair-related shaders, which only involve output options for compositing purposes. The Shader List is discussed in Chapter 5.

2.4.4 Camera Volume Shaders

The third group is the Volume group (Figure 2.188).

This group of shaders influences the volume inside the whole scene by adding things like mist the color of water, as with the Submerge shader. Again, in this chapter, we will use different samples except for the Material to Shader and the Shader List (see Chapter 5), mr Physical Sky (already discussed with the mr Daylight system), Submerge (see Chapter 5 under "Water-Related Shaders"), and the ShaveMRHairShadows shader, which leaves us with the Beam, Mist, and Parti Volume shaders.

2.4.4.1 Beam Shader

With the Beam shader, you can create atmospheric effects for lights very quickly. Open the file **Shader_beam.max** and render the scene (Figure 2.189).

We will now use the Beam shader in combination with the camera. By doing this, we will make the light on the ceiling visible with the effect of an aura around it. We need to get the Beam shader and apply it to the Camera Volume component. So,

2.4.3 Camera Output Shaders

The second group of camera shaders is the Output component. This is used to manipulate pixels by applying filters or composite buffers, whereby mental ray can save intermediate steps in the rendering process (Figure 2.187).

Figure 2.187

Figure 2.188

Figure 2.189

click the gray None button by following the route: Render dialog > Renderer panel > Camera Effects rollout. The Material/Map Browser will then open (Figure 2.190).

Select the Beam shader and drag and drop it into an empty slot in the Material Editor. When prompted, choose the Instance option so that you will be able to modify the parameters and have an effect on the rendered result (Figure 2.191).

You will see these parameters in Material (Figure 2.192).

Figure 2.190

Figure 2.191

Adjust the color to yellow. The density needs to be changed to 15. We have not used the Lights option because we want the effect on all the lights inside the scene. If you wanted the effect to be valid for just one of the lights, you would make your selection within this part of the interface (Figure 2.193).

This is the result. The color effect is obvious; the density is the amount of the yellow "fog."

Figure 2.192

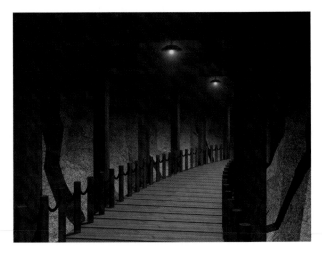

Figure 2.193

2.4.4.2 Mist Shader

The Mist shader can create layered mist. You can apply the mist to containers, which can make transparent objects look misty, without influencing the rendering times. In our sample, we will apply the mist effect to the whole scene since we are using it as a camera shader effect.

Open the file **Shader_mist.max** and render the scene (Figure 2.194).

Now open Render Scene dialog > Renderer panel > Camera Effects rollout. Select the gray None button to the right of the Volume component (Figure 2.195).

In the Material/Map Browser, select the Mist shader (Figure 2.196).

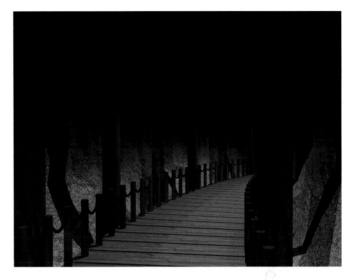

Figure 2.194

Figure 2.195

Figure 2.196

Open the Material Editor and drag and drop the Mist shader into this sample window. Make sure you choose the Instance option so that you can make adjustments to the settings of the shader (Figure 2.197).

Now, we have a long list of parameters available in the Material Editor, but the first rollout looks like the following image (Figure 2.198).

Figure 2.197

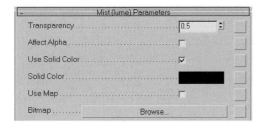

Figure 2.198

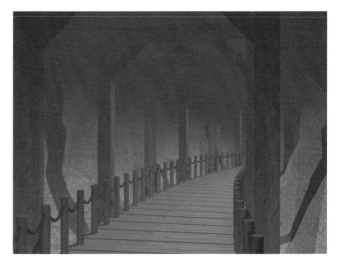

Figure 2.199

Figure 2.200

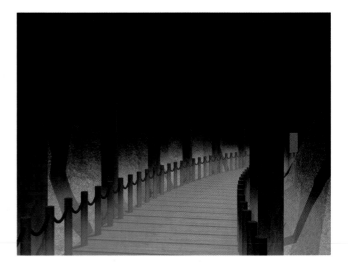

Figure 2.201

The first two, Transparency and Affect Alpha, are general settings. If you set Transparency to 0, the mist will be very thick, making the whole scene disappear behind it. If you increase the value you will get a thinner mist effect. The Alpha option will influence the alpha channel when it is checked. We will just leave this as it is.

The next four parameters let you influence the shape and color of the mist. We changed the color of the mist into a lighter gray color, which will result in one single color of mist in all viewing directions. If you want to influence this, you need to employ the Use Map or bitmap options, but for now, this will do. Render the scene (Figure 2.199).

As you can see, the mist affects the scene evenly, without taking into account the light sources. The principle is that the mist is affected by the distance that rays need to travel. So, the farther away from the camera, the thicker the mist will be.

The next set of parameters gives us the ability to influence the layering of the fog (Figure 2.200).

First, you need to enable Layering. Then, you define the direction by changing the Plane Normal values. The Plane distance is responsible for the height of the layer (change this to 20), and the Transition height is responsible for the way the layer changes from the fog into the clean air (change it to 5). Now render again (Figure 2.201).

Figure 2.202

The last set of parameters is shown in the following image (Figure 2.202).

These settings define how the mist behaves in the transition height area we have set in the last rendering. By default, the mist is using a realis-

Figure 2.203

tic falloff. For the next image, we will change to a linear falloff, which starts at 0 and stops at 10, just to show you what happens (Don't forget to uncheck the Realistic Falloff option.) (Figure 2.203).

2.4.4.3 Parti Volume Shader

Fog, clouds, and saltwater scatter the light that passes through them; in other words, they contribute to the light transport. To simulate this effect, you need a Parti Volume shader. (*Parti* is an abbreviation for *participating*.) If the media inside the volume is material other than clean air or a vacuum, then light spreading takes place. The spreading of the light is caused by the tiny particles inside the media. If the Parti Volume shader is assigned to the Camera Volume component, this means that the volume is the light beam and will be visible. Since it is a camera shader, it is applied to the whole scene.

First, we will open the file **Shader_ partivolume.max** and render the scene (Figure 2.204).

This is the same old mine entrance we have seen before, but some parts have collapsed now, so the rest of the mine is closed. Since we want to add some fog effect to the light beams, the next step is to apply the Parti Volume shader inside the Camera Volume component. Open Render Scene dialog > Renderer panel > Camera Effects rollout > Camera group. Click on the gray button to the right of the Volume component (Figure 2.205).

Figure 2.204

Figure 2.205

From the Material/Map Browser, now select the Parti Volume shader (Figure 2.206).

Finally, drag and drop the Parti Volume shader from the Render Scene dialog into an empty material slot, making sure you select the Instance option when asked so that you will be able to see and change the settings effectively inside the scene (Figure 2.207).

Because we have applied the Parti Volume shader inside the Camera Volume component, it is active for the entire scene. Since we have a number of lights inside the scene and we want to keep the rendering time low, we first apply the Parti Volume effect to just one of the lights. The one I selected is the mr Area Spot 04 light, so the first thing to do is to enable the Lights option and select this light, either directly in the scene or from the list of objects that you can get by pressing the letter *H* on the keyboard (Figure 2.208).

Don't change anything else yet. Just click the render button and see what happens (Figure 2.209).

OK, this is not good at all, but there are reasons for this. Let's have a look at the parameters of the shader and see which ones we need to adjust to get a better result. For now, the result is too bright and much too dense to be realistic.

The first parameter is the Mode option. If this value is 0, then the whole volume is filled with the effect. If the value is 1, only part of the volume is filled with the effect. Above the effect, there is clean air or a vacuum, so there will be no spreading of light visible. If the value is set to 1, mental ray will take into account the height value. For this sample, we will leave the setting at 0 for now so that the whole effect will participate.

Figure 2.206

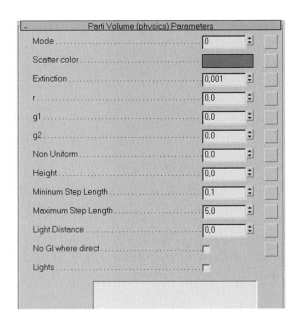

Figure 2.207

Figure 2.208

Scatter Color is the color of the light-spreading effect. This effect is still too bright, as we can clearly see. The light gray color is reflecting far too much light at present. We want a darker color, so change it to a dark gray. We used 0,15 for each of the colors. Now render again, to see what happens. (Figure 2.210)

If you look at the light passing through the danger sign, you can really see that the volume light is being blocked by the sign itself and that light passes through where the text is cut out. You can also see this well at the box in front of the scene (Figure 2.211).

Next, have a look at the *Extinction* parameter: 0 is a vacuum or clean air; higher values will give a higher density to the effect. This parameter is still set a bit too low for our scene. Just change the value to 0,008 and render the scene again. By giving a higher density, we will get back more of the scatter color we used, so more black will appear in the scene.

OK, now we are getting somewhere. We could change the scatter color to a little lighter value, but for now we will leave it like this.

Next, consider *r*, *g1*, and *g2*. These control the way the light is spread. If g1 and g2 are set to 0, then isotropic scattering is used (also called diffuse scattering). Other values create anisotropic scattering. For now, just to see the effect, change the value for r to 0,2, for g1 to −0,5,

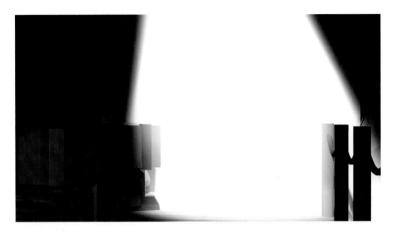

Figure 2.209 *The default partivolume effect*

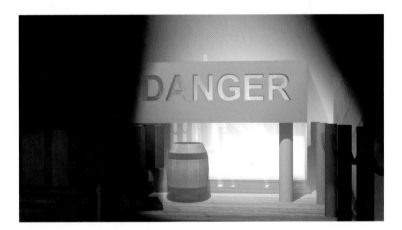

Figure 2.210 *Adjusted scatter color*

Figure 2.211 *Adjusted density value*

and for g2 to +0,5 and render again (Figure 2.212).

The differences between isotropic and anisotropic scattering is what this rendering illustrates.

Let's discuss the *Nonuniform* parameter. At a value of 0, the material is completely uniform. At a value of 1, it can be best compared with something like clouds in a clear sky. We don't want to go overboard with this option, but just so you can see what happens, change the value to 0,3 and render again (Figure 2.213).

Now you see some changes inside the fog due to the fact that we have made it nonuniform.

Height logically defines the height. Above this value, there is clean air or a vacuum; below this value, the effect occurs. This option is active when the Mode Parameter is set to 1; if you do this now, you can see what happens. Change the height value to 15 and make another rendering (Figure 2.214).

The next options are all for fine-tuning, so we will discuss them briefly but not do any more test rendering.

Minimum step length and *maximum step length* are the step lengths for rays that travel through nonhomogenous media or in media with a mode setting of 1. We will leave this option as it is in this example.

Light distance is used to optimize the sampling of area lights.

Figure 2.212 *Sample of anisotropic scattering*

Figure 2.213 *Non-uniform parti-volume effect*

Figure 2.214

No GI where direct is also used for optimization. You enable this option if the scene is set up so that there is no global illumination but there is direct illumination.

As you might have noticed, all the settings we discussed have an influence on each other. Therefore, adjusting this effect is not that simple. However, I have found that if you follow the steps we took, you will get to your destination in an efficient manner.

2.5 mental ray and Displacement
2.5.1 Introduction

One of the groups we still need to cover is Displacement. Displacement is another one of the features that become available when we start using mental ray as the render engine. mental ray is great for displacement mapping, and much better than the normal scanline renderer. Instead of creating the displacement mesh directly in the file itself, mental ray creates the extra geometry needed to perform displacement only at the rendering time. This keeps the total file size within normal limits, and is thus great for performance when working with the file. The geometry is controlled inside the Global Settings for Displacement, which we will cover now. There are no limitations on the type of geometry displacement can be applied to (i.e., more than just meshes also polys, patches, and NURBS).

To find the displacement settings, go to Render Scene dialog > Renderer panel > Shadows and Displacement rollout > Displacement (Global Settings) group; the effect applies to the whole scene (Figure 2.215).

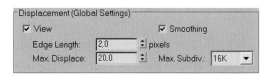

Figure 2.215

The View option defines the space in which the displacement is applied. If the View option is enabled, the Edge Length will be in pixels. If it is disabled, the Edge Length is set in world space units.

The Smoothing option is on by default with the usual Displacement mapping. mental ray simply smoothes the geometry, making the result look better (it actually uses interpolated normals). Smoothing must be disabled when you are using Height maps, which are usually generated by Normal mapping. One reason for this is that smoothing affects the geometry in a way that is incompatible with height mapping. We will discuss a second reason when we talk about one of the Displacement shaders.

The Edge Length defines the smallest potential edge length during subdivision. In other words, use this option if the image shows some artifacts in the displacement. Maximum Displacement is the maximum offset that can be reached by a vertex position during displacement. Maximum Subdivision controls the amount in which the original geometry (mesh triangle) will be subdivided. With each subdivision, an original face is divided into four smaller faces. You can set this range from 4 to 64K (65.536).

Figure 2.216

As I mentioned, these are the global settings. There is also the possibility of setting the same options on a per-object level. To find this interface you need to select the object and use the right mouse button to select the Object Properties option inside the Quad menu (Figure 2.216).

Now the Object Properties dialog is open, and you can select the mental ray panel (Figure 2.217).

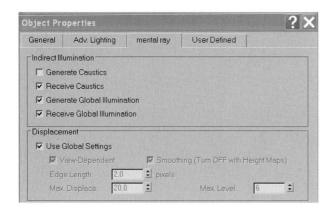

Figure 2.217

Figure 2.218

Just switch off the Use Global Settings option; then you can make adjustments to the per-object settings. Displacement can be assigned in the displacement slot of your material or to the displacement channel of the mental ray connection or mental ray material.

There are four Displacement shaders available (Figure 2.218).

We will discuss the 3D Displacement and Height Map Displacement shaders here. Chapter 5 covers the Material to Shader (under "Material-Related Shaders") and the Ocean shader (under "Water-Related Shaders").

2.5.2 Displacement without Special Shaders

The next simple exercise will show the meaning of these Displacement settings clearly. Open the file **Displacement.max** and render the scene. Inside the sample file, we have used Displacement in the normal way by applying a map in the displacement channel of a standard material. Just open the Material Editor to see it for yourself. There are different ways to apply displacement, through dedicated shaders, but we will go over those options after this first example. The next image shows the result of rendering the scene with just a simple plane with 4-by-4 segments and using the global settings. The actual displacement is performed on the basis of the black, gray, and white information from the image, which is used in the displacement channel of the material (Figure 2.219).

Figure 2.219

What happens internally is the following: the geometry that is needed to make the displacement visible is only added to the geometry during rendering. The amount of geometry that is added is based on the Maximum Subdivision setting, which is 16K by default. This is a big advantage over the scanline renderer, with which you need to actually make the extra geometry, creating a much larger data file. Now, raise the subdivision number to 64K, which is the maximum (Figure 2.220).

Figure 2.220

Render the scene; you will notice that the render time goes up but also that the quality of the displacement improves, leaving some artifacts to be adjusted in the next step (Figure 2.221).

The only problems left involve fine-tuning, as you can see on the edges of the displaced footprints. We would like them to be a bit sharper. For this, you need to change the Edge Length value inside the Displacement group. If you change it from 2 to 0,5 and render the scene again, you will get the following result (Figure 2.222).

Figure 2.221

The displacement has improved in sharpness, but the render time has increased significantly. We actually created smaller edge lengths with this option, so that's why the rendering took longer. Don't go overboard with this setting or your system will fall to pieces because of the amount of geometry that has to be created to perform this task. Remember, if you are still not satisfied with the quality of the displacement, you need to add more segments to the original geometry because we are now using basically the maximum for both subdividing and edge length, which is possible for this original 4-by-4 segmented plane.

Figure 2.222

2.5.3 Displacement Based on the 3D Displacement Shader

Another way of creating displacement is by using specific shaders to perform this task. They give you some more options to control the displacement. We will now start using the 3D Displacement shader, so open the file **Shader_3ddisplacement.max** and render the scene (Figure 2.223).

In the scene, there are just two parts of a box to which Arch & Design material has been assigned, but there is no displacement in this scene yet. We have positioned the mapping so that it looks like the stones are correctly positioned from one part of the wall to the other.

Figure 2.223

The next thing to do is to add the 3D Displacement shader. Go to the mental ray Connection rollout for the material, and remove the lock behind the Displacement component to unlock this option (Do not use the Displacement component inside the Special Purpose Maps rollout since this will not give you the shader we need for this exercise.) (Figure 2.224).

Figure 2.224

Click the gray None button and select the 3D Displacement shader from the Material/Map Browser (Figure 2.225).

The parameters of the shader will now become visible inside the Material Editor (Figure 2.226).

In the Extrusion map component, we now must put the same Tile map that we used in the diffuse component; this map is the component we want the displacement to work

Figure 2.225

Figure 2.226

on, and we want it to correspond with the image we have now. So, go back to the main Material parameter rollout and make a right mouse click on the *M* inside the diffuse component; then select the Copy option (Figure 2.227).

Go back to the mental ray Connection rollout, open the Displacement shader, and paste (as Instance) the map in the Extrusion map of the 3D Displacement shader (Figure 2.228).

Figure 2.227

Figure 2.228

This Tile map will now be responsible for the actual displacement. Put the Displacement Length option at 2. This is the value determining the amount of black and white information inside the image to be used to create the displacement. Change Extrusion strength to 2 as well. With this value, you define the height of the displacement. Now render the scene (Figure 2.229).

You can clearly see the effect of this shader, which basically results in the same-quality image as that in the previous exercise. So, fine-tuning is performed in exactly the same manner as we used to create the previous sample file.

Also evident is what displacement actually does — it really displaces geometry. That's the reason we now have a gap at the corner of the walls. We will resolve this, but first we will fix the quality. Adjust the Edge Length to 0,1 and the Maximum Subdivision setting to 64K inside Render Scene dialog > Renderer panel > Shadow and Displacement rollout > Displacement group (Figure 2.230).

Render again to get a sharper image (Figure 2.231).

Now for the problem of the gap where the walls intersect. There are easy and difficult ways to solve this. I will illustrate the difficult way first since this can be done by an option untouched previously in this shader: the Direction map. This is the option used to push the geometry into place. So just copy and paste (no Instance) the Tile map from the

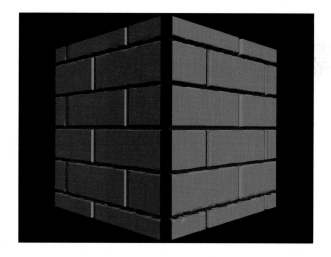

Figure 2.229

Figure 2.230

Extrusion map slot into the Direction map slot. Finally, change the Direction strength option to 80 (Figure 2.232).

The Direction map works in the UVW directions, based upon the color information inside the map that you have applied. Red indicates the *U*, green indicates the *V*, and blue indicates the *W* direction. Remember, we have used a standard Tile map, with almost black for the grout and almost white for the tiles. Let's render the scene (Figure 2.233).

OK, the walls appear connected again, but you will notice a strange shift in the grout and tiles, along with the fact that the displacement has become less. This result is not so strange. Since we used almost black and almost white for the tile setup, which means the colors are a mix of red, green, and blue, there is a shift in all three directions. That is why you see a piece of grout sticking out at the bottom of the wall. We only need each wall to be shifted inward, so this would mean the red direction for one wall and the green direction for the other. So let's just put these two together, making yellow, to get the best result. Adjust the color for the grout and tiles inside the Direction Tile map to yellow (Figure 2.234).

We're getting closer, but notice that the grout is coming out of the stones instead of receding back inside the stones. This is easily fixed. The extrusion is done based upon black and white information, so just go to the Tile map of the Extrusion and swap the grout and tile colors; you should be set. Be careful when doing this since the Extrusion and the Diffuse maps are still connected. You must make the Extrusion map unique before you adjust the colors. Now, if you not only swap the colors but also turn them into pure black (tiles) and white (grout), the displacement should become more noticeable again, almost as it was in the beginning but without the gap at the corner of the walls (Figure 2.235).

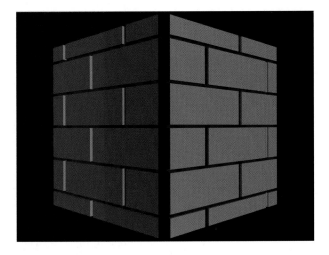

Figure 2.231

Figure 2.232

Figure 2.233

Figure 2.234

Figure 2.235

OK, that was the difficult route to remove the gap we had in the beginning. This is the easy one. First, remove the Direction map and set the value back to 0 (Figure 2.236).

Then, open the Renderer panel and go to the Shadows and Displacement rollout and check the Displacement (Global Settings) group. Now just turn off the Smoothing option, (Figure 2.237) and simply hit render (Figure 2.238).

That is all, but at least now you know what the Direction map is all about.

Finally, a little bonus: one of the new options inside the Arch & Design material is the Smoothing option, which actually also works for this setup. So just go to the Brick material and enable the Round Corners option, with a Fillet Radius of 1 inside Arch & Design material > Special Effects rollout > Round Corners group (Figure 2.239).

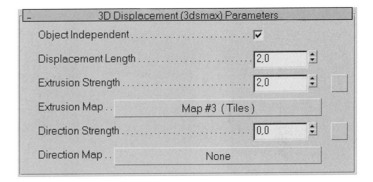

Figure 2.236

Figure 2.237

Now render again to get smooth corners. This actually proves the fact that displacement really creates extra geometry, because not only is the edge of the two connecting walls smoothed out, the stones themselves are also smoothed (Figure 2.240).

Figure 2.238

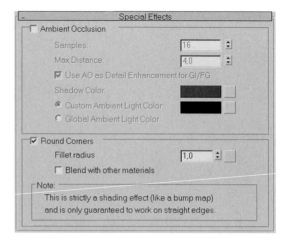

Figure 2.239

Figure 2.240 *Round corners added*

2.5.4 Displacement Based on the Height Map Displacement Shader

Similar to the 3D Displacement map, the Height Map Displacement shader displaces geometry of faces. However, it is specifically for use with Height maps generated by normal mapping. A Height map is a grayscale map that stores the relative height of the source object.

First, we will load the scene **height_map_displacement.max**, in which we have created one simple wall full of details and one plane without anything else (Figure 2.241).

We have already created a Height map for the plane that we can use for this sample file. This has been done through the Render to Texture options, which also work for mental ray. We also created a rendering of the full-detail wall, giving us a color image that we will use in our material definition for the plane.

Figure 2.241

Figure 2.242

Now, open the Material Editor and select an empty material slot with a standard material. Then apply the colored image (**Plane01complete map.tga**) of the detailed wall into the Diffuse channel. Next, add the Height Map Displacement shader. For this you need to open the mental ray Connection rollout of the material (Figure 2.242).

Look for the displacement component. Remove the lock to the right of the button by clicking it, and then click on the gray None button and select the Height Displacement map from the Material/Map Browser (Figure 2.243).

Figure 2.243

Now these options are available inside the Material Editor (Figure 2.244).

Figure 2.244

The settings are pretty straightforward. There can be displacement by using the minimum and maximum values. The value should match the one you used when you created the Height map in Render to Texture. In our case, this was 2. Change this now for the minimum and maximum height (−2 and +2). The Height map is the one we generated already for this sample file. Just click the None button and choose the bitmap option from the Material/Map Browser and select the **Plane 01height map.tga** when prompted.

Before we do anything else, there is an important step that you must do whenever using the Height Map Displacement shader: uncheck the Smoothing option for the displacement, either for the whole scene or for the object on which you have applied the shader. In our case, we will turn it off globally; open Render Scene dialog > Renderer panel and uncheck Smoothing in the Displacement group (Figure 2.245).

Figure 2.245

While you are there, you could also change the Edge Length to 0,3 and Maximum Subdivision to 64K since we will need this in the next rendering to get a decent image. Now render the scene (Figure 2.246).

The left wall is the fully detailed wall, and the right wall with the red lines around it is just one plane, and the Height Map Displacement shader has been applied. To prove that we have added real geometry to the plane, you should switch to the camera view called Camera Detail, and render again (Figure 2.247).

Figure 2.246

Figure 2.247

2.6 mental ray and Motion Blur

Another special rendering effect that became available when we started using mental ray as the alternative renderer is one we all know: the motion blur effect. If a camera's shutter speed is slower than an object's movement, there will be a blurred effect of both the object and the shadows cast by the object. Motion blur is the result of the relative movement of the object and the camera. The term *relative* is used since objects, lights, and cameras can move or stand still compared with each other. For mental ray, this is not important; it can apply Motion Blur in all different combinations.

Open the file **Motionblur.max** and render the scene (Figure 2.248).

In this file, there is an animation of a jumping shirt. Just hit the play button to see the total animation. Now open Render Scene dialog > Renderer panel > Camera Effect rollout (Figure 2.249).

Figure 2.248

Check the Enable switch in the Motion Blur group to generate motion blur. Next, move to frame 100 of the animation because we need movement to generate the motion blur effect. Because the animation starts from a standstill, there cannot be motion blur at the first frame.

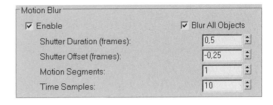

Figure 2.249

To be able to generate motion blur, you also need to check the object's properties. So, select the shirt and use your right mouse button to select the Object Properties option in the Quad menu. Check Object Properties dialog box > General panel > Motion Blur group to enable it. If it is not enabled, there will be no motion blur. Also, the Object option should be chosen; otherwise, there won't be an effect. Since we had the Blur All Objects option on in the Motion Blur group in the Render Scene dialog, the settings per object are overruled now. It is a good habit to check for the state of this setting. The Image option is only relevant for rendering with the scanline render engine (Figure 2.250).

Figure 2.250

Now you can render the scene again (Figure 2.251).

We see the motion blur, both for the object as well as the shadows that are present. This shadow blurring is special for mental ray. The regular scanline renderer is not able to achieve this type of effect for shadows. What happens is that mental ray samples the surface of the moving object multiple times during the time set (shutter duration). The pixel of the image is the same while the shutter is open, but the color changes over time because of the movement of the object. In the end, the different color samples are combined into one final color for the pixel itself.

Now it is time to play with the settings, so open the Motion Blur group again (Figure 2.252).

Figure 2.251

Enable and *Blur All Objects* are obvious, so there is no need to go into these options. Just be careful not to blur everything inside your scene because the calculation will then be applied to all objects, even those for which it is not important. This will add render time. Since we used the Blur All Objects option, the background is also blurred, which was a waste of render time.

Figure 2.252

The Shutter Duration option simulates the shutter speed of a camera in real life. When this option is 0, there is no motion blur. The next image shows what happens if the duration is set to 2. The value is based on one frame, so our sample of two means that we simulate a movement in the next image of what happens in two frames in one single option (Figure 2.253).

Figure 2.253

The Shutter Offset can offset the motion blur inside the image. The value is a relative value toward the frame, as is seen clearly with the next set of images. This option delays the opening of the shutter in comparison with the shutter speed, which you have set. So what you see with a setting of −1 is what happened in the previous frame; a setting of +1 means you would see what happens in the next frame. In other words; if you were to make the setting of shutter speed and the delay the same, there would be no motion blur. (If you want to render the same images, make sure you reset the duration value to 0,5.) (Figures 2.254 and 2.255)

Figure 2.254 *Shutter Offset = − 1*

Figure 2.255 *Shutter Offset = 1*

Motion Segment defines how many times the object's motion is sampled within one frame. This setting is not important if you have a linear motion, but if you have a curved motion, like the movement of the arms of the shirt, you would need to adjust the setting. The arms make a curved movement; without Motion Segment the motion blur lines would be straight where they are supposed to be curved. Since we hardly have this kind of motion in our sample scene, we will not use this option.

Figure 2.256 *Time Samples = 1* **Figure 2.257** *Time Samples = 25*

The next option is Time Samples. (Make sure you reset the Shutter Offset to −0,25 before moving on.) (Figures 2.256 and 2.257)

By default, the material is shaded only once and then blurred. If you need better quality, use a larger value for this setting. Of course, the render time will go up too. The number of samples is calculated based on contrast value over time, so if the contrast changes, more samples are taken. Greater contrasts create lesser-quality images; lower contrast settings give better-quality motion blur and images.

To speed up the process for motion blur, there is an alternative technique called Fast Rasterizer. What is Fast Rasterizer, rapid motion blur? As you probably understand, animations require less quality with the Motion Blur effect because of the speed of the movement of the individual frames and the slowness of our eyes. We simply do not detect this lesser quality. For this scene, we could do with a less accurate calculation method. Fast Rasterizer allows mental ray to save samples for specific areas on the surface of moving objects. It reuses this information when the same area is visible from another sample on another pixel. The result is much fewer calls to the material shaders of the moving objects, which are almost the same. The effect is that the same samples are being stretched over the image, which is not the case in reality because changes *do* happen. Of course, the result is less accurate, but with an animation, this technique can be a big time saver.

This option is also found in the Renderer panel, this time in the Rendering Algorithms rollout.

The Samples per Pixel controls the number of samples, and the Shader per Pixel controls the approximate number of shading calls per pixel used by the Fast Rasterizer method. Higher values create better results at the cost of rendering time.

If you want to see the difference between speed and quality, just open the **Fast_rasterizer.max** file. We have prepared the scene so you just have to move to frame 100 and hit Render to get a first motion blur rendering without

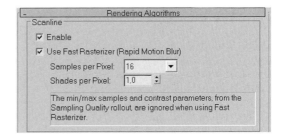

Figure 2.258

95

the Fast Rasterizer option turned on. Keep your eye out for quality and total render time. For both options, we will use the default settings so that there is no cheating going on in the background (Figure 2.259).

This is the rendering without the Fast Rasterizer option enabled. The total render time on the laptop I used for this model was almost 2 minutes.

Now turn on the Fast Rasterizer option and render again (Figure 2.260).

Figure 2.259

Figure 2.260

Although there is a difference, it is hard to notice. The major difference is the render time, which went down to about 30 seconds. (Note that Fast Rasterizer needs to have mental ray area shadows active; otherwise, it doesn't motion blur the shadows.) For people who are interested to see what the final animation would look like, there is a movie file on the DVD that shows the finished version using the Fast Rasterizer option.

One final note: in our sample, we used a moving piece of clothing. But not only did the clothing itself move, the height position of the total shirt also changed in the animation. For these two cases, mental ray uses two different techniques. For the actual motion blur inside the clothing, mental ray uses the Motion Vectors technique. For the moving of the shirt, it uses the Motion Transformation technique.

2.7 mental ray and Depth of Field

The last special effect we want to talk about is Depth of Field, which is also available within the mental ray render engine. Since it is part of the Render Scene dialog > Renderer panel, we will discuss this now.

Open the file **depthoffield.max** and render the scene. A nice sharp image results, as you might expect (Figure 2.261).

We will now introduce the Depth of Field effect, to enhance our image. Depth of Field simulates the way a real camera works. With a broad depth of field, the whole scene would be in focus; with a narrow depth of field, only objects

within a certain distance from the camera will be in focus. To add depth of field to the rendering, select the camera and go to the Modify panel > Parameters rollout and look for the Multi Pass Effect group (Figure 2.262).

In this dialog, select the Depth of Field (mental ray) option from the drop-down list and enable it. When you do this, the Depth of Field Parameters rollout will change to the mental ray–specific version. The good news is that there is only one option left: the f-Stop (Figure 2.263).

The f-Stop controls the amount of blurring for distances other than at the focal plane (target of the camera).

Now we need to set up the depth of field. First, switch to the Top view. With the Target Distance option, just underneath the Multi Pass Effect group, you can position the target of the camera. The position defines where you want to see the objects clearly.

Next you need to adjust the f-Stop value. By decreasing this value, you will narrow the depth of field effect; *increasing* the value has the opposite effect. For our sample, we changed it to 0,5. We have tested a number of values, but this was the one we liked best. It is normal that you might need to play around with this value to get the desired result (Figure 2.264).

Within the image, you can now clearly see the result of what we have done. The position of the target of the

Figure 2.261

Figure 2.262

Figure 2.263

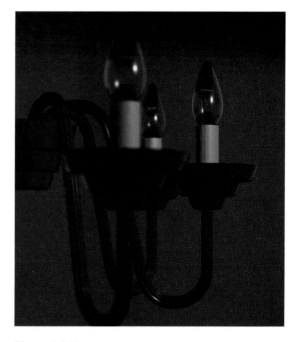

Figure 2.264

camera is the part that is in focus. The f-Stop amount gives the blurring effect of both the lamp in the front and the one in the back.

Although Depth of Field is a camera effect, it also works without any camera inside the scene. For this, you need to select the camera and delete it from the scene. If you were to render now, you would get the same overall sharp image that we had in the beginning of the Depth of Field sample.

Now go to Render Scene dialog > Renderer panel > Camera Effect rollout > Depth of Field (perspective views only) group (Figure 2.265).

Figure 2.265

As indicated by the name, this Depth of Field method only works within the perspective view, not within other views. The controls you have now are comparable to the ones we used with the camera for the Depth of Field effect.

First, turn the Depth of Field option on by enabling it. There are two different options for setting the depth of field: the In Focus Limits and the f-Stop method. The latter is the simpler one, but we will start with the In Focus Limits.

The Focus Plane option is the first thing to set, and this is comparable to the positioning of the target of the camera; the units it uses are 3ds Max units. This will be the center of the image focus. The Near and Far options define the range in which objects are in focus. So, the result will be a gradual moving from out of focus to in focus and back out of focus again. There is a mathematical relationship between the Near and Far options

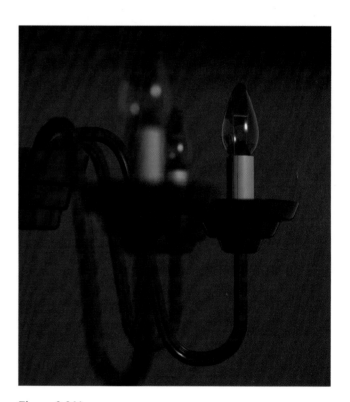

Figure 2.266

and the Focal Plane value. If you want to know more about this, check the Help file in 3ds Max. We created the next image by using a Focal Plane value of 320, a Near value of 315, and a Far value of 325,1612 (which is defined automatically) (Figure 2.266).

Now let's try the other method, which is far easier to set up. Just switch to the f-Stop version inside the Depth of Field group (Figure 2.267).

Figure 2.267

It just has a Focus Plane, which can be compared to the position of the target of the camera. The f-Stop is exactly the same as when we used the camera option. Larger values will broaden the depth of field effect, and smaller values will narrow it. The following is the result of the Focal Plane at 320 and the f-Stop at 0,5 (Figure 2.268).

Remember that rendering depth of field is a slow process because each sample on the focal plane is looked at from a slightly different position. This means that multiple calculations have to be performed by the render engine to create the blurry effect. You might consider creating this effect in another software product such as Photoshop — especially if you have a tight deadline.

Figure 2.268

Chapter 3
mental ray and Lights

3.1 Introduction

mental ray can create renderings with all the different type of lights that are available inside 3ds Max, so standard lights and photometric lights work in the manner you're used to. You are also able to work with the IES Sun, IES Sky, Daylight, and Skylight options, although these sometimes require that you make special adjustments.

In addition, mental ray also has its own specific lights. There are just four mental ray types available — Area Omni and Area Spot inside the Standard Light group, and mr Sky and mr Sun inside the Photometric Light group.

An area light is a light source that transmits photons based upon a geometrical area, unlike a point light source (regular Omni) or a targeted spotlight (which includes the sun and directional lights). You can compare an area light to a window or an array of neon tubes. The light quality cast by an area light is diffuse and has soft shadows by default.

mr Sun and mr Sky can be used to make physically correct outdoor lighting conditions for sunlight and shadow studies. They can also be adjusted to create special atmospherics; however, they are then no longer physically accurate.

We will now start making some examples in which we use the different lights and light systems that can be found inside 3ds Max.

3.2 Standard Lights
3.2.1 Omni and Spots

Open the file **standardlight.max** and render the scene. This is a regular scene with regular materials. mental ray has already been selected as the renderer. Inside the scene, we are using an Omni light with the Ray-Traced Shadow option enabled. Although we have used an Omni in this sample, the same applies to the Target and Free spots (Figure 3.1).

The result is what you would expect with sharp shadows, which is logical since we are using ray-traced shadows and we are not using an advanced indirect lighting calculation method. For all the standard lights, the same

options and workflow as in scanline rendering apply. Please note, however, that mental ray does not support the following shadow types for standard lights: (1) advanced ray-traced shadows and (2) area shadows. Whenever you use these shadows inside your standard lights, you will get an error message; however, the image will render since mental ray changes these shadow types automatically to ray-traced shadows. mental ray has the ability to create soft shadows with the standard lights, without using a Global Illumination technique. For this, we

Figure 3.1

need to change the shadow type from ray-traced to the mental ray Shadow Map option, which is, as the name indicates, mental ray specific. I will show you how this works in this sample. First, select the light and open the General Parameters rollout; then, select the mental ray Shadow Map from the shadows group drop-down list (Figure 3.2).

Now render the scene (Figure 3.3).

Figure 3.2

The edges of the shadows are still a bit sharp and have become very blocky. To resolve this, we need to adjust some parameters that can be found inside the mental ray Shadow Map rollout. Here you can find the settings that are responsible for the result we have at present (Figure 3.4).

First, we need to make the map size value higher. Change it to 2048, which will increase the sharpness of the shadow edges. Render the scene again (Figure 3.5).

Figure 3.4

Figure 3.3

Figure 3.5

The next adjustment is to change the sample range to 0,025 (Figure 3.6).

Figure 3.7

Figure 3.6

The sample range is responsible for the creation of the smoother transitions between the shadow and the rest of the environment (Figure 3.7).

The quality of the transition is the next thing we need to adjust. For this, we must increase the number of samples. Change the samples value to 200 and render the scene again (Figure 3.8).

Figure 3.8

3.2.2 Skylight

Model provided by Louis Hankart, Industrial, Jewelry and Lapidary Stone Designing

Open the file **skylight.max** and render the scene. It is evident that this is a scene with regular materials and no lights, just an HDRI file in the environment. For the renderer, we have already selected mental ray (Figure 3.9).

Figure 3.9

Now create a skylight (Create panel > Standard Lights > Skylight) in the scene. Remember, the skylight is a helper object, so it is not important where you place it in the scene (Figure 3.10).

Figure 3.10

Figure 3.11

In this example, we have placed it in the Top Viewport somewhere inside the scene. Next, we render the scene again. The image is almost black, except for the ring itself, which is reflecting the HDRI we are using inside this scene environment (Figure 3.11).

To be able to work with a skylight in combination with mental ray, you must use the Final Gather option. Turn this option on in the Basic group of Render Scene Dialog > Indirect Illumination panel > Final Gather rollout. For this example, we have chosen the medium preset, just to choose one out of drop-down list (Figure 3.12).

Figure 3.12

Now render the scene again. You will get a beautiful image with nice soft shadows, accomplished by using just a few mouse clicks. This method is extremely useful when rendering product designs (Figure 3.13).

During the rendering progress, you will see the two-pass rendering, which we saw before when we were working with these preset options for mental ray. The first pass is the rough result, and the second pass is the final result. To improve quality, you could add more bounces to the Final Gather solution, as in this final rendering where we have increased the number of bounces to 5 and rendered again (Figure 3.14).

Figure 3.13 *Result with skylight*

3.2.3 mental ray Area Lights (mr Omni and mr Spot)

Model provided by Dennis de Priester, www.priestermedia.com

Inside the Standard Light group, there are two mental ray–specific lights. Both of them are area lights, which means that they actually have a geometric area that can be specified as the light source. There are two types: Spot and Omni. An

Figure 3.14 *Result with 5 bounces*

Area Spot emits light from a two-dimensional area and an Area Omni emits a three-dimensional volume of light. By using area lights, you can generate beautiful realistic soft shadows, based upon ray-traced shadows. The disadvantage of area lights is that they can increase the render time because of the extra calculations that need to be performed. Even though the next sample will end up with serious render times, we have decided to use it anyway. So, if you want to perform all the steps yourself, be prepared to wait when the area lights are rendered.

Open the file **Arealights.max** and render the scene (Figure 3.15).

We have used spotlights in this scene, and for the rendering we have already turned on mental ray. The spotlights are set to use ray-traced shadows, which gives the sharp shadows you can see in the rendering. Now we will start introducing area lights inside our scene using a special dedicated MaxScript. This script converts all selected lights into area

Figure 3.15

Figure 3.16

lights. To find the script, go to the Utility panel and select the MaxScript option (Figure 3.16).

Even though you can see the Utility Convert to mr Area Light, you still need to select it from the drop-down menu. After this, the user interface of this script becomes available (Figure 3.17).

Figure 3.17

Click on the Convert Selected Lights option with the lights selected. The system will ask you the following question (Figure 3.18):

Figure 3.18

The safe choice here is no. By doing this, new lights are created; the old ones remain there but are switched off automatically. Now render the scene with the newly created mental ray Area Lights. Be prepared to wait for a while because the rendering time will now increase (Figure 3.19).

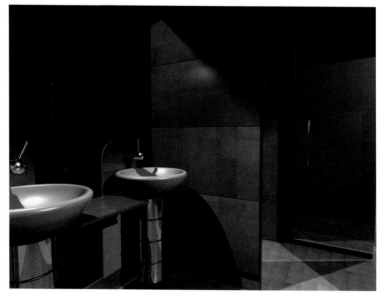

Figure 3.19

The rendering time increases because we are now calculating with area lights, which are able to generate soft shadows, even though we are using ray-traced shadows. The render time goes up because of the area that has been introduced by the new light source. By default, the area is 1 by 1, which is divided into a pattern of 5 by 5 (we will adjust this later). Now each point on the surface has to check whether or not all or just a part of the light is still visible, which means casting extra rays and adding more calculation time. The original point light was either visible or not, but an area light can be partially visible.

For now, the rest of the image is not much different — there are just a few changes visible on the wooden wall and the shower door, where you see soft shadow edges. The reason for this is simple: the size of the areas used by the light is still set to the default value, which is still too small and not adjusted to the area needed for the different lights. They need to be changed manually by selecting mr Area Spot 4 and opening the Modify panel, Area Light Parameters rollout (Figure 3.20).

Figure 3.20

Of course, the first parameter needs to be turned on, but this is done by default. For this exercise, we have not turned on the Show Icon in Renderer option, so you won't see the area rendered inside the image. (It would be represented by a white icon the size of the area we have set.) The type of area we have chosen is the Rectangle option. The default size is set to 1 by 1, and the samples divide this area into a grid of 5 by 5. In the example, I set the rectangle width and height values to 25 (do so as well). Repeat these settings with mr Area Light 5. Leave the samples as they are for now. We will adjust them later to see the effect of enlarging the size of the area without dividing it any further.

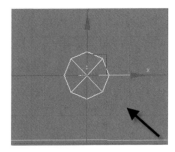

Figure 3.21

Follow the same procedure for the mr Area Lights 1, 2, and 3, but this time, change the height to 5 and the width to 95. A problem when adjusting the area sizes is that you can only see the area icon change inside your Viewport (in wire frame) when you are using the spinners for the height and width values. Activate the Top Viewport and watch for thin blue lines to appear when you are adjusting the value with the spinners (Figure 3.21).

We already made the orientation correct for the lights that have different height and width values; otherwise, you would have to rotate them to get them lined up with the walls.

Figure 3.22

107

Don't change anything to the sample setting yet. First, render the scene again, and be patient because this will take a while to render (Figure 3.22).

Now the soft shadows are much more evident because we have created bigger areas, so the shadows start behaving accordingly. When you are using mr Area Lights, the area for Spots is two-dimensional (rectangular or a circle) and for Omnis is three-dimensional (spherical or a cylinder).

However, we can still see grain inside the rendering, which is due to the small sampling values we are using for the individual light. In both directions, we are using a value of 5. The area is divided into a grid of 5 by 5, from which light rays leave the surface. You could increase this as you like, but be careful because render time will increase even more, so don't go overboard with this value. For this rendering, we changed the value for Area Lights 4 and 5 to 20 samples in both directions since this area has been defined as square. The other lights have been adjusted only in the biggest direction (V value), from 5 to 50.

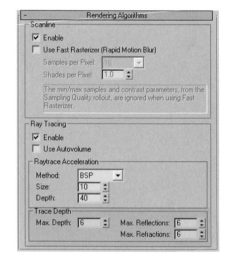

Since we have added this extra sampling, we are sure that the render time will increase compared with the previous rendering. We will make one adjustment that could help us specifically with this scene, which has a lot of reflections from all the glass and mirrors. For this you need to open Renderer panel > Rendering Algorithms rollout (Figure 3.23).

Figure 3.23

There are two main groups within this part of the interface. The following is important: if you are working in 3ds Max with Ray Trace Reflection maps, then this information will be passed on to mental ray. mental ray will use its own ray-trace engine for the reflection calculation. The ray tracer from mental ray is much more powerful than the regular scanline ray-trace engine. Both options are on by default, as you can see in the scanline and ray-tracing groups. So, in fact, by default, you will be using the best of both worlds, without knowing it.

The scanline ray-tracing is used during the calculation time to generate the direct illumination only (the primary rays). The mental ray ray-tracing is responsible for the indirect illumination (caustics and global illumination) and also for the reflections, refractions, and lens effects you have inside your scene.

Inside the Trace Depth group, we control the number of times light rays are refracted or reflected. The max depth defines the total number of times (for either reflection or refraction) that bouncing of rays may happen inside the scene. So either 6 reflections and no refraction, or the other way around, can be calculated as the maximum. The maximum reflection and refraction values define the individual maximum per type of ray. By lowering the maximum depth number to 3 for the next rendering, we still have enough reflections and refractions going on, but we reduce the calculations by 50%, which can be a great time saver in these types of scenes. Render the scene if you want to see this result. Remember, this scene has a long render time, even after reducing the reflection and refraction settings (over 1,5 hours on my laptop) (Figure 3.24).

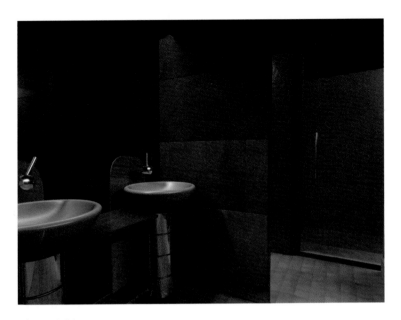

Figure 3.25

Figure 3.24

Finally, a piece of practical information. As you might have noticed, the render time increases when you start using area lights. You can save time during test renderings when you convert them temporarily into point lights again during the calculation process. You can find this option in Render Scene dialog > Common panel > Options group (Figure 3.25).

3.3 Photometric Lights
3.3.1 Photometric Lights

mental ray can also handle photometric lights. We will create a room with photometric lights using IES files for the light distribution. Inside the test scene, there are two photometric free point lights, but the same procedure applies for all the target and free photometric lights. Let's suppose we have set the light distribution to be isotropic. Open the file **photometriclights.max** and render the scene.

We have already turned on the Global Illumination (Render Scene dialog > Indirect Illumination panel > Caustics and Global Illumination rollout > Global Illumination group) and the Logarithmic Exposure options (Rendering menu > Environment option > Exposure Control group), which give the following result (We did this because we wanted to create a correct physical image for this sample.) (Figure 3.26).

Figure 3.26

The next step is to place the IES file in the lights and to set the light distribution of the lights to Web inside the Intensity/Color/Distribution rollout, and then select the supplied IES files through the Web Parameters rollout (Figure 3.27).

Figure 3.27

Because we have created the lights as Instance, we only have to do this for one

light. You can see that if you zoom in to the light, the geometrical shape has been adjusted to the IES data. The only thing you need to do now is render the scene again. The influence of the IES data file is clear because the light distribution in the room has changed completely (Figure 3.28).

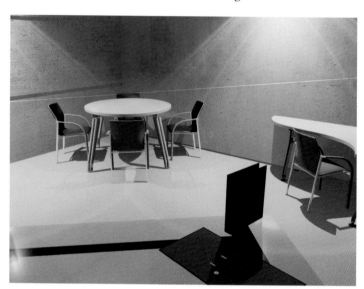

The image looks lighter on the floor, which is due to the fact that the IES file also changed the intensity of the light, so this is correct. If you want to bring the light intensity down, just change the "cd" amount inside the Intensity group of the Intensity/Color/Distribution rollout.

Figure 3.28 *IES based light distribution*

3.3.2 IES Sun and IES Sky

It is important to note that there are special mr Sun and mr Sky options within the photometric lights. They are, by far, the best and most accurate way to render with sun and skylights. I promised to show you how you can reach results with all the different lights, so I have included the IES options, but my advice is to use the mr Sun and mr Sky options in combination with mental ray.

Open the file **IESsun.max** and render the scene (Figure 3.29).

I specifically used an indoor scene, just to show you how this works for the

Figure 3.29

IES Sun option. There are some things to consider compared with the mr Sun system. Inside the scene, we are using just an IES Sun as a light source, but you can see from the rendering that there are a number of things to be corrected in this scene. First, we must start working with the Logarithmic Exposure control. Go to Rendering menu > Environment and turn on the Logarithmic Exposure option. Make sure the Process Background and Environment Maps option is off since we are using as a background a standard jpeg image and not an HDRI image (Figure 3.30).

Figure 3.30

Now render the scene again (Figure 3.31).

Figure 3.31

OK, that didn't help much. We need something else — indirect light! For this to happen, we need to turn on the Global Illumination inside Render Scene dialog > Indirect Illumination panel > Caustics and Global Illumination rollout > Global Illumination group. Just use the default settings for now (Figure 3.32).

Now render and see what happens (Figure 3.33).

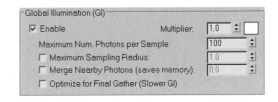

Figure 3.32

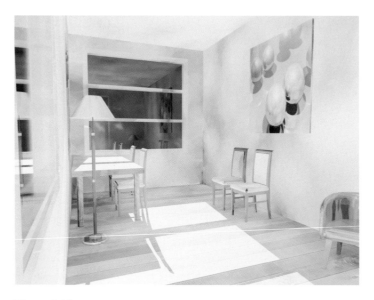

Figure 3.33

Although it looks better, we have some major problems. If you look at the areas where the sun hits directly, you can see that the colors are washed out. In addition, the global illumination needs some fine-tuning. The reason the image is too bright is simple: we are using exterior daylight to light the scene, so we need to make some adjustments within the Logarithmic Exposure control (Figure 3.34).

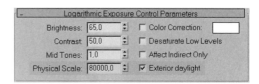

Figure 3.34

We changed two things: (1) we checked the exterior daylight option and (2) we adjusted the physical scale value to the IES Sun's light intensity value inside the scene, which is 80.000. Now render again (Figure 3.35).

The colors are back, but now we are lacking overall brightness. There is a relatively simple reason for this too. This IES system just hasn't got enough energy to light up the room, so we need to adjust the Global Illumination solution by adding more energy. This can be done by changing the Multiplier value to 5 and rendering again (Figure 3.36).

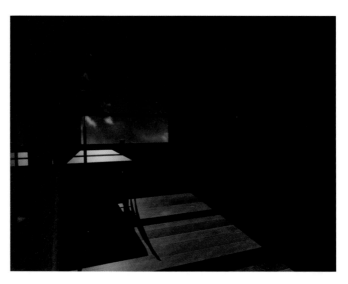

Figure 3.35

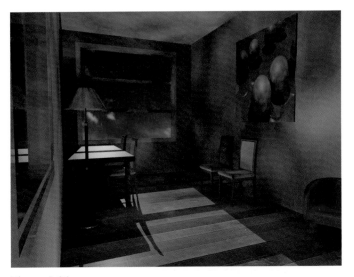

Figure 3.36

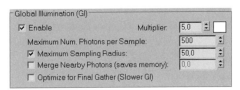

Figure 3.37

By playing around with the settings as I did when we discussed the Global Illumination feature in detail, I found that using the following settings for the sampling and sampling radius gave a good result (Figure 3.37).

Then I rendered again with this result, which will do for this sample (Figure 3.38).

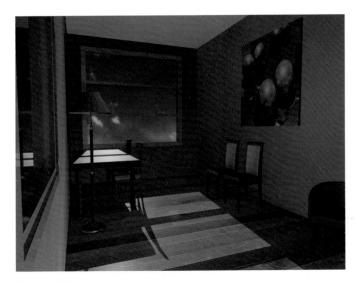

Figure 3.38

3.3.3 Daylight System (IES Sun and IES Sky)

We already mentioned in the previous IES Sun sample that there are special mr Sun and mr Sky options within the photometric lights, but the options are also available when you are using a daylight system. These options are, by far, the best and most accurate way to render with a daylight system, especially in combination with the specific mr Physical Sky shader, which works with this option. Since I promised to show you how you can reach results with all the different lights, I have included this section, but my advise is to use the new mr Sun and mr Sky options if you can, and not the ones I will demonstrate now.

The daylight system is the light system that can be found inside the Systems group of the Create panel since this one can be animated. There is also the Sun system, which we will not use throughout this book since it is just a standard

light type, which we discussed already. Since the daylight system can use both the IES Sun and IES Sky options, I have chosen to use these options together inside the daylight system.

Open the file **IESdaylightsystem. max** and render the scene. (The fiat 500 model is a free download model with evermotion.org.) (Figure 3.39).

Inside this scene, we have used a daylight system for illumination purposes. We get a strange result, so we will follow the next steps to resolve this problem.

Figure 3.39

First, open the Environment dialog through the Rendering menu (Figure 3.40).

One problem in this file is that the Exposure control is switched off (specific for this case, to show its effect). Select Logarithmic Exposure control and make sure it is switched to on.

Figure 3.40

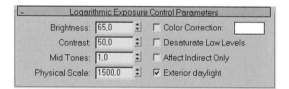

Figure 3.41

Since we are using a normal jpeg image as the background, there is no need to turn on the Process Background and Environment Maps option. This would only be needed if we had used an HDRI in the background since this option basically tells 3ds Max to process the background in a real physical scale. Before you start rendering, check inside the Environment dialog in the Logarithmic Exposure control rollout to make sure Exterior Daylight is switched on. We are dealing with an exterior scene, so we need this (Figure 3.41).

Then render again (Figure 3.42).

There are only a couple of things to do to fine-tune and correct the image. First, adjust the Physical Scale setting from 1500 to the brightest light inside the scene, which is the sun, with a value of 88586,117. This will make

Figure 3.42

Figure 3.43

Figure 3.44

our scene more realistic by dimming the overly bright sunlight we have at the present (Figure 3.43).

Finally, turn on the Final Gather option to get an even better result. You can find this option inside Render Scene dialog > Indirect Illumination panel > Final Gather rollout. I selected the preset medium option to get some nice settings directly and to keep the render time low. This also makes our shadows more realistic (Figure 3.44).

Now render again and pay attention to the shadow changes, which are affected by the indirect illumination (Figure 3.45).

Figure 3.45

3.3.4 Daylight System (mr Sun and mr Sky)

Model provided by Dennis de Priester, www.priestermedia.com

The daylight system to use is the light system found inside the Systems group of the Create panel since this system can be animated. There is also the Sun system, but we will not use it since it is just a standard light type, which we have discussed already. Since the daylight system can use both the mr Sun and mr Sky options, I have chosen to discuss their use together inside the daylight system. The daylight system, in combination with the mr Physical Sky shader, which works with this system, is the preferred way to create outdoor scenes.

The mr Daylight system is far superior to the IES daylight alternative. These are a number of actions the mr Daylight system can perform for you that are simply not available inside the IES version:

- Create soft shadows
- Adjust the background to the time of day
- Create haze in the scene (which painters call *aerial perspective*)

So, I advise you to use this mental ray Daylight system whenever you need to create an outdoor scene; it is far better than the alternatives previously available inside 3ds Max.

First, open the **mrdaylightsystem.max** file and render the scene (Figure 3.46).

Figure 3.46

This looks very bad, but the result is logical. We have applied a default daylight system but not set it up properly, which we will do now. We will first set up the system in a quick way, and then we will go more into detail to explain which options to change and why they result in a better rendering.

Select Daylight system and open the Daylight Parameters rollout in the Modify panel (Figure 3.47).

We need to change the default Standard Sunlight and Skylight to the mental ray versions of these options. First, select the mr Sun in the drop-down list for the Sunlight option (Figure 3.48).

Next, do the same with Skylight and select the mr Sky from the drop-down list (Figure 3.49).

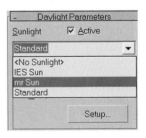

Figure 3.48

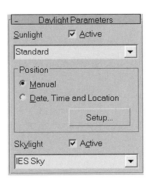

Figure 3.47

Now a new dialog box will appear, asking if you want to apply an mr Physical Sky shader (Figure 3.50).

Make sure you click the Yes button because this automatically places mr Physical Sky inside the Environment map, which can be found at Rendering menu > Environment > Environment tab (Figure 3.51).

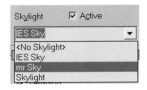

Figure 3.49

Figure 3.50

Also in the Environment panel, switch on Logarithmic Exposure, and don't forget to tick the Exterior Daylight option. We need the logarithmic exposure because we are dealing with a true high-dynamic photometric range daylight system (Figure 3.52).

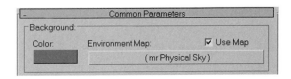

Figure 3.51

If you had started by creating the daylight system from scratch from the Create menu, you would have been asked directly if you wanted to turn on the Logarithmic Exposure.

Finally, check the Final Gather option inside Render Scene dialog > Indirect Illumination panel > Final Gather rollout > Basic group. We used the low preset just for this example. Because we are using a skylight, it is absolutely necessary that we render with the Final Gather option turned on. If we forgot this, the shadows of the sun would become unrealistically dark, instead of blue (Figure 3.53).

All of this could have been done by using the available render presets located at the bottom of the Render Scene dialog. Since we used them when we discussed indirect illumination with the Final Gather option in Chapter 2, we will not use them again for this sample; instead, we will adjust the settings manually.

Now render the scene (Figure 3.54).

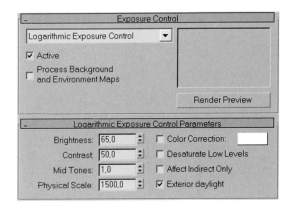

Figure 3.52

Figure 3.53

The result is a beautifully lit outdoor scene, even though we have used just the low version of the Final Gather option. However, we still have one problem, and that is the gray horizontal strip at the horizon. I will tell you later what this is and how we can resolve it.

Now I will go into more detail regarding the different settings that are available. You should know that mr Sun, mr Sky, and the mr Physical Sky shader can all be created individually. However, the true power becomes available when they are used together, creating accurate daylight scenes or daylight simulations. mr Sun is responsible for the color and intensity of the sunlight, as well as for emitting photons from the sun. The mr Sky shader is responsible for creating

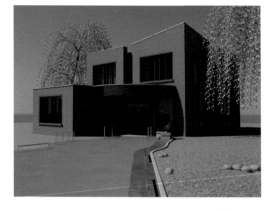

Figure 3.54

the color gradient that simulates the atmospheric sky dome, which is then used to light the scene, with the help of final gathering. The mr Physical Sky shader makes the sky and sun visible to the camera and in reflections.

If you look at the three components and their results individually, you would get the following images (Figure 3.55).

Figure 3.55

This image illustrates only the mr Sun, showing the sunlight. The gray background is the standard environment color (Figure 3.56).

Figure 3.56

Here, only mr Sky is seen, showing the skylight influence (Figure 3.57).

Finally, this is the result with only mr Physical Sky shader, showing the sun (not visible here) and sky to the camera plus the virtual ground plane.

Some of the parameters for mr Sun, mr Sky, and the mr Physical Sky shader are present in all these different components and do exactly the same thing. It is therefore important to keep these parameters in sync with each other if you want to do realistic daylight simulations. To make life easier, you can inherit the settings in both mr Sun and the mr Physical Sky shader from the driving force, which is mr Sky. When this inherit option is on (which it is

Figure 3.57

by default), one can focus on the settings in one place without bothering to keep them the same in other places. If we look at the interface, you can find this Inherit option for mr Sun in the Modify panel in the mr Sun Parameters rollout (Figure 3.58).

Since this Inherit option is on, the other options are now grayed out.

To adjust the mr Physical Sky shader, you first need to drag and drop the shader from the Environment panel to an empty sample slot in the Material Editor to get the setting available. (Remember to choose the Instance option when asked by 3ds Max). The settings of this shader appear as follows (Figure 3.59).

Figure 3.58

Also, the most important common parameters are now grayed out, but they are crucial since they actually drive the entire shading and colorization. They are Haze, Red/Blue shift, and Saturation. The horizon option is also one of the common parameters, but this one has no effect on the shading and colorization.

mr Sky is the driving force, as mentioned, which means that here there is no Inherit option available for it, and all the settings that are grayed out in mr Sun and the mr Physical Sky shader are active in the mr Sky rollout. Select the Daylight system and open the mr Sky Parameters rollout in the Modify panel. We will play a little bit with these settings, starting with the Horizon option, so that we can position it correctly for the rest of this exercise. Also, put the Final Gather preset to draft, just to keep the rendering time as low as possible. We will start with the mr Sky parameters because they are the most important settings and drive the others (Figure 3.60).

Figure 3.60 **Figure 3.59**

The names of the settings indicate well what they stand for. Horizon is a virtual ground plane that exists below the model; therefore, it is not necessary to create geometry all the way to the imaginary horizon anymore. This ground plane actually provides the visual surface as well as bounced light from the ground surface. For this sample, we changed it to a red color just to make it clearly visible in the rendering, as you can now see in the next image. The ground color swatch is the color of the virtual ground plane, which is a diffuse reflectance value and therefore bounces the light based upon the ground color value, supplementing the sky illumination in the scene (Figure 3.61).

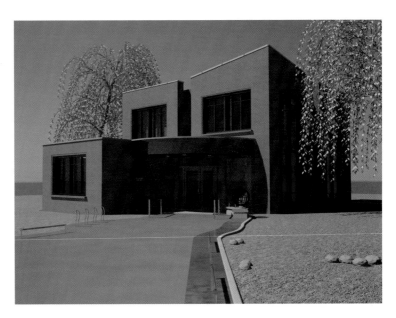

Figure 3.61

The Height option sets the relative level of the horizon. Since background color is not an actual geometrical object, it does not exist at a specific height in three dimensions but is simply a shading effect for rays that go below a certain angle. The height does, however, influence the position and color of the physical sun and sky when it sets in the evening or comes up in the morning. In the image, you can see that the Horizon exists all the way around the model, as you see it reflected in the windows of our building. This was the problem we had when we first rendered the daylight system—the reflected gray band!

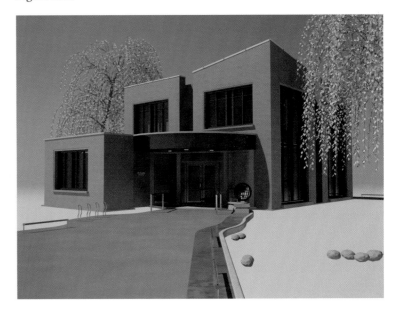

Figure 3.62

The Blur option is determines the amount of blurring from the Horizon to the actual background of the rendering.

In the next rendering, we changed the height value to −0,2 and Blur to 0,5, and adjusted the color to light green to simulate the grass. This illustrates the bouncing of light we referred to earlier. No shadows are visible on the ground because we have hidden the grass temporarily (Figure 3.62).

The next option to discuss is Haze, which sets the amount of haze in the air. It can range from 0 to 15, in which 0 is a complete clear day and 15 is complete hazy. Haze has an influence on the intensity and color of the sky and horizon, intensity and color of sunlight, softness of the sun's shadows, softness of the glow around the sun, and the strength of the aerial perspective. Change the value to 5 and render again to see what happens (Figure 3.63).

You can clearly see that all the components we mentioned have been influenced by adjusting the Haze option.

The last two common parameters are more for artistic control and, thus, the group is called Nonphysical tuning (Figure 3.64).

The Red/Blue shift gives control over the redness of the light. The default is 0, which is physically correct, but it can range from extreme blue (-1) to extreme red ($+1$). The next rendering has been made with a $-0,5$ value (Figure 3.65).

The saturation value can give a complete grayscale image (value 0) or extremely saturated colors (value 2). The default value is 1 and is the physically calculated saturation. The next rendering is obviously made with a value of 0 for the saturation, after putting Red/Blue shift back to 0. Notice the difference in the background, which went from a clear blue to a hazy gray (Figure 3.66).

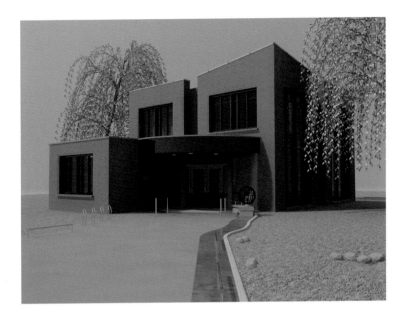

Figure 3.63

Figure 3.64

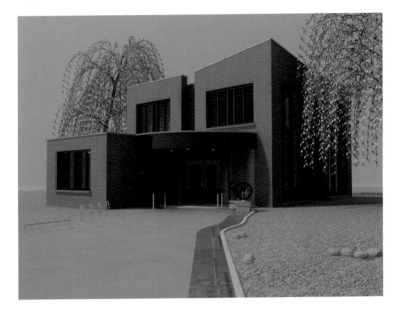

Figure 3.65 *More blue inside the scene*

So far, we have handled the common parameters. We will now focus on the unique settings for each of the three main components. Since we used the mr Sky parameters as a starting point, we will first adjust this and some of its options.

The first to consider are the On and Multiplier options (Figure 3.67).

Of course, you need to switch mr Sky on for it to become effective. The multiplier multiplies the light output value (Figure 3.68).

Night color is the darkest color for the sky; it will never be darker than this value (Figure 3.69).

Figure 3.67

Figure 3.68

Figure 3.69

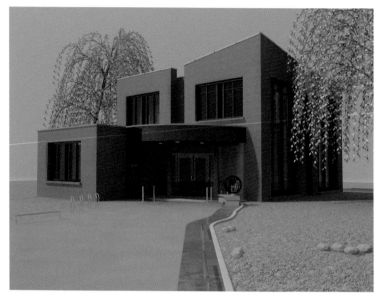

Figure 3.66 *Saturation set to 0*

Aerial perspective is a term that originates from the painters' world, and it states that objects are perceived hazier and tinted to the blue end of the spectrum when they become more distant. This is what the Aerial Perspective option simulates, so the default value represents the distance at which 10% of haze is visible, even if the value of Haze is set to 0. If you change the Aerial Perspective value to 750 and set the Haze value to 0, you can clearly see the effect (but this time closer to the viewer) of starting before the building and giving the haze some blue tint. (Don't forget to turn the saturation back to 1, if you have not done this already.) (Figure 3.70).

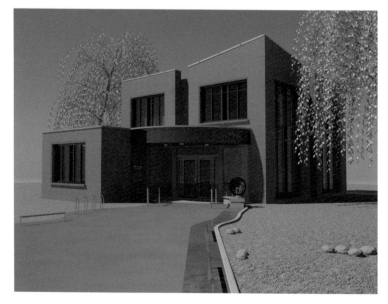

Figure 3.70

Now, we'll move on to the mr Sun parameters but, first, reset the Aerial Perspective setting to 393700. After you have selected the Daylight system and opened the Modify panel, you will find three rollouts related to the mr Sun. The first rollout is the most universal one — mr Sun Basic Parameters (Figure 3.71).

Figure 3.71

Of course, mr Sun needs to be turned on. The Targeted option only applies when you have added an mr Sun as an individual object instead of being part of the day-light system that we are using now. If you were to use an individual mr Sun, you would have a target value available next to the Targeted option, which you could adjust to your choice.

Shadows On means that we will have shadows that will use the Softness and Softness Samples settings. Softness set at 1 is the actual softness of shadows generated by the sun. A lower value makes the shadows sharper, and a higher value makes them softer. The number of Softness Samples should be clear. The following image is the result of a Softness value of 15 and a Softness Samples value of 20. Note that if this value were set to 0, no soft shadows would be generated (Figure 3.72).

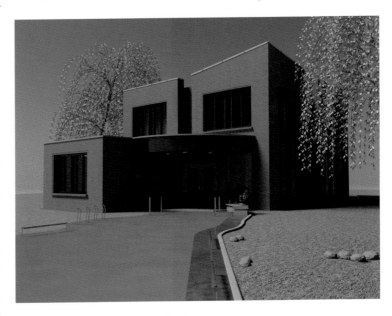

Figure 3.72 *Softer shadows introduced*

Here you can see the result in the shadows, which are now much softer than they were before.

The next rollout is mr Sun Parameters (Figure 3.73).

As you can see, the Inherit from mr Sky option has been checked, which is the best way to keep mr Sun in phase with mr Sky. The options that you can influence indi-vidually are the same as we discussed with the mr Sky settings.

Figure 3.73

Finally, there is an mr Sun Photons rollout, with which you can focus the Global Illumination photons to a certain area of the scene (Figure 3.74).

By default, mental ray shoots photons all over your scene, but it could be that just a small portion of the scene is of importance for your rendering. By using this Radius option, you can speed up the rendering process and enhance the quality of the ren-dering since more photons will reach the specific place you want, rather than the

Figure 3.74

whole scene. If you check Use Photon Target and start adjusting the radius, there will be some lines surrounding the sun ray (Figure 3.75).

Figure 3.75

This is the target area for the photons in this specific case. If we wanted to render the interior of this office building, Use Photon Target would be great to employ. For our scene, this option is not relevant, so we will leave it as it is.

Finally, there is the mr Physical Sky Environment shader. For this, you need to open the file **mr_physical_sky.max** since we have already adjusted the position of the sun in this file. We also dragged and dropped the shader from the Environment rollout into the Material Editor, so you can directly access the parameters (Figure 3.76).

The first part involves the appearance of the sun disk inside the rendering. The disk intensity and glow intensity define the look of the actual sun disk in the sky. The Disk option controls the intensity of the sun disk itself, and Glow controls the amount of glow around the disk. The scale value sets the size of the actual disk. The default value is set at 1, but I don't perceive this as appropriate. A good value for the scale is 4, so change this one. And, in our case, we also adjusted the disk intensity to 2 and the glow intensity to 5 and made the following rendering (Figure 3.77).

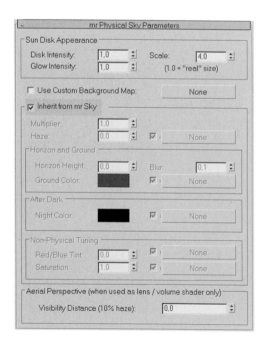

Figure 3.76

I have also created an animation of a daylight simulation, which is on the DVD if you'd like to watch it. It's called **Daylight_animat**.

Figure 3.77

The Use Custom background option can be useful for compositing purposes. If you select this option but no specific background map has been set, it will render transparent black. If you place a bitmap to be used as a background, the image will overrule the visibility of the physical sun, but reflections and refractions will remain visi-

ble. In this rendering, we have replaced the background with one of the **clouds_color.jpg** file from the DVD. Make sure you set the mapping to Spherical after you have applied the background. Also, adjust the output amount of this bitmap to 10 inside the Output rollout inside the Material Editor; otherwise, it won't show up in your rendering. The reason for this is that the daylight system is high dynamic range and the bitmap we are using is not. To get it in phase, we need to boost the output (Figure 3.78).

I know the colors of this background do not belong to this time of day—early morning—but I just wanted to show you what happened, so I needed a position where the sun is visible inside the rendering. This

Figure 3.78

picture now overrules the visibility of the sun. So, what do you need to do if you want to have a sun plus a cloudy sky? We need to apply a trick, which I will explain to you now.

Figure 3.79

Go to the next set of settings, which are usually inherited from the mr Sky parameters. There is one big extra here: you can add shaders or mappings to each of the effects; for example, a map could be used for the haze and the ground color of the virtual ground plane. For our trick, clouds and a physical sun disk in the same picture, use a map in the Haze channel. Uncheck the Inherit from mr Sky option. Click the Map Channel button and apply the black and white bitmap of the sky background, which is on the DVD (**clouds_bw.jpg**) (Figure 3.79).

It is important to open the Output rollout of the bitmap (Figure 3.80).

Change the output to a value between 0 and 10 to boost the intensity of the Haze map.

Figure 3.80

125

Now, think back to the start of the daylight system, where we adjusted the value for the horizon to −0,2 because there was some horizon showing in the back. Since we have disabled the Inherit option, we need to adjust this setting manually, in addition to the green and the blur amount (0,5), to get the same result. After that, render the scene and watch what happens (Figure 3.81).

Figure 3.81 *Sun and clouds visible at the same time*

Now, there is the Aerial Perspective effect again, but this time it can only be used when the mr Physical Sky shader is used as a lens or volume shader in the Camera Shaders group in the Render Scene dialog. If you use mr Physical Sky as a volume shader, it applies to all the rays inside the scene, including the reflected and refracted rays. If you use mr Physical Sky as a lens shader, it only applies to the primary rays, so it doesn't appear in reflections. So, let's open the Render Scene dialog and move to the Camera Shaders group. Click the None button to the right of the Lens component, and select the mr Physical Sky shader from the list (Figure 3.82).

Figure 3.82

Now drag and drop this mr Physical Sky shader to another empty material slot in the Material Editor, and adjust the Aerial Perspective value to 250 and render the scene; this will give you a nice hazy view (Figure 3.83).

You could also try the same thing with the shader inside the Volume component; but, trust me, the rendering is the same as this one since our scene is not using any kind of

Figure 3.83

secondary bounces (we are using only Final Gather). However, even if we were to use secondary bounces, the result would still hardly be visible with this sample scene, actually just making the leaves of the tree in front a little greener than in this rendering.

3.4 mental ray–Specific Light Rollouts and Shaders

Each light, regardless of whether it is photometric or standard, that you create inside 3ds Max has two specific mental ray rollouts once you have placed it inside your scene. These are the mental ray Indirect Illumination and mental ray Light Shader rollouts. We will go over these two now. First, open the file **lightoptions.max** and render the scene.

There are two mental ray Area Spots used inside this simple office. Both Global Illumination and Final Gather have been turned on, so if you want to render it yourself, be patient. This will take a couple of minutes to get the following result (Figure 3.84).

Now, select the light above the desk (Area Light 02), open the Modify panel, and scroll all the way down to where you find the two mental ray–specific rollouts, which we will discuss more in detail.

Figure 3.84

3.4.1 mental ray Indirect Illumination Rollout

The mental ray Indirect Illumination rollout is only active when mental ray is the current renderer; although the rollout is always there with any type of light and any kind of render engine. Inside this rollout, you can control the individual light source when generating caustics and/or global illumination. Inside Render Scene dialog > Indirect Illumination panel > Caustics and Global Illumination rollout > Light Properties group, you can influence all the lights in the scene at once (Figure 3.85).

If the Automatically Calculate Energy and Photons option is on, then the global Multiplier values are based upon the settings in the Render Scene dialog. As we mentioned at the beginning of the book, mental ray depends on real-world measurements. The use of this automatic option depends heavily on the real-world

Figure 3.85

measurements. If they are not correct, you must use the manual settings. Switching off this option gives you complete control over this specific light. To test this, while the light above the desk is selected, uncheck the Automatically Calculate Energy and Photons option for this light. Change the energy value for this light to 50 and the decay to 0, which means you can disable the decay for this light. The intention is not to get a perfect image but to show you the influence you can have on each individual light source and its obvious result. Now, render the image again and you will get the following result (Figure 3.86).

Figure 3.86

3.4.2 mental ray Light Shader Rollout

The next adjustment is in the mental ray Light Shader rollout. Here you can assign a mental ray Light shader or a Photon Emitter shader to the light source. You will influence the behavior of the light by the shader that has been selected. To make the option active, you need to check the Enable option (Figure 3.87).

Figure 3.87

Next, you can choose to use a Light shader or a Photon Emitter shader by clicking the appropriate None button. For the Light shader, you can choose from four different shaders (we will go in to more detail for each of them in the next section) (Figure 3.88).

Our discussion of the Photon Emitter shader will be brief. There are no Photon Emitter shaders available inside 3ds Max with the standard installation.

After you have changed the Light shader, you can render the scene again and the selected shader will be used. I will now show you what each of the four individual shaders can do for you.

Figure 3.88

3.4.2.1 Ambient/Reflective Occlusion Shader

For lights, we have available the Ambient/Reflective Occlusion shader, which can also be used inside materials (I will show you later how to do this). Ambient occlusion is a great way to cheat by creating an environment illumination effect without using global illumination, and it can be placed inside all the different lights available inside 3ds Max.

Ambient occlusion is often used to create maps for external compositing, where the Occlusion shader is assigned to every material in the scene. The output can be used to modulate other render passes to achieve proper compositing

in postproduction. It can also be used directly to scale the contribution of ambient light. Another use of occlusion is reflective occlusion, where the shader is used to scale the contribution from a reflection map.

First, open the file **Shader_ambient_reflec-tive_occlusion.max** and render the scene. Inside our scene, we have applied one gray material for all objects, just so you can clearly view what the Ambient/Reflective Occlusion shader will do for us. There is just one spot-light inside the scene, to which we will apply the Ambient/Reflective Occlusion shader (Figure 3.89).

Figure 3.89

Select the spotlight and open the mental ray Light shader rollout (Figure 3.90).

Check the Enable option and click the None field to the right of the Light shader option.

Now, from the Material/ Map Browser, select the Ambient/Reflective Occlu-sion shader (Figure 3.91).

Once the shader is assigned, drag and drop this shader button into an empty slot inside the Material Editor

Figure 3.90

Figure 3.91

so that the option for the shader becomes available. Don't forget to choose the Instance option when prompted. Now just render the scene (Figure 3.92).

This is rendering result with ambient occlusion. You can still see a bit of roughness, but we will adjust this by changing some of the parameters that have become available inside the Material Editor (Figure 3.93).

Figure 3.92

Figure 3.93

The Samples option is responsible for the graininess that is now present inside the rendering. Just adjust it to 128 and render again (Figure 3.94).

The result is much better. The bright and dark options are responsible for the overall brightness range of the scene. Change these color swatches to slightly different ones, such as light gray for Bright (0,75) and dark gray for Dark (0,25), and render again (Figure 3.95).

As you can see, the overall range of the brightness has changed. Actually, Bright is the color used when no occluding objects are found, and Dark is the color used when total occlusion occurs. Reset the brightness values back to black and white before moving on.

Next, we will change the spread of the ambient occlusion effect. A value of 0 results in no spread at all. So, for testing purposes, change the value to 2 and render again (Figure 3.96).

The "shadows" are still there, but their spread has become much larger. Change the Spread option back to 0,75 before moving on.

Maximum Distance is the range within which geometry is sampled. A value of 0 means that the entire scene will be sampled. A value other than 0 means that only objects within this distance will be taken into account, where objects outside this range do not occlude at all and objects that are closer occlude more strongly as the distance approaches 0. Change the value to 800 and render (Figure 3.97).

Figure 3.94

Figure 3.95

Figure 3.96

It is clearly illustrated that the distance from the road to the ceiling is not within the applied distance since no occlusion is present anymore. Before moving on, change the Maximum Distance value back to 0.

The next option is the Reflective option. By checking this, we generate a reflective occlusion pass, which looks like the next image. If the Reflective option is on, the samples are distributed around the reflection direction and not the normal direction, as they are when this option is off (Figure 3.98).

Now we have generated a reflective occlusion pass that can significantly enhance the realism of reflection mapping. This is most evident in the tiles of the pavement. Uncheck the option and move on to the Type option.

The Type option is on by default for the Occlusion option. There are two other options available, one for Environment and one for bnorm. Environment takes into account the current environment. The bnorm option is used to produce a bent normal map. When the Environment option is chosen, the current environment is sampled and weighted based on how occluded that particular direction is. Since we don't have any kind of environment inside our scene, we will leave this option as is.

Now turn on the bnorm option (type 2 as indicated) to get the bent normal map. The average unoccluded world space normal direction is calculated and returned encoded as a color value where red is X, green is Y, and blue is Z (Figure 3.99).

Figure 3.97

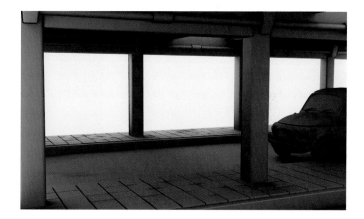

Figure 3.98

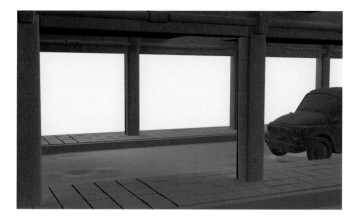

Figure 3.99

The Return Occlusion to Alpha stores the occlusion information in the alpha channel, which then makes the map very useful for compositing purposes. You could actually put this value to 3, which generates a kind of bent normal map, but now the normals are encoded into the camera coordinate space.

The final two options involve how the objects are handled inside the scene. The first one, Include/Exclude Object ID, indicates whether the shader will include in or exclude from consideration an object with a specific ID number. The second one, Non-Self Occluding Object ID, defines which objects don't self-occlude or occludes objects with the same ID number.

The next shaders are rarely used when working inside Max. This is because the 3ds Max lights already have much the same kind of standard functionality. But I've chosen to mention them because numerous people have asked me in the past what these options are all about. So let's unravel the mystery.

3.4.2.2 Light Infinite Shader

Infinite (directional) lights cast parallel rays of light. The source is infinitely far away, and attenuation is disregarded. Open the file **Shader_light_infinite.max** and render the scene (Figure 3.100).

Figure 3.100

Inside this scene, there is a standard spotlight. To demonstrate this shader, we will apply it to this spotlight and go over the options. The first step is to select the spotlight and open the Modify panel. Open the mental ray Light shader rollout (Figure 3.101).

Figure 3.101

Check the Enable option. Click on the None button below Light shader option. The Material/Map Browser will open; select the Light Infinite shader. For the Photon Emitter shader option, there are no shaders available, so this option is not relevant now (Figure 3.102).

Figure 3.102

Once the shader is selected, drag and drop the Light Infinite shader to an empty slot inside the Material Editor to access the parameters (Figure 3.103).

Figure 3.104

Figure 3.103

Make sure you select the Instance option so that when you change the parameters, they will directly affect the shader (Figure 3.104).

What we have done at this point is to replace the spotlight with a light with parallel light rays. We have the following options available:

- **Color**. This refers to the color of the light, so change this to a light yellow.
- **Shadow**. Check this option if you want the light to cast shadows. We'll do this for our sample.
- **Shadow transparency**. This gives transparency to the shadows. The value 0 gives completely black shadows, 1 results in completely transparent shadows, and every value in between generates a level of gray tinted shadow. We are using 0,5 in our sample file.

Now render the scene again; you will see that you get more or less the same result (Figure 3.105).

3.4.2.3 Light Point Shader

The Light Point Shader will emit uniform light in all directions. It can take into account attenuation, based upon the distance from the light source. Open the file **shader_light_point.max** and render the scene (Figure 3.106).

The results are as expected. In this scene, we have used a Target Spot to light the entire scene.

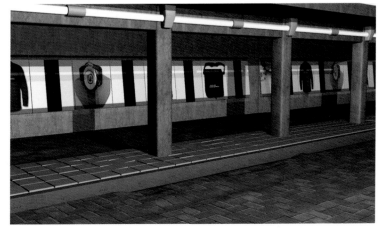

Figure 3.105

Figure 3.106

Figure 3.107

Now select this light source and open the Modify panel. Look for the mental ray Light shader rollout and open it (Figure 3.107).

Check the Enable option. Then click on the None field for the Light shader option, and the Material/Map Browser will open (Figure 3.108).

Choose the Light Point shader. Once this is assigned, you need to bring up the parameters of this option. For this,

Figure 3.108

Figure 3.109

The Light shader settings are now adjusting the light source, so we will make the following changes:

- **Color**. This refers to the color of the light, so change this to a light yellow.
- **Shadow**. When this option is on, shadows will be generated. We turn this option on for our scene.
- **Shadow transparency**. This gives the ability to make the shadows more or less transparent. The value 0 gives completely black shadows, 1 results in completely transparent shadows, and every value in between generates a level of gray tinted shadow. We are using 0,5 in our sample file.

Now render the scene again (Figure 3.111).

drag and drop the shader into an empty slot inside the Material Editor (Figure 3.109).

Make sure you select the Instance option so that you can modify the parameters in the Material Editor and the final rendering (Figure 3.110).

Figure 3.110

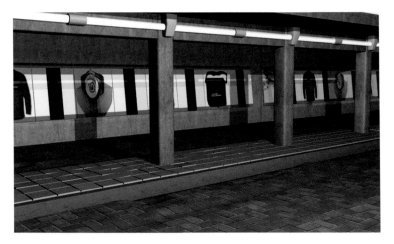

Figure 3.111

Attenuation is the effect of light diminishing over a distance. Check the Attenuation option. *Start* is the beginning point of the attenuation effect. Place this value at 0 so that the attenuation will start immediately. *Stop* signals the end of the attenuation effect. Put this value to 1300, which means that the light will be completely off at this distance from the source. Render the scene to see the result (Figure 3.112).

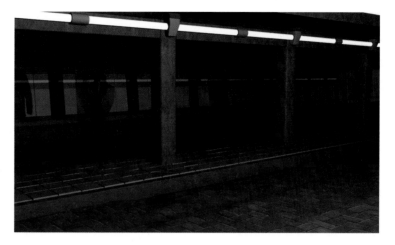

Figure 3.112

3.4.2.4 Light Spot Shader

The Light Spot shader is comparable to the Point Light shader. However, there is one extra option that controls attenuation based upon the direction of the light source. Open the file **shader_light_spot.max** and render the scene (Figure 3.113).

A normal rendering result occurs, with a standard spot for the lighting with a small falloff value. Select this light and open the Modify panel. Then look for the mental ray Light shader rollout and open it (Figure 3.114).

Check the option Enable. Click on the None field for the Light shader option. The Material/Map Browser will now open (Figure 3.115).

Select the Light Spot shader. Once this is selected, you need to drag and drop it into an

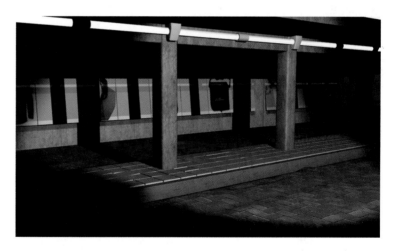

Figure 3.113

Figure 3.114

Figure 3.115

Figure 3.116

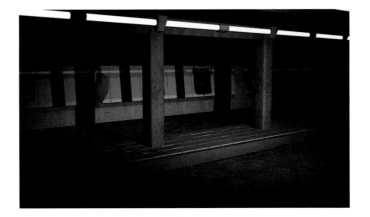

Figure 3.117

empty sample slot inside the Material Editor to get the parameters available of this shader (Figure 3.116).

Make sure that you select the Instance option so that you can change the parameters and ensure they're adjusting the shader we are using. The parameters will then become available inside the Material Editor (Figure 3.117).

We will make the following changes to the settings to the shader:

- **Color**. This refers to the color of the light, so change this to a light yellow.
- **Shadow**. When this option is on, shadows will be generated. Check it for this sample.
- **Shadow transparency**. This allows you to add transparency to your shadows. The value 0 gives completely black shadows, 1 results in completely transparent shadows, and every value in between generates a level of gray tinted shadow. We used 0,5 for this sample. Change the Falloff Angle (grad) option from 1 to 0 and render the scene (Figure 3.118).

The difference between this and the first rendering is that the hotspot/falloff effect

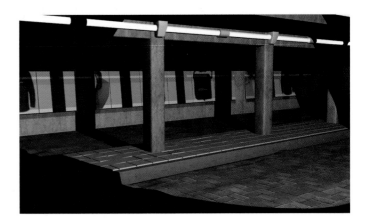

Figure 3.118

Figure 3.119

has gone. There is a very hard edge between light and shadows. The Falloff Angle option is responsible for the attenuation effect in this direction. Change it back to 1 and render the scene again (Figure 3.119).

Figure 3.120

Now check on the Attenuation option so that we can start using attenuation inside the rendering for the distance the light travels. Set the Start value at 0 so the attenuation will start directly at the light source. Change the Stop value to 1200 and render the scene again (Figure 3.120).

This is the final result with attenuation in two directions, based upon light distance and light direction.

Chapter 4
mental ray and Materials

4.1 Introduction

In this chapter, we will talk about the various mental ray materials that are available inside 3ds Max once mental ray is the active rendering engine. As mentioned before, it is not necessary to use these materials, but it is advisable if you want to take full advantage of all of mental ray's rendering capabilities.

mental ray can handle, with a few exceptions, most of the existing materials that are common to 3ds Max. If a material is not supported, mental ray will simply render the material type as black or white, so it is easy to spot. An overview of what is and isn't supported is provided in the Help file that comes with 3ds Max.

mental ray materials only work when mental ray is the rendering engine; they do not work with scanline renderer. Once you start using these materials, you are forced to continue using mental ray. There is no option to revert back to scanline, unless you start over.

There are nine mental ray—specific materials available. You can find them inside the Material/Map Browser, where they are recognizable as yellow spheres in front of the material type. The regular 3ds Max material types have blue spheres (Figure 4.1).

Of this list, the most simple mental ray–specific materials to use are those that became available with this latest release of 3ds Max and mental ray. They are the Arch & Design material and the Car Paint materials. They are a lot easier to use and understand than the other materials, with a more relatable set of options. We will start with these when we discuss the materials individually. Their use is more similar to the way we have been working in the past than the use of other mental ray materials, as you will see during the course of this chapter.

Figure 4.1

Behind the Glass and the DGS materials, you can see the name *physics phen* between brackets. The abbreviation *phen* means *phenomenon*. In mental ray language, this means a combination of shaders or a Shader Tree. All of these shaders combined make up a physically accurate description of the material for the object. Actually, the Glass and DGS materials are derived from the mental ray material. The mental ray material can also create Glass and a DGS material, but you need to apply the shaders required manually; in physics phen, this has already been programmed for you.

The SSS materials are also phenomena based. They are followed by the abbreviation *mi*, which stands for *mental images*, the name of the manufacturer of mental ray. The Subsurface Scattering (SSS) materials are useful, especially for modeling skin and other organic materials whose appearance depends on more than one layer of light scattering.

Let's get started with the mental ray materials. First, we'll discuss the new ones, Arch & Design and Car Paint. Then, we will move on to the mental ray material and the associated DGS and Glass materials. The final group will be the Subsurface Scattering materials. Some sample files will assist in understanding both the content of what is provided and what can be done.

4.2 Arch & Design Material
4.2.1 Introduction

The first material we will cover is the Arch & Design material, which is new with this release of 3ds Max and mental ray. This is actually the most important material we will discuss. It makes life a lot easier and mental ray much more accessible for the average user. In fact, it replaces the DGS and Glass materials, which we will discuss later in this chapter. It also has a number of built-in effects, which, in the "old days," could only be created by the use of dedicated shaders or by constructing complex Shader Trees.

Although most of the shading effects that can be achieved with this new Arch & Design material could already be achieved in previous versions of the software by creating a large complicated network of shaders, this was only an option for more advanced users. Now, everyone can get the quality they are after by using this new material, without being an expert in building complicated shader structures. Internally, this complexity is being handled for you since the Arch & Design material is one big piece of code that presents all these variables through a user interface that is understandable by everyone, even those without a deep knowledge of shaders. The Arch & Design material can reuse data that is already calculated elsewhere, and it also cross-references data within the shader, which is difficult to manage in a multishader network.

Arch & Design material is designed to support most of the materials that are used inside the architectural and product design environment. It supports different kinds of materials, such as wood, metal, and glass. It is specifically tuned for fast glossy reflections and refractions and high-quality glass. These are the most important tasks that it replaces from the old DGS and Glass materials.

Before we start using this new and exciting material, there are some fundamental things you should know to get the most out of this material in your daily work. The important fundamentals for using Arch & Design material at its best are as follows:

- Since the Arch & Design material, by definition, attempts to be physically correct, it produces a high dynamic output range. How "good" the material looks on the screen depends, therefore, on how the mapping of

colors inside the renderer is done before they are displayed. A true linear color space is calculated inside the renderer, where each value represents the actual light energy. A normal monitor doesn't have a linear color space, so we need a tool to help us put the colors from the render engine correctly to the screen. Therefore, although it is not mandatory, it is highly recommended that you use the 3ds Max Logarithmic Exposure control, which controls this process of tone mapping from the renderer to the computer screen. If you don't like the Exposure control option, use the gamma correction — but never use them together.

- Since the Arch & Design material is designed to be used inside a realistic lighting environment with direct and indirect illumination, you should use it in combination with Final Gather and Global Illumination, or at least Final Gather, to get the best results. Whenever you use an environment for your reflections, make sure that this environment is also used to light the scene through final gathering. In 3ds Max, this can be achieved by adding a skylight (or mr Sky with the Daylight system) that has been set to use the scene environment in its settings.

- Whenever you work with the Arch & Design material in combination with Global Illumination, use the photometric lights from 3ds Max. All these lights are guaranteed to have their photon energy in sync with their direct light. It is built in so you don't have to worry about this anymore. If you do not use photometric lights, the Arch & Design material will not work properly. The use of photometric lights does not pertain to Final Gather since this technique is only concerned with the transport of light from one surface to the next, not with the transport of light from the light source to the surface, as with Global Illumination.

Now that you know the important ground rules, it is time to start working with this material. Open the file **featuresroom.max**. All of the following images I will show you are made inside this room. If you select the camera that has the name of the settings we are playing with, you can render the scene yourself at any time. You can also check the material settings in the Material Editor for the different objects in the scene.

We will start by looking at the material from a features point of view.

Conserving Energy

One of the most important features is the conservation of energy. This means that if you take the Diffuse, Reflectivity, and Refraction values together, the total value always has to be equal to or smaller than 1, as it is in real life. The Arch & Design material uses these three components for its shading model. If the material didn't follow this rule, you would be creating energy in your scene. If, for example, you increase the Transparency value, the Diffuse level must be decreased. This is clearly illustrated in the next image **(camera_diffuse_transparency)**. (Figure 4.2)

Figure 4.2 *Energy conserving in action, increasing transparency at the cost of diffuse information*

The following rules are being adhered to:

- The Transparency value takes energy from the Diffuse value. So, when we have 100% transparency, there is no diffusion at all.
- The Reflectivity value takes energy from the Diffuse and the Transparency values. So, when we have a 100% reflectivity, no diffusion and no transparency are present.
- Translucency is a kind of transparency, and the Translucency Weight defines the percentages of transparency and translucency.

View Angle–Dependent Reflectivity and Reflectivity Settings

For a lot of materials in real life, the reflectivity of their surface is dependent on the viewing angle. Obvious examples are water and glass, but there are more materials that behave in that way — just think of varnished wood and plastics. The term used for this is *BRDF*, which means Bidirectional Reflectance Distribution Function. This is what mental ray uses to define how much a material reflects when viewed from various angles.

The Arch & Design material allows this effect to be defined by the Index of Refraction, which is used by glass and water. A manual setting is also available (BRDF cameras) (Figures 4.3–4.8).

Figures 4.3, 4.4, 4.5, 4.6 *View dependent reflectivity of the reflection of the train on the floor*

Figures 4.7 & 4.8 *View dependent reflectivity of the reflection of the train on the floor*

The "old Max users" among us know that the view angle–dependent reflectivity used to be achieved by using a Falloff map. But with the new Arch & Design material, falloff is built in.

The final surface reflectivity in the real world is caused by the sum of the diffuse effect, the actual reflections, and the specular highlights that simulate the scattering of light sources. In the real world, "highlights" are just (glossy) reflections of the light sources. In computer graphics, it's more efficient to treat these three elements separately, which is why in older materials, such as the standard material, there is a separate setting for each. With the Arch & Design material, this is not the case. To maintain physical accuracy, the Arch & Design material automatically keeps "highlight" intensity, glossiness, anisotropy, etc., in sync with the intensity, glossiness, and anisotropy of reflections; therefore, there is no need for separate controls as both are driven by the reflectivity settings. So, again, this is built in with this new material.

Transparency, Translucency, and Cutout

The Arch & Design material supports transparency, as well as translucency. Translucency is handled as a special case of transparency, and there must be at least a small amount of transparency to create translucency. The amount of translucency is controlled through a weight factor that defines the shift from transparency to translucency.

The Arch & Design material's primary goal is to support thinner materials such as curtains and paper, where it allows the shading of the reverse side of the object to "bleed" through. The Arch & Design translucency is not designed to replace the SSS shaders and materials, but it is a simplification of their translucency effects. With thicker surfaces, translucency is only concerned with the transportation of light from the back of the object to the front.

The transparency or translucency can simulate objects either as solid or thin walled. This is a tremendous time saver in modeling as well as in rendering time. If

Figure 4.9 *Sample of the cutout option*

all objects were treated as solids at all times, for example, each window in your scene would have to be modeled as two faces—an entry surface and an exit surface (Figure 4.9).

The cutout method gives the ability to use an opacity channel for creating geometry based on mapping. This is not a true "physical" transparency, of course.

Special Effects: Round Corners, and Built-In Ambient Occlusion

The Arch & Design material can create an illusion of round corners at render time for geometry that has not been modeled in that way. The function is not a displacement process but merely a shading effect (like bump mapping), and is best suited for straight edges and simple geometry, not advanced, highly curved geometry (Figures 4.10 and 4.11).

Simulating rounded corners speeds up the modeling process because you no longer need to establish these round corners yourself by filleting and chamfering your geometry.

The Arch & Design has Ambient Occlusion built in, so you can use this material to emulate the look of true global illumination. Although the built-in ambient occlusion can be used for adding an omnipresent ambient light, its main purpose is to improve details in the existing indirect lighting methods. Ambient Occlusion minimizes the illusion of "floating" objects that have lost their contact shadows. It also gives you the option to add detail to a fairly low indirect illumination calculation, keeping the render time as fast as possible but with a good detailed result (Figures 4.12 and 4.13).

Figures 4.10 & 4.11 *The difference between no rounded corners (left) and rounded corners (right)*

Figures 4.12 & 4.13 *Without (left) ambient occlusion and with (right) ambient occlusion*

Performance

Finally, perhaps the best feature of them all—Arch & Design material has great performance. It uses not only a smart and understandable user interface but also smart internal optimizations and shading techniques. For example, the glossy reflections and refractions are created by importance-based sampling techniques and other internal optimizations to accelerate renderings. And isn't that what we all want? Faster results without loss of quality?

4.2.2 User Interface

Let's look at the user interface, now that we have a better understanding of how it's all supposed to work. We know most of the major features by name, so it should be fairly easy to understand what the settings are all about.

Figure 4.14 *All rollouts of the Arch & Design material*

We'll continue using the scene we have been using in the previous sections, so the next options also can be previewed by picking cameras with the same name as the feature. We will now start with looking at parameters in the user interface of the material, so check a material in the Material Editor; it is not important which material you open. An Arch & Design material has a total of eight rollouts (Figure 4.14).

Open the first material you see in the Material Editor and have a look at the different rollouts available. The first one is the templates rollout, which is pretty easy to use (Figure 4.15).

Figure 4.15

On the right, you have a drop-down list with all the available presets in 3ds Max for the Arch & Design material. On the left, there is a short explanation of what each preset is all about (Figure 4.16).

The previous image gives you a nice overview of the different templates that are available with this new release. (This image is not in our scene but used a separate scene.)

Figure 4.16 *Overview of different preset Arch & Design materials*

Depending on the preset you choose, there will be settings displayed in the Main Materials Parameters rollout, either with or without map slots (Figure 4.17).

The first group in the Main Materials Parameters rollout is the Diffuse group. It gives you the option to introduce a level and color for the Diffuse component. Remember that

Figure 4.17

the final color for the object will also be influenced by the next groups, reflectivity and transparency, since the material is energy conserving (Figure 4.18).

As a point of interest, the material uses the Oren-Nayer shading model. This means that when the roughness factor is 0, it is identical to the Lambertian shading. As soon as you set a higher roughness value, your material will be adjusted to resemble a more powdered or matte look.

The second group is the reflection group (Figure 4.19). Again, there are value and color options for the reflectivity. These two options combined define the level of the reflection and the intensity of the specular highlight. Remember that I mentioned that one of the features of the Arch & Design material is that reflectivity is dependent on the angle at which the material is viewed. The value in this part of the interface is the maximum value since it is adjusted by the BRDF curve settings or Index of Refraction value, depending on which value the material uses.

The Reflection Glossiness parameter defines the surface "glossiness," ranging from 0 (a diffusely reflective surface) to 1 (a perfect mirror). (Figure 4.20)

Figure 4.18 *Increased roughness (left to right) gives a more matte look*

Figure 4.19

Figure 4.20 *Increased reflection glossiness value from left to right*

With the Glossy samples value, you define the quality by adjusting the number of rays shot to create the glossy reflection. Lower values are faster in rendering, of course, but are also lower in quality. If the Glossiness value is set to 1, the Samples option will not be available. A Glossiness value of 1 is a perfect mirror, so there is no use shooting more than one reflection ray. Similarly, the same applies if the sample value is set to 0; this means that there are no reflections, so again only one ray will be shot, regardless of the value inside the Glossiness option.

Finally, there are the last three checkboxes on the right, the first one being the Fast (interpolate) option. For a smooth result, glossy reflections need to trace multiple rays, which is an inefficient way to calculate and render.

The Fast (interpolate) option is designed to speed up this process. It uses a special smoothing algorithm that allows rays to be reused and smoothed. The result of using this option is an improvement in speed and smoother glossy reflections, but at the cost of accuracy.

The other speed-improving option is the Highlights plus FG option. When this is enabled, no actual rays are traced; only the highlights are shown and the soft reflection that is emulated by using the Final Gather technique. Of course, this trick cannot be used for highly reflective surfaces, where you need true reflections. But for all less reflective surfaces, this option can be a great time saver. This technique adds essentially no render time, even when the emulated surface is highly reflective. Specifically, this option can be useful for materials with weak reflections or very blurred glossy reflections.

The last option is the Metal material checkbox, which is used when you need to influence the color of the reflection based upon the material base color, a specific attribute for metal materials. If this option is enabled, the Diffuse Color parameter defines the color for the reflections and the Reflectivity value defines how the diffuse and glossy reflections will be mixed. When Metal is disabled, the normal Maximum situation occurs, where the surrounding objects that are being reflected in the (nonmetal) object are not influenced by the base color of this (nonmetal) object.

Figure 4.21

Now we will move on to the Refraction group, where the first option is the Transparency (Figure 4.21). Transparency can have a value plus a color, where the value defines the level of refractions and the Color option defines the color. This Color option is useful when you want to create colored glass, for instance. Again, the value you define for the transparency is the maximum value since it is also influenced by the BRDF curve, because the Arch & Design material uses the energy-conserving techniques (Figure 4.22).

Figure 4.22 *Refraction glossiness with increasing glossiness value, and thus transparency, from left to right*

The Glossiness value is responsible for the sharpness of the refraction's transparency. The highest value (1) is completely clear, and the lowest value (0) is extreme blurry transparency. The number of samples is responsible for the accuracy of the blurring effect. You can see the result of this in the previous image. There is also a Fast (interpolate) switch that can be used to create less accurate glossy transparency but that is faster and smoother.

IOR means Index of Refraction, which is a measurement of how much a ray of light "bends" when entering a material. It therefore depends on the type of material. The direction in which the light bends depends on whether the ray is entering or leaving an object. Since the Arch & Design material uses the face normal direction of the surface as the most important indication of whether a ray is entering or leaving, you should always make sure that when modeling refractive objects, the surface normal points in the right direction. Changing the IOR value will give you a different reflectivity for the object since the IOR can be set to influence the BRDF (discussed later in the section on BRDF).

In the Translucency group, you have the option to enable translucency (Figure 4.23). But since translucency is a special kind of transparency, the object must already have a certain amount of transparency; otherwise, turning on the translucency option will have no effect. The Weight option defines the balance of the transparency and the translucency. If the Translucency Weight is 1, all of the transparency is used for translucency and there is no real transparency anymore (Figure 4.24).

Figure 4.23

Remember that translucency is designed to be used with thin objects, such as paper and curtains. It can be used with solid objects, but it is not as accurate as Subsurface Scattering, which we will discuss in detail under "SSS Materials."

Figure 4.24 *Example of increasing thin walled translucency from left to right*

The Anisotropy group is there to create anisotropic reflections and refractions (Figure 4.25). The Anisotropy value defines the ratio between the width and height of the highlights. If this value is 1, there is no anisotropy.

Figure 4.25

The Rotation value defines the amount of rotation, where 0 indicates no rotation and 1 indicates a 360-degree rotation. You can use this option to position your optional texture map. It is important to remember that when you use a map, you must turn off the Blur (set the value to 0) in the bitmap parameters, or you will get artifacts in your rendering. When enabled, the Automatic mode causes the base rotation to follow the object. If it is disabled, the map channel will take over.

Now it's time to move on to the BRDF rollout (Figure 4.26).

Figure 4.26

As a reminder, *BRDF* means Bidirectional Reflectance Distribution Function and is what mental ray uses to define how much a material reflects when seen from various angles. On the right side of this rollout, you will see a representation of this reflection falloff in a small diagram, which shows us a curve for the reflectivity versus the angle we are watching.

This curve is driven by one of the two options on the left side. If the By IOR (fresnel reflections) is enabled, then this curve is defined only by the Index of Refraction of the material. This is known as the fresnel effect. Typical material examples of the fresnel effect are water and glass.

The second option is a manual mode in which you can define your own specific curve: 0 degrees Reflectivity defines the reflectivity for surfaces perpendicular to the viewer, and 90 degrees Reflectivity defines the reflectivity of surfaces parallel to the viewer. The Curve shape parameter defines the falloff of the curve. Usually, with most materials, the 90-degree value can be kept at 1. Metals need a higher value of about 0,8, and many floor materials such as lacquered wood something like 0,1 to 0,3.

Figure 4.27

The next rollout is the Special Effects one (Figure 4.27).

Once you have enabled the Ambient Occlusion (AO), you have two operation methods available. If Use AO as Detail Enhancement for GI/FG is enabled, the ambient occlusion will work as a detail enhancer of the indirect illumination. This type of ambient occlusion is added to the calculated Indirect illumination solution and creates more details. If the Use AO as Detail Enhancer option is disabled, then ambient occlusion works much like the Ambient Occlusion shader we discussed in Chapter 3.

The Samples option defines the amount of grain in the ambient occlusion result since it defines the number of rays and thus affects quality and render time (Figures 4.28 and 4.29).

Figures 4.28 & 4.29 *Without and with ambient occlusion applied to the material*

The Maximum Distance defines the radius within which occluding objects are found. The bigger the radius, the bigger the area covered. But keep in mind that more render time is needed for a bigger area. The Shadow Color option defines the darkness of the shadows created by the ambient occlusion pass. Finally, there is an option to use the global ambient light color or to use your own defined color, if needed.

Figure 4.30

The next special effect is round corners (Figure 4.30). Once turned on, this effect will create rounded corners on straight edges. The effect is intended for straight edges, so rounded edges in geometry will give you problems. It is just a shading effect, so no real displacement is performed. The Fillet radius option defines the amount of the effect. I showed you a sample of this already, so I'll skip it here.

The Advanced Rendering Options rollout is useful for performance increase (Figure 4.31). Both groups have similar settings, so we need to discuss this just once. The Maximum Distance allows you to limit the reflections or refractions to a certain distance, so you can skip objects that are very far away in the scene. The Fade to End

Figure 4.31

Color within the Reflections group makes the reflections fade into this color when it is enabled. When it is disabled, the reflection fades into the environment color.

The Color at Maximum Distance within the refraction group works a little differently. When Maximum Distance is used and Color at Maximum Distance is not used, transparency rays will fade to black, as with the middle object of the next image. Transparency will just completely stop at this distance. However, when Color at Maximum Distance is used, the material calculates physically correct absorption values. At exactly the distance given by Maximum Distance, the refractions will have the color set by Color at Maximum Distance—

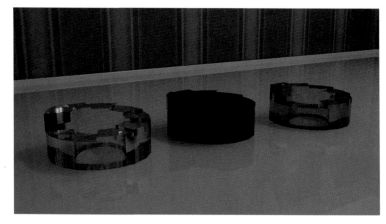

Figure 4.32

but the rays are not limited in reach. At twice the distance, the influence of Color at Maximum Distance is double; at half the distance, the influence is half; and so on. This is shown with the right-hand object in the next image. The left object is without any adjustments (Figure 4.32).

With the Maximum Trace Depth option, you can limit the number of times that rays reflect or refract on a per-material base. With the older version of mental ray, you could only set this for the whole scene, which meant that even though you needed a certain high amount of reflection and refractions for one specific material, you would have to apply this to the whole scene. This added a lot of extra render time, when just a small portion was really needed.

The Cutoff threshold means that reflection and refraction rays are rejected if they contribute less than this threshold value to the final pixel. A value of 0,01 indicates 1%.

The next advanced reflectivity and transparency options contain several checkboxes that control some of the deepest details of the material (Figure 4.33). The Visible Area lights Cause no Highlights option deals with the behavior of

Figure 4.33

visible area lights. This option causes visible area lights to loose their "highlights" and instead only appear as reflections. mental ray area lights can be visible, so this option prevents them from being added twice.

The Skip Reflections on Inside option is enabled by default. Most reflections on the inside of transparent objects are very faint, so they can usually be ignored, thus saving render time.

You have the choice to define whether a glass or translucent object is solid or thin walled. Solid objects create refractions, and thin-walled objects don't (Figure 4.34).

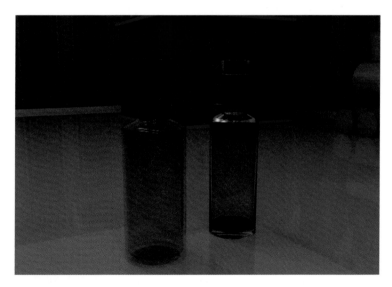

Figure 4.34 *Thin walled and solid object*

You can either select the Refract Light and Generate Caustic effect or the Use Transparent Shadows option for each material. Depending on which one you have chosen, the appropriate shadows will be generated. Transparent Shadows is more than enough for objects like windows. In the previous version of mental ray, the moment you enabled caustics, lights would stop the casting of transparent shadows for all objects, even where this was not needed. Again, this is a big improvement in both speed and performance.

The Back Face Culling checkbox enables a special mode that makes surfaces invisible to the camera when seen from the reverse side. For instance, if you were to use a plane as a wall and put the camera on the reverse side

of the plane, the camera would see right through the plane, although the plane would still cast shadows and bounce photons.

When the Propagate Alpha option is enabled, refractions and other transparency effects will propagate the alpha of the background "through" the transparent object. When Propagate Alpha is disabled, transparent objects will have an opaque alpha.

The FG/GI Multiplier value adjusts the strength of the material's reaction to indirect light. The FG quality is a local multiplier for the number of Final Gather rays shot by the material. When the value for these options is 1, the global values are used.

Figure 4.35

The next rollout deals with glossy reflections and refractions (Figure 4.35). Since they can be interpolated, they can work faster and become smoother. The first drop-down list controls the density of the interpolation grid. The grid is used for the precalculation of the glossy reflections. Interpolation can cause artifacts and loss of details. Both the reflective and the refractive interpolation groups have a Neighboring Points to Look Up option. The grid that is used is made up of points in which the actual data are stored. This option defines how many grid points surrounding the actual rendered point are being used for information gathering. Higher values cause oversmoothing of the reflections.

Figure 4.36

As a result of this smoothing, all reflections are smoothed out, even the reflection starting directly at the point where the object touches the floor, and this effect is not realistic. To prevent this global smoothing from happening, we have the High Detail Distance option to set a sharp reflection at a particular distance from the intersecting surface.

The Special Purpose Map rollout contains a number of mapping options (Figure 4.36). The Bump option can give you a normal bump effect but also a special function. When the option Do Not Apply Bumps to the Diffuse Shading is enabled, the bumps are seen in reflections and highlights but the diffuse shading shows no bumps. It is as if the material's diffuse surface is smooth but covered by a bumpy lacquer coating (Figure 4.37).

Figure 4.37 *Difference regular bump and bump not applied to diffuse clearly visible*

Displacement obviously performs displacement, but you don't have to apply a specific displacement shader anymore; you can use a bitmap image directly inside this slot.

The Cutout is used to apply an opacity map to completely remove parts of objects. We have shown you this already inside the Arch & Design features room scene.

Environment is another obvious option, in that you can apply a specific environment. If no environment is used here, the Global Camera Environment will be used.

The Additional Color/Self Illumination is an input possibility that accepts any kind of shader. The output of this shader is simply added to the Arch & Design material and could, for example, be used for self-illumination purposes.

Finally, there is the General Maps rollout, which is divided into four different groups. All these maps can be accessed directly in the different rollouts we have discussed, or directly here — whichever way you prefer.

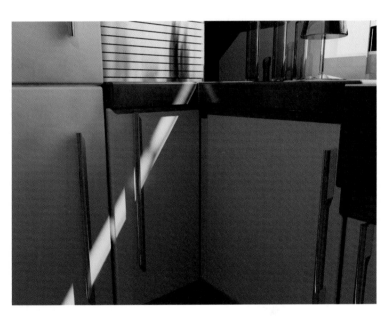

Now it is time to use a real scene. For this purpose, I have prepared a kitchen for you so that we can talk a bit about some common materials such as flooring, ceramic tiles, glass, and (brushed) metals.

The first material is a (glossy) paint or wood material, which, in this case, has been used on the cupboards. Open the file **kitchen_archdesign-mat.max**, which would render as in the next image (Figure 4.38).

Figure 4.38 *A sample of not so glossy paint used on the cupboards*

Let's talk about the characteristics of these types of materials, which would also include flooring, such as linoleum, lacquered wood, and glossy wood.

By default, these materials don't use Index of Refraction, so they need the custom BRDF curve. The best approach is to start out with a 0-degree reflectivity of 0,2 and a 90-degree reflectivity of 1, and apply some texture map to the Diffuse Color if needed. Set Reflectivity at about 0,5 to 0,8.

Then decide how glossy the material is that you want to create. Whether the reflections are clear or blurry, strong, or weak are important considerations. There are rules of thumb that apply for the different cases:

- For clear, fairly strong reflections, keep Reflection Glossiness at 1.
- For slightly blurry but strong reflections, decrease the Reflection Glossiness value.

- For slightly blurry but also very weak reflections, one can often "cheat" by setting a lower Reflection Glossiness value (to get broader highlights) and setting the Reflection Samples value to 0. This shoots only one mirror ray for reflections—but if the reflections are weak, one often can't really tell.

- For medium blurry surfaces, set an even lower Reflection Glossiness and perhaps increase the Reflection Samples. Again, for performance, try Fast (interpolation).

- For extremely blurry surfaces or surfaces with very weak reflections, try using the Highlights plus FG Only mode.

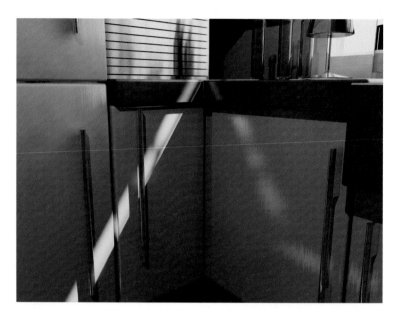

Figure 4.39 *By using glossy sampling more details become available*

For the image we created, we used the kitchen fronts material that is found in the Material Editor. We used a Reflectivity of 0,7, a Glossiness of 0,5, and 0 for the Glossy Samples and turned on the Highlights plus FG Only option, so we did cheat but got a fairly good result, I would say. If we hadn't cheated, by disabling the Highlights plus FG option and using a Glossy Samples level of, let's say, 16, we would have gotten the next image (Figure 4.39).

Now you can see that some extra reflection is being picked up, but this costs you a fair amount of additional rendering time.

Now let's replace this kitchen front material with the preset Satin Varnished Wood. A classic wooden floor could use a Reflection Glossiness of 0,5, a Reflection Samples of 16, a Reflectivity of 0,75, and probably a slight bump map, within which you could enable the Do Not Apply Bump to Diffuse option that I showed you previously. This would

Figure 4.40 *Sample image using the Satin Varnished Wood preset*

be similar to the one we have selected now by choosing the Satin Varnished Wood. Compared with the default settings, we have just changed the number of Glossy Samples from 8 to 16 for the next rendering (Figure 4.40).

Now change our camera view to the camera flooring. (I applied the previous kitchen fronts material to the cupboards before moving on.) Following the same rules as for the previous materials, we will first start creating linoleum. Linoleum could use a Reflectivity with a slightly lower value than the wood, such as 0,6, and a Reflection Glossiness of about 0,4. That's basically it. If you want to render the next image, just unhide the object floor linoleum before rendering (Figure 4.41).

Now I would like to show you some ceramics and stone materials applied to the floor. To get to the next image, hide the floor linoleum object again so that the floor tiles object becomes visible. Normal building bricks, as well as some types of floor tiles, are matte, and if there is any reflection it is very blurry. The typical look of stone can be simulated with the Diffuse Roughness parameter, starting at around 0,5 and higher if needed. Stone has a very low Reflection Glossiness (lower than 0,25), so is ideal to use the use Highlights plus FG Only option to increase performance. Another good idea might be to use a map that varies the Reflection Glossiness value. The Reflectivity would be around 0,5 to 0,6, with By IOR (fresnel reflections) off, 0-degree reflectivity at 0,2, and 90-degree reflectivity at 1 (Figure 4.42).

Figure 4.41 *Sample of flooring with linoleum*

Figure 4.42 *Sample of a stone type of floor*

Another type of floor or wall material is ceramic tiles. Ceramic materials are glazed, so there is a layer of transparent material on top. They follow similar rules to the glossy wood materials I mentioned earlier. Make sure the Index of Refraction option is enabled in this case and set to 1,4; the Reflectivity Color should be 1. For the next image, we used the preset material glazed ceramics, which is a bit over the top for a kitchen but could be appropriate inside a bathroom (Figure 4.43).

Figure 4.43 *Sample of the glazed ceramics preset used on the tiles*

Another material is Metal, both normal and brushed, which happens to be on the stove and the pans. Change the camera view to camera metal (Figure 4.44).

Metals are very reflective, which means they need something to reflect. Having nothing to reflect gives a horrible result, so use some kind of HDRI or make sure you have an environment other than black.

To set up chrome, do not use the IOR option but use the manual curve instead. Change the values to a 0-degree reflectivity of 0,9 and a 90-degree reflectivity of 1. Set Reflectivity to 1. Set Diffuse Color to white and put on the Metal Reflections option so that you will also get an influence of the color for the reflections. This creates an almost completely reflective mate-

Figure 4.44 *Different metals used*

rial. For blurry reflections, tweak the Reflection Glossiness value. We used high reflective settings for the pans. The simple blurred setting is used on the metal back plate of the stove.

To create aluminum, make sure the Metal Reflections option is turned off. If you were now to change the Reflectivity, the result would blend the reflections (based upon the diffuse color) and the normal diffuse shading, both driven by the same color.

Brushed metal is a different story. Tiny grooves are visible that work together in creating anisotropic reflections. Also, the highlight isn't continuous but, rather, broken up in small segments. In order to create realistic brushed metal, we need to simulate these two characteristics. The anisotropic highlights are the easy characteristic; there is a specific rollout for this. By using the rotation option, you can actually make the highlights perpendicular to the grooves, as they are supposed to be. Breaking up the highlight is a bit more complicated but can be achieved by using a bump map, a map that varies the Anisotropy or Reflection Glossiness, or a map that varies the Reflection Color.

Finally, let's consider glass materials (Figure 4.45).

Glass is a dielectric material, so the Index of Refraction must be at value of 1,5. The Diffuse Level to has to be 0, and Reflectivity and Transparency have to be 1. Together, these will give you a completely clear refractive glass.

For a window, you have to enable the Thin Walled option. Open the file **thin_walled_samples.max** and render the scene (Figure 4.46).

All the windows are made by starting off with the Preset Glass Thin Walled. The top row has different colors. To do this, you simply need to adjust the refractive color to the desired one, which means that we actually just set the transparency at the surface of the glass (Figure 4.47).

Figure 4.45 *Glass types*

Figure 4.46 *Different thin walled glass samples*

Figure 4.47 *Refractive color changed to red, making the glass red*

Figure 4.48

Figure 4.49

Figure 4.50

Figure 4.51

What happens is that a ray of light enters the glass where it loses intensity to a darker color. It holds that color when it travels through the glass, and drops again a bit in color when it leaves the glass. This process is illustrated in the next image where the light ray starts as a very light blue and changes color during its travel (Figure 4.48).

Compared with real-life situations, this solution is sufficient for thin-walled objects like our windows.

The middle row in Figure 4.46 has different Translucency Weight Factor values (Figure 4.49).

The bottom row in Figure 4.46 illustrates a frosted type of glass. This is achieved by using the Translucency and changing the Glossiness value (Figure 4.50).

As we discussed, the approach for creating colored glass using the thin-walled type is more than sufficient, but for solid pieces of glass, you need another approach because it is not an accurate representation of reality. The reality looks like this next image (Figure 4.51).

When the ray of light enters the glass, the drop in color is not a straight line. It decreases as it moves along inside the glass, toward the color it reaches when it exits the glass object. This results in color differences between pieces of glass that are actually the same color but have larger dimensions compared to each other, as in real life. In the Arch & Design material, this is accomplished by enabling the Maximum Distance, using the Color at Maximum Distance, and setting the Refractive Color to white (Figure 4.52).

Figure 4.52

Here is a sample image in which we have used this option in the right-hand glass object. This is why this object changes color where the material gets thicker at the sides, and the other one doesn't. The base color for both objects is exactly the same (Figure 4.53).

The strength of the attenuation is such that exactly at the Maximum Distance, the attenuation will match the Color at Maximum Distance. The falloff is exponential, which means that at double Maximum Distance, the effect is that of the Color at Maximum Distance value squared.

Figure 4.53

To correctly render the shadows of a material using this method, one must either use caustics or ensure mental ray is rendering shadows in "segment" shadow mode. If this is not used, the shadow intensity will not take the attenuation through the media into account properly.

Another important thing to know involves the interaction of glass with a liquid. Open the **wine_and_soda_glass.max** file, so we can discuss in detail how you should set this up properly (Figure 4.54).

In this scene, we have created a wineglass with some red wine inside and a glass with some lemonade. I need to explain a bit more about how refraction through multiple surfaces is handled by the Arch & Design mate-

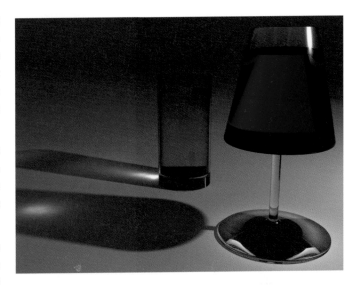

Figure 4.54 *Wine and soda, where the soda shows clearly the air gap*

rial. The most important areas are the transition areas, for example, from the glass to the wine and from the wine to the air. These transition areas are referred to as interfaces.

If you imagine the whole process, it will become clear how this interaction works. A ray of light comes from the surrounding air and enters the glass, where it is refracted by the Index of Refraction of the glass (1,5). Then, it leaves the glass and enters the lemonade, where it uses the IOR of the liquid (1,3), which is different than the IOR of glass—so, it passes an interface.

If we modeled this, we could create the glass as a separate closed surface with the normals pointing toward the inside of the glass. For the lemonade, we could model another closed surface with normals pointing inward. We would position these two closed surfaces a little apart from each other, leaving a small air gap between the glass and lemonade. We have actually created the glass with the lemonade in it in this way. The problem with this

approach is that there is a good chance that you will get an effect called *total internal reflection*, which occurs when light goes from a high IOR to a lower one. Although you have probably never heard of this effect, you must have seen it. Imagine you are looking up to the sky when you are underneath the water in a swimming pool. You would only see the objects above the water in a small circle straight above you; anything below a certain angle only shows a reflection of the pool and things below the surface. Larger differences in IOR enhance this effect. So, with our lemonade glass, there is a good chance that this effect will occur since we have modeled with a small gap between the glass and lemonade object.

To avoid this problem, we need to adjust our modeling. We must stop thinking in terms of glass and liquid objects and think instead in terms of these transition areas. The wine glass has been modeled in this way.

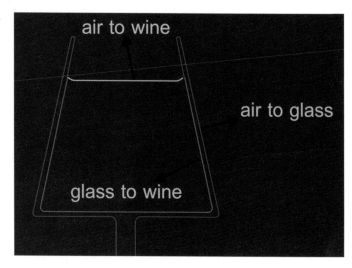

We have three transition areas. The first is from the air to the glass, which covers the area where the air is in direct contact with the glass. This transition surface has an IOR of 1,5 and must have normals facing outward. The second one is from the air to the wine, which is the area where the wine is in direct contact with the air. Normals must face outward, and the IOR is 1,33. Finally, there is the area where the glass and the wine are in direct contact. Normals face inward, and there is an IOR of 0,8 (1,33/1,5) (Figure 4.55).

Figure 4.55 *Explanation on adjusted modeling*

We have adjusted a suitable Maximum Distance and Color at Maximum Distance for the wine- and lemonade-related parts of the model to get the color of the wine and the lemonade.

4.3 Car Paint

The Car Paint material is also one of the new materials that are available with this new release. First, open the file **carpaint.max** and render the scene (Figure 4.56).

Inside our scene, we are using a Fiat 500 model, which is available from www.evermotion.org as one of their free downloads. Note the use of the mr Daylight system in the scene, with the Final Gather active. Initially, a standard material has been applied to the body of the car; this will be

Figure 4.56

replaced with the new Car Paint material.

Open the Material Editor and select the bodywork material to replace this standard material for the Car Paint (Figure 4.57).

Figure 4.57

Don't make any other changes yet; just render the scene (Figure 4.58).

Not bad at all for standard setting, I would say.

It's time to alter the settings again, but first, a short explanation on how this materials works. The material shader consists of several layers that all work together, which is the same as with real car paint (Figure 4.59).

First, there is the body of the car. On top of this is a pigment layer with or without metal flakes inside. On top of that is a clear coat layer. The light shines and creates the clear coat and flake specularity plus the pigment diffusion. The surrounding creates the flake and clear coat reflection. Together these make up the car paint.

Open the Material Editor. Consider the car paint diagram. On the actual bodywork of the car, there is a thin

Figure 4.58 *Result of the default car paint material*

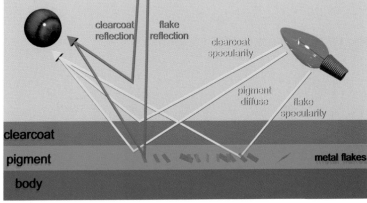

Figure 4.59 *The basic principle of the car paint material*

layer of pigment. In the interface, this is the Diffuse Coloring rollout (Figure 4.60).

The options inside this rollout all make up the color of the car as it is perceived, taking into account a color shift depending on the viewing angle and the incident angle of the incoming light.

Figure 4.60 *The diffuse coloring rollout*

The first setting is the Ambient/ Extra Light option. The addition of Extra Light is important because this is not an ambient parameter as you are used to. The color is actually influenced by the other Diffuse Color components and represents more of the incoming light than the ambient color. Since the effect is very small, we have not enclosed any test images.

The Base color and the Light Facing color are conceptually easy to understand. Together (actually with the edge color), they make up the actual color of the car as we perceive it. Base color is

Figure 4.61 *Result with a red base and a blue light facing color*

the basic color of the car. The Light Facing color is mixed with the Base color at the parts of the car that face the light; this is why there is a slight color difference in our first rendering in the colorization of the car. In the next rendering, I changed these colors to red for the Base color and blue for the Light Facing color, creating a purple color as a result on the light facing parts. Toward the parts where the viewing angle becomes bigger, you can see that the overall color gets darker, which is the influence of the edge color (Figure 4.61).

For the edge-related options, two extremes were set in the following images: one with the lowest possible value of 0,1 and one with a value of 10, which is the highest useful value (although you could go up to 20) (Figures 4.62 and 4.63).

Figure 4.62 *Edge bias = 0,1 / result of changing edge bias setting*

Figure 4.63 *Edge bias = 10 / result of changing edge bias setting*

The edge color is the color seen at glancing angles, which tend to make the color darker. The Edge Bias option defines the falloff of the color toward the edges. The image with the low Edge Bias value shows that the overall color of the car has leaned toward the Base color and looks very unrealistic. All the black (the edge color) is more

or less removed because this low a value essentially turns the effect off. In the image with the high Bias value, the Base color is almost gone. It is virtually replaced by the Edge color and the Light Facing color in places where we are looking at the car's bodywork from an angle. Before moving on, return the Edge Bias value to 1.

The Light Facing Color Bias works in the same manner as the Edge Bias, but it also uses the Light Facing color. This is the color of the area facing the light source. The useful range for this bias is also approximately 0,1 to 10 (although we used 20 this time). The low value turns the effect off, just as with Edge Bias. Two images follow; one shows the result with no bias, and the other one shows the maximum amount (Figures 4.64 and 4.65).

Figure 4.64 *Light facing color bias = 0,1 / result of changing light facing bias*

Figure 4.65 *Light facing color bias = 20 / result of changing light facing bias*

The low value makes the blue come up inside the red since this bias setting determines the falloff rate of the color toward the light. The low value makes it extremely wide. The right-hand image has a narrower colored region for the part of the car facing the light. Before moving on, return the Light Facing Color Bias value to 8.

The last settings to discuss are Diffuse Weight and Diffuse Bias. The weight factor determines the overall level of the Diffuse Color components (Figures 4.66 and 4.67).

Figure 4.66 *Diffuse Weight = 0 / result of changing diffuse weight*

Figure 4.67 *Diffuse Weight = 5 / result of changing diffuse weight*

The left image has basically no Diffuse Color components remaining; however, when it is turned up to 5, the Color components are back again. Change the Diffuse Weight value to 1 before moving on to the final option, the Diffuse Bias.

Diffuse Bias causes a shift in the falloff of the diffuse shading. Again, two images follow with setting extremes, to demonstrate the influence of this parameter (Figures 4.68 and 4.69).

Figure 4.68 *Diffuse Bias = 0,1 / result of changing diffuse bias* **Figure 4.69** *Diffuse Bias = 10 / result of changing diffuse bias*

Low Bias values cause a flattening of the diffuse peak; higher values cause the diffuse peak to move toward the light source.

Before moving on to the next rollout, load a new fresh Car Paint material over the one just used. Everything should be reset to the default values for the Diffuse Color components.

The second part of the interface relates to the same layer of paint but involves the tiny metal flakes. The flakes are responsible for the typical sheen of metallic paint, where the flakes reflect the light and can be seen in clear daylight since they reflect the light directly to the eye of the person watching the car (Figure 4.70).

Change to the Camera flakes view in any Viewport and render the scene, to confirm starting with the default settings. The following view is a close-up of the fender (Figure 4.71).

Figure 4.70 *The flakes rollout*

The small white dots are the flakes. The color (actually the reflectivity) of the flakes is set by default to white since this is usually the case in real life. The weight factor is a multiplier factor for this color.

In reality, the flakes are actually small metal particles. To achieve this effect in 3d, the flakes must create ray-traced reflections, which are controlled by the next option: Flake Reflection. By default, this option is off since the value is set to 0. Because these particles are so small, the result is very subtle and a value of 0,1 is more than enough.

In this next rendering, I have used a yellow for the flakes with a Weight Factor value of 2 and a Flake Density value of 3 (Figure 4.72).

The Flake Specular exponent controls the Phong Specular exponent for the flakes, which means that if we were to increase the Flake Specular exponent setting, you would see smaller regions of the flakes. Bigger ones would be seen if we decreased this value, as is shown clearly in the next set of images (Figures 4.73 and 4.74).

Since flakes are tiny metal particles, it is important to realize that using flakes could cause problems in the rendering in two ways. First, they add unnecessary calculation time because they will not be seen in certain parts of the rendering, even though they are still being calculated. The second problem is jittering artifacts in animations because the flakes can easily be smaller than a pixel. The Flake Decay option makes sure that the flakes fade out when these things could happen.

Figure 4.71 *Close up view with evident flakes*

Figure 4.72 *Yellow flakes with bigger weight and size*

Figure 4.73 *Flake Specular exponent = 15 / result of changing flake specular value*

Figure 4.74 *Flake Specular exponent = 75 / result of changing flake specular value*

Note that the default value means no decay, so keep this in mind. The default settings could cause you to fall into one of the two mentioned traps.

The final options control the flakes' Strength and Scale values. The Strength factor controls the orientation of the flakes, and the Scale factor, the size of the flakes. The flakes inside the Car Paint material are a kind of procedural mapping. Their size can be influenced if the entire model were to be scaled, for instance.

In this next image, the Strength value was set to 1, more or less the maximum useful variation in the orientation of the flakes. The Scale value was also set to 1, introducing much bigger flakes, which are actually way too big for this small car. (Before you render, set the Flake Specular exponent back to 45.) (Figure 4.75)

Figure 4.75 *Big flakes*

The top layer in the diagram is the clear coat layer of the paint. It has two rollouts: one for the specularity and one for the reflectivity. These two parameters represent the visual quality of the car paint. The clear coat has an obvious fresnel effect by default, reflecting more and more light when the angle becomes increasingly larger. Most of these options work basically the same way as the other rollout options, but it is important to realize that the effects are very subtle. Reload a new Car Paint material as in the previous exercise; then scroll to the Specular Reflections rollout (Figure 4.76).

If we look at the first rollout, we can see that we're able to define specular colors 1 and 2. The other two options that go with the colors, Weight and Exponent, work in the same way as the comparable options for the flakes, previously discussed.

The option Glazed Specularity enables a special mode on the primary specular highlight called glazing. It simply makes the surface appear more polished and shiny. This option is good for representing a brand new car still inside the showroom with a lot of wax. For cars that are a bit older, turn Glazed Specularity off to get a more realistic look.

Figure 4.76 *Specular reflections rollout*

Figure 4.77 *Reflectivity rollout*

For the reflectivity rollout, again there is a Color option, an Edge factor; Weight is also there (Figure 4.77). For both the Edge and the Facing Reflection weight factors, the default values are the most suitable ones. Car paint can be glossy, but since they are almost like mirrors, these optional settings should be kept low for a more realistic look.

Finally, there is one other optional layer, which is user dependable, as in reality—the amount of dirt that on the car (Figure 4.78).

Figure 4.78 *Dirty layer rollout*

The Dirt Color is the color of the marks of dirt. Adjust this depending on whether the car is dirty. The Dirt Weight controls the amount of dirt. Here it is possible to use a map, for instance, to simulate the typical mud trails one would get when driving on a muddy road. For this last rendering, I put in a standard Splat map inside the Dirt Color component, just to demonstrate the influence of this option. The splat colors are set to white (color 1) and black (color 2). As usual, the black and white information of the mapping stands for the amount of dirt that will be shown. The Dirt Weight has been increased to 0,15.

Figure 4.79 *Basic dirt applied to the car*

Figure 4.80 *Advanced options rollout*

Although it doesn't look realistic, the result illustrates clearly what the Dirt Layer option represents. It is possible to use a bitmap of your own dirt pattern to better the rendering solution.

The final rollout is one for advanced use only (Figure 4.80).

Irradiance Weight sets the influence of indirect light (photons and final gathering) on the surface. Global Weight is a global tuning parameter affecting the entire diffuse, flake, and specular subsystems. It does not effect reflections or dirt. Since these settings are for advanced use only, they are not discussed in this book. We will leave them for the car rendering experts.

4.4 mental ray Material

Until now, we have been using the new materials for this version of mental ray. These materials are pretty intuitive to use, not too hard to understand, and very flexible. We will now start using the older materials that were available prior to this release. They need some explanation if you have no experience working with them.

The origin of all the materials is the mental ray material itself. The others that follow, like Glass and DGS materials, are derived from this one. The mental ray material is much like a toolbox where you can use different kinds of shaders, and shaders inside shaders, to reach the desired result inside the different main components. In fact, all the materials, even the new ones, work in much the same way "under the hood," but the user interface is completely different.

By using the mental ray material, you are binding yourself exclusively to the mental ray renderer. The regular scanline renderer does not know how to handle this material and will not render it. The mental ray material is made up of one main component and 10 optional components. Together these make up the material definition. Open the **mentalray_material.Max** file. I will try to help you understand the logic behind it all with a basic example (Figure 4.81).

Figure 4.81

Inside our scene, we are using objects to which we have assigned standard material definitions you were accustomed to when working with the scanline render engine. We will now start transforming these standard materials into mental ray material.

First, open the Material Editor and select an empty material slot. Change from standard material to a mental ray material and have a look at the options displayed (Figure 4.82).

There are two rollouts, Material shaders and Advanced shaders. How a mental ray material is composed is different from the way "normal" materials are made. The principle, however, is the same. mental ray uses different components to make up the complete material definition. Within the mental ray material, you have four main groups with a total of 10 components that can be influenced. Since mental ray calculates primarily the response to light, it is logical that some of the names of the components make you think of light.

Figure 4.82

168

The Surface component in the Basic Shaders group of the Material Shaders rollout is mandatory. All the others are optional. If you don't put a shader inside this Surface component, the material will stay invisible for the mental ray renderer. Each component has its own influence on the total material definition, and this influence can be modified using different shaders. The Surface shader will only take direct light into account, and nothing else. If you need a specific shadow to be displayed, you must add a shader to this component. If you want to calculate correctly the use of indirect illumination, you need to specify how the photons should react on the surface or inside the volume of the object. And, finally, if you want to add bumping, displacement, and so on, you must put a shader inside the Extended shader options to make this happen during rendering.

Figure 4.83

We will start by turning the back wall material (which is just plain red) into a mental ray material. First, click on the None button filed behind the Surface component, and select from the Material/Map Browser the shader you want to use. In this specific case, we need the DGS shader. This shader is a so-called Shader Tree that makes up a physically accurate surface of a material (Figure 4.83).

DGS means Diffuse, Glossy, and Specular, so what we have done is put a shader inside the Surface component that is able to check the direct and ambient lights inside the scene and give us the feedback for the correct values for surface color, surface glossiness, and highlight reflections, based upon the surface orientation and light position inside the scene. This is much like selecting a shader such as blinn, phong, etc. inside the standard material (Figure 4.84).

Figure 4.84 *DGS Material Parameters rollout*

As you can see, there are some other things that this shader can control, such as Transparency and Index of Refraction; it is called a Shader Tree because it holds more than one shader. So, what we need to do is to change the Diffuse color to red and, for now, bring the Shiny value back to a value of 3. Change the Glossy Highlight to black for now. Then assign the material to the back wall and render the scene to see the result (Figure 4.85).

Figure 4.85

We guessed the values we used well—the image is 100% identical. You could make some small adjustments by playing with the settings if you want to, but the principle should be clear.

Now let's move on to the next material, the floor. If you look at this material, it currently has a Tile map in both the Diffuse and Bump channels. So, go back to the Material Editor and create another empty mental ray material. Again, assign to the Surface component the DGS shader. Adjust the Shiny value to 3 and the Glossy Highlight color to black, as you did with the back wall object.

Since we need the material to display the texture of the Tile map, you need to apply a Tile map to the Diffuse color, just as you would with standard materials. Click the small square behind the Diffuse option and select the Tile map from the Material/Map Browser. Note that we used a tiling of 5 in both directions for the Tile map. Now, move back to the top of the material and open the Bump component; we need to add this effect since there is a small bump in the floor. Again, the Material/Map Browser will open, but it will show you only mental ray shaders (Figure 4.86).

Figure 4.86

Of course, we need the Bump shader, which is the little program that will add the desired bump effect. Open it and apply the Tile map inside the Map component (change the tile values to 5 for both directions again) (Figure 4.87).

Figure 4.87

Apply this material to the floor object and render again (Figure 4.88).

And again, we have achieved the same result. I assume that the principle is clear at this point, so I will now give a brief overview of the different components of the mental ray material and their purpose.

The Basic group consists of the Surface and Shadow components. The Surface component should be clear—this one determines how the surface responds to direct illumination. The Shadow component determines how light rays pass through objects. As you know, the shadow created by a transparent object is different than that by a nontransparent object. This component is necessary when the object has some transparency.

Figure 4.88

The next group is the Caustics and GI group. Here photons are important, so that's why we see the Photon and Photon Volume components. The Photon shader determines how the material reacts in indirect illumination (Caustics and/or Global Illumination). The Photon Volume shader determines how photons respond inside an object to indirect illumination. So, if you would like to render a physically correct image using indirect illumination, you must put a shader into one of these components. Quite often, this is the shader with the same name as the one used inside the Surface component.

For the Extended Shaders group, there is the Bump component, which we already seen. The purpose of this component is to introduce bump effects for the material. Displacement can influence the shape of the surface based upon black and white information that is added to this component by actually adding geometry to the object. The Volume shader controls the volume of an object, so it can give you effects such as smoke and mist inside objects. The Environment shader supplies you with an environment for an object independent of the object's real environment. The environment is what surrounds the scene, which is needed when rays do not hit any objects and therefore escape from the scene. In this case, we know which color to return.

The next rollout holds the Contour and Light Map options. Contour shaders give you the option to render hidden line contour renderings. The Light Map shader ensures that the object is being sampled, creating a Light Map. Inside this map, there is information (usually regarding the lighting) about the object that can be reused in rendering to save time. Note that no Light Map shaders are provided inside 3ds Max.

We have talked about different shaders in different components briefly. We will go into details about the different shaders and their effects in Chapter 5, giving you explanations about their purpose and how they work from an options point of view.

I hope you now understand why the new Arch & Design material is such a big step forward. Setting up a realistic material by using mental ray material is much harder and complex to do. It also uses more calculation time during the rendering process. So, go for the Arch & Design material whenever you can; it is the best choice.

4.5 DGS Material

One note before we start with DGS material. The new Arch & Design material has, in fact, replaced the DGS material. I am just showing this to you to be complete. DGS material has some negative effects inside, which can result in beautiful images but at the cost of long render times. I will show you these effects and how to resolve them so that you can experience yourself how this increases the render time. My advice is to use the new Arch & Design material when working with 3ds Max 9 and mental ray 3.5.

So, let's meet the DGS material. *DGS* means Diffuse, Glossy, and Specular. This material is a so-called phenomenon (or a Shader Tree). You can obtain a physically accurate surface just by applying DGS material directly to the object. You should not mistake this material for the shader of the same name, which we used in the previous sample. The major difference is that the material is already prepared to take into account direct and indirect light, whereas the shader is not. If you wanted to create a DGS material by using DGS shaders, you would need one DGS shader inside the Surface component for the interaction with direct light, and one inside the Photon component for the interaction with indirect light. With the DGS material, there is no need to apply this extra shader, as with the mental ray material.

Let's discuss the options for DGS material (Figure 4.89).

Figure 4.89

Figure 4.90

The Diffuse option defines the diffuse color of the material (or, for greater complexity, you can apply a shader to this option), and Glossy Highlight color influences the highlights. Specular works in a slightly different way. The black color actually means that there is no reflection of the surroundings; a white color means there is total reflection of the surroundings, as with a mirror. The Shiny value defines the size of the glossy highlights. Higher values give smaller highlights. The Transparency value sets the transparency of the material: 1 is totally transparent. The Transparency option also influences the reflectivity of the material. The calculation method for this step is 1 minus the value of the transparency. Finally, you can apply Index of Refraction to the material.

Now open the scene **DGSMaterial.max**, which already has DGS material applied to most of the elements. There are some important things to know when you start using this material, so I have prepared this scene to show you some common problems. Let's first render the scene and see what happens if you don't change anything to the default mental ray settings (Figure 4.90).

This noise occurs because we are using a light source inside our scene and glossy reflections are used inside the different DGS materials. Since DGS material always puts in a specular highlight, the pattern you see is the specular reflection of the light, which occurs even if you turn this option off within the light itself. This graininess is a common problem when using a DGS material.

The graininess is a result of the sampling we are using. The DGS material doesn't do any built-in multisampling, so it sticks to the maximum of the settings we are using. This is simply not enough at present, with the default settings of 0,25 and 4 for minimum and maximum values. We need to "pump up" these values. I have adjusted this from the default values to 16 as a minimum and 64 as a maximum setting for the samples per pixel (Figure 4.91).

Figure 4.91

Figure 4.92

Figure 4.93

The disadvantage of this approach is that mental ray will now start using this new sampling setting for each and every object inside the scene, so, basically, the rendering time will increase a lot (Figure 4.92).

In the end, the graininess is gone but the rendering time has gone up tremendously. So, although the DGS material can give a great result, it is not very productive since it needs a relatively large sampling value, which will be applied to everything inside the scene—even to parts and objects that don't have this problem of graininess—since it is a global setting.

Finally, open the Material Editor and have a quick look at the material used for the floor (Figure 4.93).

As you have seen, the DGS materials have just a limited number of components that can be influenced. This means that some parts needed for a proper material definition cannot be added directly into the appropriate channel as with the mental ray material, simply because it is not there. For instance, there is no channel available for Bump, so we need to use a trick to add it here: the Shader List option. This shader gives you the possibility to combine a number of shaders. We used the DGS material and placed a Shader List inside the Diffuse channel. Then, inside the Shader List we added two shaders, one to show us the bitmap we are using in this case and one to create the bump effect we can see inside the final rendering. In Chapter 5, I will show you more about this shader.

4.6 Glass Material

Glass material has some good and bad points, just like the DGS material. Major improvements have been made for creating glass with the new Arch & Design material, which is actually better and faster than Glass material. To give you the best possible overview, we'll explore Glass material, but my advice is to use one of several Glass presets inside the Arch & Design material when you need to use glass inside your rendering.

The Glass material by itself is pretty straightforward. Just select it and apply it to your object, and you're basically set. If you would like to create a Glass material with the mental ray material as base, you need to apply the Dielectric Material shader to both the Surface and Volume components. This is already done inside Glass material, which is also a physical phenomenon, just like the DGS material. One small note of caution: if you are creating glass with the mental ray material, don't make the mistake of using the Glass (Lume) shader inside the mental ray material components, although the name is tempting. This one doesn't create physically correct glass like the Dielectric shader does, although it can give a very good result.

Figure 4.94 *Black spots visible inside the door on the right*

Inside our sample scene (**Glass.max**), we have already applied the Glass material to our object, which is a revolving door. The scene has been prepared to show a common problem you might face when using the Glass material. Just render it and the problem will occur (Figure 4.94).

Tiny dots become visible where there is one glass in front of the other, especially at the right side of the model. We will explain why and solve this in a moment, but first let's take a quick look at the settings for this material. Open the Material Editor and check the Glass material (Figure 4.95).

The settings mean the following:

Figure 4.95 *The Glass material settings*

- **Light Persistence**. This option works in combination with Persistence Distance and influences the percentage of light that is being transmitted by the volume. If you need colored glass, just change the Light Persistence color.
- **Index of Refraction**. Here you define the Index of Refraction. In reality, the IOR is the result of the relative speed with which light travels through the transparent material in relation to the position of the eye. So, this also involves the density of the material. The higher the IOR, the denser the material. If the value is close or equal to 1, there will be no light refraction and you will hardly or will not see the object. The 1.5 value we have used is the IOR for this object.
- **Outside Light Persistence**. This options works in combination with the Persistence Distance and checks how much light is being transmitted on the other side of the material. If the color is set to black, this option has no effect. We'll leave it as is since our object only interacts with the air (so we don't need this option).

- **Index of Refraction (Out)**. Here you define the IOR on the other side of the material. This option is used if you have different types of glass materials inside one a scene (as in our scene in which a wineglass is filled with wine). By default, this setting is set to 0 and thus has no influence. Air is not a 3ds Max object, so there is no need to change this option.
- **Persistence Distance**. This option works together with the (outside) Light Persistence color and has an influence on the percentage of light that is being transmitted by a volume. It is the distance at which the light transmission decreases, based upon the percentage that you indicate by the Light Persistence RGB values. Remember that this option and Outside Persistence need to be changed only when two transparent 3ds Max objects are adjacent, such as wine inside a wineglass.
- **Ignore Normals**. If this option is on, there is no check for light entering or leaving the object based upon the normal direction. This check is instead made based upon the number of times a light ray crosses an object. This option needs to be used with objects that have nonunified normals. Again, we don't need it for any of our materials in this scene.
- **Opaque Alpha**. If this option is off, then a transparent alpha channel is made. This option is only relevant when you are compositing. Since we are not doing this, leave it off for all materials.
- **Phong Coefficient**. At values larger than highlights will be made based upon the Phong algorithm. The value must be set relatively high in order to see the result. For this exercise, we will not use this option.

As you can see, there is no option to add bumps, for instance, so there are limits to Glass material that have been resolved with the new Arch & Design material.

That's it for the settings. Now, let's get back to the problem of the dots. These artifacts are introduced because the glass is 100% transparent, and some reflective rays hit a dark part of the environment and some refractive rays hit the brighter part of the environment. The solution is to use more samples (as we did with the DGS material). Just increase the sample per pixel settings to a minimum of 16 and a maximum of 64, and render again. Of course, the render time will go up, simply because a lot more sampling needs to be done (Figure 4.96).

This result is much better. We have lost the dots, as promised. But in some scenes, you would need an even higher sampling range and, thus, more rendering time, which is already very high considering the lack of complexity in the scene we are using. So, since the Glass material has two major disadvantages, rendering time and the spot problem, let's try something different.

Figure 4.96 *Rendering with higher samples will remove the artifacts*

Let me quickly show you the difference with the new Arch & Design material Glass preset. Just open the Material Editor, select the Glass material, and replace it with the Arch & Design material. Select the Glass (Physical) preset from the template list, and apply it to the glass objects inside the scene (Figure 4.97).

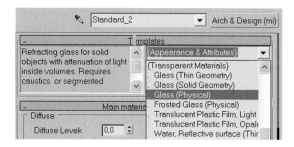

Figure 4.97

Return to the samples setting and make them the default values again—0,25 for minimum and 4 for maximum. Now render. You will see that the spots are no longer present, even with this low sampling and the greatly reduced rendering time (Figure 4.98).

I rest my case. Glass material is good, but Arch & Design is more flexible to use.

Figure 4.98

4.7 SSS Materials

Inside mental ray, a number of SSS materials are available. *SSS* means Subsurface Scattering, so these are defini-tions that apply to materials composed of different layers on top of each other. These layers all contribute to the way light is reflected, adsorbed, and transmitted back to the surface, and all have their own characteristics. Examples of these types of materials are human skin, wax, cheese, and marble. Inside mental ray, four different SSS materials are available:

1. SSS Fast material
2. SSS Fast Skin material
3. SSS Fast Skin material plus Displacement
4. SSS Physical material

We will now start with a number of exercises for these mate-rials. The first one is SSS Fast material.

4.7.1 SSS Fast Material

We will start our Subsurface Scattering material tour with the most simple material, the SSS Fast material. Open the file **SSS_fast_material.max** and render the scene (Figure 4.99).

The SSS Fast material is used whenever there is no need to make an accurate simulation of skin and there is no need to be

Figure 4.99

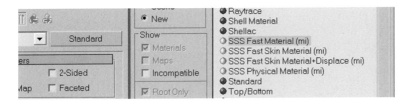

Figure 4.100

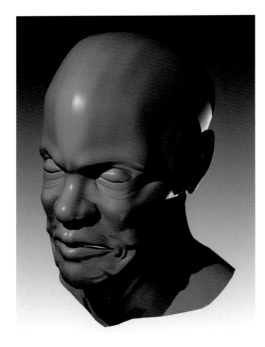

Figure 4.101 *SSS Fast material defaults rendering*

physically accurate. In fact, SSS Fast is usually the best choice since it is much more flexible than the physically correct shaders, which are tough to handle. For now, we have applied a standard material to this head, so we will start by applying the SSS Fast material to the model. For this, open the Material Editor and hit the Standard button; select SSS Fast material from the Material/Map Browser (Figure 4.100).

Don't change anything yet. Render the scene first (Figure 4.101).

As you can see, there is no Subsurface Scattering going on at present, but we will get there. Have a look at the options of this material inside the Material Editor (Figure 4.102).

Figure 4.102 *The different rollouts of the SSS Fast material*

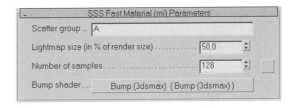

Figure 4.103 *SSS Fast material Parameters rollout*

By default, five rollouts are available for this material. The first rollout is the SSS Fast material parameters (Figure 4.103).

The first option, Scatter group, is generally left unchanged. This would only be relevant if you were to make other SSS materials—the interactions of these materials could cause visible problems.

The same applies to the Lightmap option; leave it as it is. Only increase this value if you get artifacts inside the rendering.

The number of samples is exactly what it suggests. The result is currently most obvious at the ear. If you were to decrease this value, that part would become much blotchier. For the rest of our exercise, we will increase this number to 128.

The Bump option gives you the ability to introduce bump mapping to your SSS material. Remember that Bump only has an influence on the Specular and Diffuse layers of the SSS material. Subsurface Scattering, as the name indicates, happens below the surface; thus, bumps have no influence on the surface itself.

For this example, we select the Bump (3ds Max) field and choose Cellular map inside the Material/Map Browser (Figure 4.104).

Figure 4.104 *Bump shader rollout*

Render the scene to see the effect of the cells (Figure 4.105).

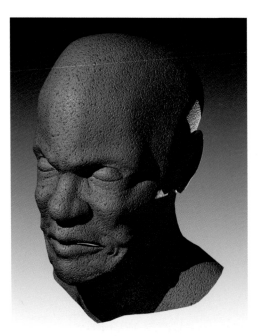

You can see clearly the influence on the Specular component. For the rest of this example, we will not use the Bump option, so make sure you remove the Cellular map before continuing.

The next rollout is Diffuse Subsurface Scattering (Figure 4.106).

Figure 4.105 *Bump influence inside the SSS Fast material* **Figure 4.106** *Diffuse Subsurface Scattering rollout*

This rollout is responsible for the overall coloration of the material we are using. You can see from the different options that there are basically three groups (layers of materials): Unscattered Diffuse, Front Surface Scatter, and Back Surface Scatter. They all have a color and a weight factor, which determines the amount of influence of one on the other layers. For the Front Surface and Back Surface options, there is a radius that is responsible for the spreading of the light inside the material. Finally, for the Back Surface option, there is a depth, which determines how much light passes through.

The Ambient/Extra Light option speaks for itself. This is the best place to use an HDRI light source, for example.

Overall Diffuse Coloration is the best place to apply mappings that have an influence on the diffuse light, such as information for the eyebrows or moles on the skin, in this example. To get an idea of what happens, try the

following: change the Unscattered Diffuse color to full red, the Front Surface Scatter to full green, and the Back Surface Scatter to full yellow. Then render the scene (Figure 4.107).

You can now see well the mixing of the red and green colors, being the first two layers of the material. Since we still do not see any Subsurface Scattering, there is no influence of the yellow color yet. We will adjust this now.

The Subsurface Scattering (in other words, the influence of the yellow) can be introduced by increasing the Back Surface Scatter radius (i.e., 1.000) and the Back Surface Scatter depth (that is, 1.000) of the Back Surface option, giving the next rendering result. The radius increase is responsible for the spreading of the yellow information into the other two colors, making the head greener. The depth is responsible for more yellow on the surface (Figure 4.108).

Now we can see the Subsurface Scattering—just check the ear where the light from the back passes through the material. It is colored slightly yellow. The final color of the head is a combination of the red and green and also

Figure 4.107

some yellow at this point. We could do with some more samples to get the noise out of the ear, but just leave it for now.

Now, you know how to play with these three components to create exactly the effect you would like for your scene. By changing the settings of the different layers, you can achieve any result you like.

The third rollout is Specular Reflection (Figure 4.109).

The Specular color works with black (maximum) and white (minimum) values. Just play with these values to see their results; they are very straightforward. The value of Glossiness defines the size of the glossy highlight. Bigger values create a smaller highlight.

Next, the fourth rollout—the Advanced Options (Figure 4.110).

Figure 4.109 *Specular reflection rollout*

Figure 4.108 *More back surface scatter color influence*

Figure 4.110 *Advanced options rollout*

Lightmap gamma is the gamma curve of the light stored in the lightmap. If this is set to 1, normal (Lambertian) diffuse light is stored. Decreasing this value flattens the curve, so light will spread out toward areas perpendicular to the incoming light. Increasing this value does the opposite. A setting of 0,75 is sufficient in most cases.

Scatter Indirect Illumination takes indirect illumination into account with the scattering process. Usually this doesn't make a big difference, but it does add rendering time.

Since scattering is distance dependent, loading a material designed for a model made in inches will not work on a model whose unit is meters, and vice versa. In this situation, you can use the Scale Conversion factor. Usually you would make a rendering first and check whether you see Subsurface Scattering happening. You would expect this to happen at thin places inside the model, where it is possible for light from the back to shine through the material. If there is no scattering, you could use the Scale Conversion factor to adjust this before starting anything else. In our sample, we used the Scatter Radius and Scatter Depth options instead. If you want to test it with our original sample file, just change the setting to 0,01 for this conversion factor, and you will be able to see Subsurface Scattering happening at the ear.

The Scalar option simply affects all the radii as a divider. We will leave the Scalar option as is for the rest of this exercise. So, if you have an existing model (that is perhaps not made to scale or in real-world units) with the SSS Fast material, and the result has way too much scattering or no scattering at all, play around with Scalar option to get a good starting point. This can be much easier and faster than adjusting the different radius options individually inside the Diffuse Subsurface Scattering rollout (which we will show you later in this sample).

The Scatter Bias option can range between −1 and +1. Negative values favor the back scattering influence, and positive values favor the forward scattering.

The Falloff option handles the shape of the distance falloff along the scatter radius.

Screen Compositing allows the use of what is known in many compositing applications as a screen transfer mode between the layers. It yields a softer, more pleasing result. That's why it is turned on by default.

To conclude this section, I adjusted the settings (**sss_fast_material_final.max** on the DVD) to get of the following rendering (Figure 4.111).

Figure 4.111

4.7.2 SSS Fast Skin Material

Model provided by Aydin Uluc

The next material to discuss is the SSS Fast Skin material. I have created another sample file that you should open and render to get started: **sss_fast_skin_material.max** (Figure 4.112).

First, apply the SSS Fast Skin material to this face. For this, you need to open the Material Editor and create an SSS Fast Skin material. Take an empty material slot and click the Standard button. Select SSS Fast Skin material from the Material/Map Browser (Figure 4.113).

Figure 4.113

Don't change anything yet, but apply the material to the head and render the scene (Figure 4.114).

Figure 4.112

Now we will start adjusting this material. First, have a look at the different rollouts that have become available inside the Material Editor (Figure 4.115).

Just as with the SSS Fast material, SSS Fast Skin material has five rollouts. These are, of course, specific for skin material, but some comparison can be made. The first rollout has exactly the same options as those for SSS Fast material.

Our first step is to set up the basics for the material, making sure that we have some Subsurface Scattering present. The best place to spot this effect is at this guy's ear; we would like to see the typical reddish glow from the light that shines behind him. With the SSS Fast material, we tried the different radii to get the proper setting for the Subsurface Scattering. We will use another approach now. It involves the Scale Conversion factor that is inside the Advance Options rollout (Figure 4.116).

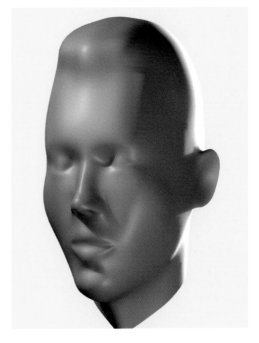

Figure 4.114

Figure 4.116

| SSS Fast Skin Material (mi) Parameters |
| 3-Layer Diffuse Subsurface Scattering |
| 2-Layer Specularity and Reflections |
| Advanced options |
| Shaders |

Figure 4.115

Figure 4.117 *Scale conversion = 0,1*

Figure 4.118 *Scale conversion = 2*

The Scale Conversion factor divides all the radii options in one go. This simply means that if you set it lower, you will get more Subsurface Scattering, and if you set it higher, the scattering will become less. I made two test images to show you how these appear (Figures 4.17 and 4.18).

The effect is clear to see, but both images are completely wrong. The left one has too much scattering, and the

right not enough. For our head, I have chosen a value of 0,5, which I assume to be correct in this specific case since it gives a believable reddish ear (Figure 4.119).

Skin is a complex material. It is made up of different layers, which all contribute to the final effect. Skin scatters light, and so-called subsurface elements (e.g., bones and veins) also have an effect on how the skin is represented. This is why you will find different layers inside the interface, each having settings for how it contributes to the total effect. Also, skin is able to let light that shines from behind pass through.

To continue, we will start with the first rollout, which is exactly the same as the one for the SSS Fast material. We will use 128 as the number of samples from now on (Figure 4.120).

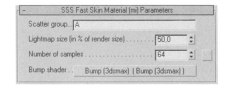

Figure 4.119

Figure 4.120

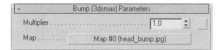

Figure 4.121

For our scene, I have prepared some textures that we will use in our sample, instead of working with colors that we used with the SSS Fast material. This gives me the opportunity to show you where these maps are supposed to go. The first thing is to apply the **head_bump.jpg** image inside the Bump channel. Open the Bump shader that is already applied by default, and load the bump image (Figure 4.121).

Leave the multiplier value as it is, and just render the scene (Figure 4.122).

As with the previous material, the Bump option gives you the ability to introduce bump mapping to your material. Just as we saw with the SSS Fast material, the bumping happens below the surface; thus, bumps have no influence on the surface itself. This means that you will see the bump itself but not the obvious shadows that go with it.

Figure 4.122

The head still looks like wax, so let's move on to the material settings. The second rollout, 3-Layer Diffuse Subsurface Scattering, is mainly responsible for the way the skin looks (Figure 4.123).

Skin is simulated in three layers as follows: (1) a top reflective layer (for specularity and surface nonscattered diffuse reflections), (2) a dual-layer subsurface scattering (simulating both the scattering in the epidermis and the layers below, here collectively named *subdermal*), (3) and scattering from the back side. Each layer has options for color, weight of the color, and radius for the scattering. Mixed together, these create the final result, as in real life. If you now consider all the options, you will easily spot these different layers.

As you saw in the last rendering, the default values give you a reasonable result. We will leave them as they are for now, and start adding the maps to get a more interesting image.

Figure 4.123

If you look at the first part inside the 3-Layer Diffuse Subsurface Scattering rollout, you will see that it focuses on the Diffuse component. If you only have a colored image of this guy's face, then you would put it into the Overall

Diffuse Coloration option. Let's see what happens if you apply the **head_overall_diffuse.jpg** map to this component and render the scene again. I lowered the Bump amount slightly to 0,5 because it was a bit too high with the default setting (Figure 4.124).

Forget about reflection and other things that are still wrong inside the image—the overall look is not that bad. But this is not the preferred way to work. There could be a problem if you have a very dark or black area inside this colored image: you would loose the scattering effect at that place. With this map, the light is multiplied, and, obviously, multiplying black still leaves you with black.

The best thing to do is to apply another kind of map (which I also prepared) and apply this to the Unscattered Diffuse color slot. (Don't forget to remove the colored map we just used since we don't need it anymore). The name of the image to use is **head_unscattered_diffuse.jpg** (Figure 4.125).

Figure 4.124

Although the image we used essentially colorless, we still get a kind of skin color inside the rendering. The reason for this is simple. Have a look at the options again and check out all the different weight and radii settings. The weight controls how much influence each layer has on the other, and the same applies to the radii option. This means that what we see now is a mixture of all the different layers, based upon the present settings of the weight and radii. And where no map is used yet, a mixture of the colors is assigned to these layers. So the color we see now is a mix of the epidermal, subdermal, and back surface colors—as happens in real life. The color of the skin itself it almost white; it is all the other layers that make up the final color as we perceive it.

Now we move on to the next group, the Epidermal Top layer. We have another map for this part, which needs to go into the Epidermal Top layer Scatter color. This map one is the same we first used, but this time it has the name **head_epidermal_top_layer_scatter_color.jpg**. Select this one, apply it to this slot, and render (Figure 4.126).

Figure 4.125

The eyes are now more visible. But why? We have removed the influence of the epidermal color with this map. So, we have taken out some of the color and replaced it with this essentially colorless map.

Now, we could play with the remaining two colors and the weight and radii settings to get the desired skin color, but we will leave them as they are. Also we could alter the Bump value to get a slightly lesser bump, which might look a bit more realistic, but we will also leave this one as is for now. We want to move on and make the skin look better since it still looks like wax. For this, we need to go to the next rollout (Figure 4.127).

The Specularity at present is set to universal. We need to adjust this one by, again, using a prepared map. This one has to be placed into the Overall Specular Weight option and is called **head_specular.jpg**. Render again.

If you are working with a specular map, make sure that it is not too dark because that will remove all the specularity. White information ensures that the specularity shines through; black does the opposite (Figure 4.128).

Although the specularity is still a bit much, we have now made sure that only the typical parts, like the forehead and the nose, are showing the effect. For fine-tuning, we could use the two specular layers that are available. The primary one is

Figure 4.126

Figure 4.128

2-Layer Specularity and Reflections	
Overall specular Weight	1,0
Edge narrowness (higher = narrower)	5,0
Specular Color #1	
Specular Weight #1	0,3
Specular Edge Weight #1	0,8
Shininess #1	5,0
Specular Color #2	
Specular Weight #2	0,3
Specular Edge Weight #2	0,0
Shininess #2	33,0
Reflection Weight	0,0
Reflection Edge Weight	0,0
Reflection glossiness (0 = mirror reflection)	2,0
Only reflect environment	☐
Local environ...	None

Figure 4.127

for broad and soft specular highlights. The second one is narrower, for a detailed sheen. So, if you are creating a guy who is inside a sauna, you should increase the second specular level. We have lowered it a bit to 0,15 to get the next result (Figure 4.129).

One final step could be made—creating some reflections from the outside world. For this, you could use the full ray-traced reflection, which is supported. But you could also simulate the effect by playing with the Reflection Weight and Reflection Edge Weight factors. This introduces the fresnel effect for the reflection, meaning that if you look at the guy in the image head on, there is less reflection, but the reflection increases toward the sides of his face. The ray-traced reflection is skipped when the option Only Reflect Environment is used. So let's add an HDRI map inside the Local Environment option, switch on the Only Reflect Environment, and change the reflection weight to 0,1 and the Reflection Edge Weight to 1 and render (Figure 4.130).

Figure 4.129 Figure 4.130 *With the local environment applied*

The influence is subtle, but it's there.

Of course, there are a lot more fine-tuning options for this SSS Fast Skin material, but we will leave that for the experts. I just gave you the basics here, which should help you to create nice skin materials.

4.7.3 SSS Fast Skin Material plus Displacement
The SSS Fast Skin material plus Displacement is completely the same as the SSS Fast Skin material, with one extra option: displacement. With this material, you can add to your model true displacement for things like warts and so on. The specifics of displacement have been covered in Chapter 2, so we will leave this material at this point.

4.7.4 SSS Physical Material

So far, we have been using Subsurface Scattering material mainly for skin materials. But there are more Subsurface Scattering materials that are fundamentally different from skin—which has different layers—such as jade, soap, wax etc.—which have just one layer of material. For this, we have the SSS Physical material, which renders physically accurate material for you such as jade and soap, and milk and ketchup can also be created in this way. I will show you SSS Physical shader; however, due to the fact that this physical version is challenging to understand, it is better to use the SSS Fast shader.

Open the file **sss-Physicalmaterial.max** and render the scene (Figure 4.131).

We have already turned on the Global Illumination option since we will need this for our SSS material. We will now try to give this head a jade material. First, we need to apply the SSS Physical material to the head, replacing the standard material we are using at present. So, open the Material Editor, find an empty material slot, and select for the material SSS Physical material and apply it to the model (Figure 4.132).

Figure 4.131

Figure 4.132

Now have a look at the options of the material before doing anything else (Figure 4.133).

At the bottom you can see the Lights option. Turn it on and then select the mr Area Spot 01. This means that we have now decided that only this light, which shines at the back side of our model, influences the SSS Physical material. We do this to emphasize the Subsurface Scattering we are creating. Now render again (Figure 4.134).

It is obvious that we need to start doing some adjustments. The colored spots are the photons going around inside the material, and we can see through the model by the ear and by the metal stick that connects the head to the pedestal. We will start by having a look at the options we have at hand by opening the Material Editor, and checking the parameters of the material again (Figure 4.135).

First, change the color of the material to match that of reddish jade because that is the material we want to

Figure 4.133

SSS Physical Material (mi) Parameters			
Material .			
Transmission .			
Index of refraction	1,5		
Absorb. Coeff. . .	0,001	0,001	0,00231
Scatter. Coeff. . .	0,657	0,786	0,9
Scale conversion	10,0		
Scattering anisotropy	0,75		
Depth .	1,0		
Max samples .	16		
Max photons .	64		
Max radius .	3,0		
Lights .	☑		
mr Area Spot01			

Figure 4.134 **Figure 4.135**

create. So, change the material color into a reddish color (0,59 − 0 − 0). Next, adjust the Transmission value to the same amount. The Material option sets a color or a Color shader. The effect is additive. Transmission sets a color or a Color shader; it controls the intensity of the SSS effect and acts as a multiplier.

Change the Index of Refraction to 1,5. This is the IOR for the material we want to create.

The Absorb Coefficient is responsible for the attenuation of the light inside our material. There are given values (experimentally found), and for jade they are 0,001, 0,001, and 0,00231.

The Scatter Coefficient is responsible for the amount of light scattering when the light travels through the material. This also has a given value: 0,657, 0,786, and 0,90 are the numbers for our material.

The Scale Conversion factor is a transform between the world coordinate system and the units used to represent the scattering and absorption coefficients. This has to be set to 10 since the scene units are centimeters and the absorption and scattering are by default in millimeters.

Scattering Anisotropy is changed to 0,75. The Scattering Anisotropy factor is a measure of the degree of scattering since light in our material is not scattered uniformly. Values may range from −1 to 1. Minus 1 represents complete back scatter and 1 represents forward scatter. Zero indicates uniform scattering in all directions.

So far, we're set for the fixed values (except maybe for the two colors, which might need fine-tuning). The next step is to render the scene again (Figure 4.136).

Figure 4.136

This image is better, but we still see some obvious problems. The colored spots are the photons that are being returned by the SSS Physical material, and you can now see how the photons are distributed inside the material according to our adjustments. But we need to do more.

We will start by increasing Maximum Photons (the maximum number of photons to sample per lookup per kd-tree) to 1.000 and Maximum Radius (the maximum radius of a sphere centered at a sample point from which to collect photons from a kd-tree) value to 100. We have chosen 100 since this is approximately the size of the head. Now render again (Figure 4.137).

Maximum Radius and Maximum Photons are increased to force photon averaging. The two options work together to produce a better result.

There is some improvement, but the red is too bright at the moment. Change the material color to full black (Figure 4.138).

Figure 4.137 **Figure 4.138**

Here, you can see the effect of Subsurface Scattering starting at the back of the head (due to the light we selected in the beginning). Light is being transmitted through the material when it is lit from behind. We now want to increase the Subsurface Scattering effect. Simply enlarge the Depth option value from 1 to 1,5 and do another rendering (Figure 4.139).

Finally, I did some extra fine-tuning. I increased the maximum number of samples to 50, the maximum number of photons to 5.000 inside the material, and the overall photons that are being shot inside the scene from 100.000 to 500.000. This is done inside Render Scene dialog > Indirect Illumination panel. These changes give some additional improvements (Figure 4.140).

Figure 4.139 **Figure 4.140**

Chapter 5
mental ray and Shaders

5.1 Introduction

As we mentioned in Chapter 1, mental ray is a render engine that controls an enormous number of shaders that all work together to translate the scene data into the final rendered image. Just consider mental ray as the mastermind behind it all. mental ray can work with most of the existing map types that are available in 3ds Max. For instance, if you want to apply an image to an object, there is no need to use a specific mental ray shader. You can just keep on using the bitmap, as you are accustomed. But in addition to the regular mapping techniques, there are also a number of mental ray–specific shaders available. You can find most of them through the Material/Map Browser where they can be recognized by the yellow parallelogram, instead of the green ones, which indicate the regular scanline maps (Figure 5.1).

Inside the Material/Map Browser, you will find all the shaders, which are divided into three main libraries. The name of the library is usually behind the name of the shader between the brackets. The three main libraries are as follows:

- Specific for 3ds Max (3dsmax), in the browser
- Lume shaders (lume), in the browser
- mental ray shaders (base), in the browser

In addition to these main groups that come standard with 3ds Max are shaders that have been written by others and made available. You can even program your own specific shader if you want to. Of course, the custom shaders have not been included in this book.

Figure 5.1

The Material/Map Browser will show you the available shaders for the particular component of the mental ray–specific material definition to which you want to add a shader. The shader shown does not depend on the libraries we just mentioned. It depends on the part of the material you want to influence. For instance, a displacement shader needs to go into the component that deals with displacement, not

into a shadow component, and so on. That is why mental ray will not display the displacement shader when a shadow shader is needed.

We will now focus on the shaders that have not been discussed yet and that are the most important ones. The tiny shaders that control just small specific effects will not be discussed, and we will leave them as they are. The first section discusses material-related shaders, not only surface-related shaders but also photon, photon volume, shadow, etc. A separate section follows about the shaders that are used to create water, with all its effects. Since there are related shaders, I grouped them together.

I would like to point out that a number of shaders have become somewhat redundant because of the new Arch & Design material's built in functionality that is comparable to, or even better than, some of the shaders we will cover. So please keep this in mind since this new material is powerful and easier to control — it is usually the better option.

5.2 Material-Related Shaders

We will discuss the material-related shaders first. I have grouped them together since they all affect the material definitions in some way. I tried to make the sequence as logical as possible by starting with shaders for the Surface component and then moving on to shaders for the Shadow and then Photons components. I also endeavored to make sure that the shaders that function together are discussed inside one sample, instead of making individual samples. The first exercise demonstrates this since the DGS shader needs to go into the Surface component and the Photon component if you want to create a physically accurate material in your rendering. I will also show you a number of shaders that are superseded by the new Arch & Design material, which has a lot of the shaders built in, such as the Bump shader and displacement shaders.

5.2.1 DGS Material Shader

DGS means Diffuse, Glossy, and Specular. The DGS shader is also called a phenomenon or a Shader Tree, and it will give you a physically accurate material once you apply it to the Surface or the Photon component, as you'll see in the next exercise. The DGS shader is different from the DGS material, even though it has the same name. However, it does have the same side effects and settings. And what I stated for the DGS material is also true for the DGS shader: it has largely been replaced by the new Arch & Design material, which is faster and more flexible.

Figure 5.2 *DGS shader with grain problem very obvious on the wall*

For comparison purposes, we will use the same scene for the DGS shader as we did with the DGS material. Open the file **Shader_dgs.max** and render the scene (Figure 5.2).

As you can see from this rendering, the materials we applied are basically the same as those we used when work-

ing with the DGS material, but now we are using the mental ray material with the DGS shader. The problem with graininess is also the same one we had before.

For this sample, we used the material that we applied to the floor. The materials we are using are essentially all made in the following way (Figure 5.3).

Figure 5.3

So, inside the Surface and Photon components, we have used the same DGS shader. For the surface DGS shader, we added a bitmap of the tiles from the Diffuse component and, finally, added a Bump shader inside the Bump component of the mental ray material. The options for the DGS shader are exactly the same ones as we had for the DGS material, so we will not go into them again. Refer to Chapter 4 if you want to know what these options do.

The solution to the problem of graininess is also the same. We need more samples, which, in turn, will add some significant rendering time. Also, the extra sampling is applied to the whole scene, so even parts that don't

Figure 5.4 *Grain problem resolved but at the cost of serious render time*

need this sampling amount will be calculated in this way. If you want, you can create the following image by increasing the number of samples to a minimum of 16 and a maximum of 64. Be prepared to wait; it will take serious render time! (Figure 5.4)

5.2.2 Dielectric Material Shader

The Dielectric Material shader will create a physically accurate material, taking into account transparency and refraction. A Dielectric material (such as glass) is a material in which the surface scatters the most light when the light rays hit the surface perpendicularly. It reflects more light when the rays hit the surface at an increasing angle. If you put the Dielectric shader into the Surface component, it will influence the way the surface is being rendered. If you put it in the Photon component, it will influence the way the photons behave when you are using Global Illumination and Caustics. The mental ray Glass material is, in fact, a material that uses the Dielectric Material shader, with identical settings inside the Surface and Photon components. Since we will try to make physically correct glass in this sample, we will use the Dielectric Material shader in both the Surface and Photon components of our mental ray material.

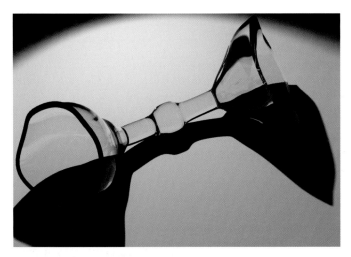

Figure 5.5

Material Shaders	
Basic Shaders	
☑ Surface	Map #2 (Dielectric Material (3dsmax))
☑ Shadow	None
Caustics and GI	
☑ Photon	None
☑ Photon Volume . . .	None
Extended Shaders	
☑ Bump	None
☑ Displacement	None
☑ Volume	None
☑ Environment	None
Optimization	
☐ Flag Material as Opaque	

Figure 5.6

Dielectric Material (3dsmax) Parameters	
Light Persistence .	
Index Of Refraction .	1,5
Outside Light Persistence	
Index Of Refraction(out)	0,0
Persistence Distance .	1,0
Ignore Normals .	☐
Opaque Alpha .	☐
Phong Coefficient .	0,0

Figure 5.7

Again, remember what we said when we introduced the Glass material: Arch & Design material is the best choice for creating glass. Since the Dielectric shader is basically the same as the Glass material, the same assertion applies for the Dielectric shader.

Open the file **Shader_Dielectric_material. max** and render the scene (Figure 5.5).

Open the Material Editor and check the first material: Glass left part. In the Surface component of this mental ray material, we have placed a Dielectric Material shader. Since we are using a mental ray material, we must have a shader inside the Surface component to apply to one of the rules of mental ray: Surface shader must be present (Figure 5.6).

To create a Glass material, we also need to add a Dielectric shader in the Photon component. So, drag and drop the Dielectric Material shader from the Surface component into the Photon component. When asked, choose Instance from the options so that you will be sure that whenever you change a setting inside the Surface component's Dielectric Material shader, it will also affect the Dielectric Material shader inside the Photon component.

Once you have cloned the shader, have a look at the settings of the Dielectric Material shader inside the Surface component (Figure 5.7).

As you might remember, we have seen this exact setting before, when we used the Glass material for the revolving door. Since we discussed all the options at that time, we will now just apply a bright red color to the Light Persistence option so that this part of the glass will become red inside the rendering.

Next, go to the next material called Glass middle part, and repeat the same procedure for the Dielectric Material shader, but leave the Light Persistence color as it is. Finally, check the next material, Glass right part, and repeat the procedure with the Dielectric Material shader for

the Photon component, but this time apply a bright yellow color to the Light Persistence. After changing the three materials, render the scene (Figure 5.8).

Although there is no real difference (besides the colors, of course), we have now created a physically correct Glass material. This means that we can now create caustics and apply global illumination. Enable the Caustics option inside the Indirect Illumination panel of the Render Scene dialog to get to a fully rendered image like the next one. I have already prepared the settings, so you will get a nice image (Figure 5.9).

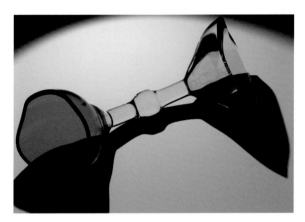 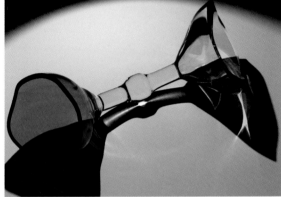

Figure 5.8 *Colors added to the dielectric shader* **Figure 5.9** *Caustics added to the rendering*

You might have noticed that mental ray is rendering without any error messages. This means that we are using a correct material in this specific sample. If you remove the Dielectric Material shader inside the Photon component from all the materials and try to render the scene, you will get an error message (Figure 5.10).

Although it is claiming that no photons are stored, mental ray is actually complaining about the fact that it has to render a physically correct image without a physically correct material inside the scene.

Figure 5.10

5.2.3 Metal Shader

With the Metal shader, you can make realistic metal. Again, this is now a standard template in the Arch & Design material. Arch & Design actually has a simple setup for brushed material, which is much harder to perform with the Metal shader. But I think you know by now which one I would advice you use.

Open the file **Shader_metal.max** and render the scene (Figure 5.11).

We have already applied a mental ray material with the Metal shader inside the Surface component to the salad bowl and the pepper and salt set (Figure 5.12).

For the two spoons, we have assigned an Arch & Design material, with the preset of Metal Chrome, just for comparison.

There are already some nice reflections going on inside the different predefined metal materials (Figure 5.13).

Figure 5.11

saladbowl (mental ray)
Surface Shader: Map #25 (Metal (lume))

Figure 5.12

Metal (lume) Parameters		
Surface Material .		
Reflectivity .	0,9	
Reflect Color .		
Blur Reflection .		
Spread .	10,0	
Samples .	10	

Figure 5.13

Figure 5.14

We have been using the following default settings of this shader for both the salad bowl and the pepper and salt set:

- **Surface Material**. This color swatch is responsible for the color. Make it bright green (R = 0, G = 1, B = 0) for the salad bowl and render the scene again (Figure 5.14).
- **Reflectivity**. This setting is the amount of reflectivity. The minimum value is 0, which leaves no reflection at all with full surface color. The maximum is 1, which is full reflection and minimum surface color. Let's change the setting to 0,8, just to show you what happens (Figure 5.15).

The green color becomes more apparent since we have lowered the factor between the green (surface material) and the gray (reflect color).

Figure 5.15 **Figure 5.16**

- **Reflect Color**. This is the color of the reflection. Leave the Reflectivity at 0,8 and change the Reflect color to bright yellow. Now render again (Figure 5.16).

 Now you can better see the influence of the Reflect color for the metal we created here.

- **Blur**. If you turn the Blur option on, you will get blurry reflections. Select the salt flacon and enable the Blur option for this metal. You will now be able to see the difference between the salt and pepper flacons well (Figure 5.17).

- **Spread**. A lower value of Spread makes the blur effect less evident. The higher the value, the stronger the blur effect. To be able to maintain the quality of the blur, you will need higher samples.

- **Samples**. A higher samples value gives a better quality of the blur effect. Be careful because it will also affect the rendering time needed. For the salt flacon, we changed the spread to 25 and the samples to 50 and rendered the scene again (Figure 5.18).

Figure 5.17 **Figure 5.18**

Now you have a nice comparison in one scene of the original metal shader without blurring (the pepper) and with blurring (the salt), the adjusted reflection color and surface material, as well as the alternative way to make a metal chrome material by using a chrome template from the new Arch & Design material.

5.2.4 Car Paint Shader

Image provided by Dave McKie, www. dmmultimedia.com

Since we have already covered Car Paint material in depth, we will not spend much time on the Car Paint shader. It has completely the same options as the Car Paint material.

As with the DGS and Dielectric shaders, you need to do something extra to make the image physically correct, since the shader doesn't do the clear-coat reflections, but since we have the Car Paint material, I won't bother you with how it is supposed to be set up. I will just provide a very nice image of what you can do with the Car Paint shader and/or Car Paint material (Figure 5.19).

Figure 5.19 *Image created by Dave McKie, www.dmmultimedia.com*

5.2.5 SSS Physical Shader

We will now start using the Sub Surface Scattering shader that is available inside mental ray. This Sub Surface Scattering happens with materials into which light can penetrate but is scattered when it gets into the material. Examples are jade, wax, and milk, which we will try to create in the next exercise. Actually, the settings of SSS Physical material are identical to those of this shader, so you should be familiar with most of the settings already. Please remember that this shader is, like the SSS Physical material, rather difficult to set up. Therefore, the safer choice would be to use the SSS Fast material when you want to create the kind of material we will create now; it is much easier to set up and control.

Open the file **shader_sssphysical.max** and render the scene (Figure 5.20).

Inside the scene, there are a few planes and there is a spotlight. Then there is a glass, to which we have assigned an Arch & Design material with a template of Physical Glass. What is important now is the substance inside the glass, which we want to represent as milk.

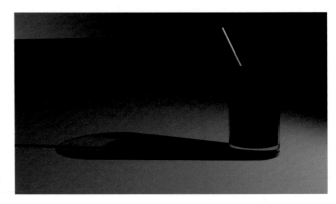

Figure 5.20

Figure 5.21

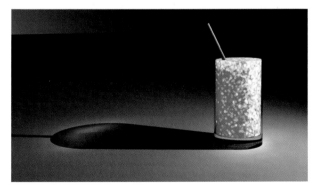

Figure 5.22 *SSS Physical Shader Parameters*

The material has been defined as shown in the following image (Figure 5.21).

The same SSS Physical shader has been applied in the Surface and Volume components of the mental ray material to create a physically correct material. They have been instanced, so you only need to change one of them to affect both. If you look in the Material Editor and open the Surface component of the mental ray material, you can see the settings of this shader (Figure 5.22).

The first thing to do is to change the color of the material to match the color of milk. So, change the Material color to a light gray (0,5 –0,5 –0,5). Next, adjust the Transmission values to the same amounts. The Transmission color filters light as it enters the object. Change the Index of Refraction to 1,3, which is the IOR for milk.

The Absorb Coefficient is responsible for the attenuation of the light inside the milk. The values for milk are 0,0014, 0,0025, and 0,0142. Make sure your 3ds Max presets are correct so that you are able to input these numbers. (If the numeric fields just accept a precision of three decimal places, for instance, change the precision inside Customize menu > Preferences > General panel > Spinners group from three to five decimal places.)

The Scatter Coefficient is responsible for the amount of light scattering when it travels through the media. This is also a given value for milk: 0,70, 1,22, and 1,90.

The Scale Conversion factor is a transform between the world coordinate system and the units used to represent the scattering and absorption coefficients. This has to be set to 10 since the units of the scene are in centimeters and the units of the absorption and scattering are by default in millimeters.

Scattering Anisotropy has to be changed to 0,75. The Scattering Anisotropy factor is a measure of the degree of scattering since light in milk is not scattered uniformly. Values may range from −1 to 1. Minus one represents complete back scatter and 1 represents forward scatter. Zero indicates uniform scattering in all directions.

That's it for the fixed scientific values. The two colors swatches might need fine-tuning.

Figure 5.23

The next set of parameters control the quality and complexity of the rendering. Leave them as they are for now, and, after you have turned on the Caustics and Global Illumination rendering options, start rendering (Figure 5.23).

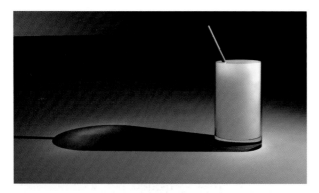

Figure 5.24

Figure 5.25

Figure 5.26

The colored spots are the photons that are being returned by the SSS Physical shader. You can now see how the photons are distributed inside the milk. Of course, we need to make adjustments to get a better result. As expected, most of the photons are on the top and the right side of the glass since the light comes from that direction.

We will start by increasing the Maximum Photons (the maximum number of photons to sample per lookup per kd-tree) to 1000 and the Maximum Radius (the maximum radius of a sphere centered at a sample point from which to collect photons from a kd-tree) value to 50.

We have chosen 50 since this is the size of the glass. Now render again (Figure 5.24).

Maximum Radius and Maximum Photons are increased to force photon averaging. The two options work together to produce a better result.

You can see that there is some improvement, but the material is much too white at the moment. A way of lessening this is by reducing the Transmission color (which was set to 0,5 –0,5 –0,5) to values of 0,1 –0,1 –0,1. Render again to see the result (Figure 5.25).

Now it is time to make a serious rendering. First, enlarge the Depth value from 1 to 15. The Depth setting is the calculation of subsurface scattering and is broken into three components: single scatter, multiple scatter, and diffusion. Depending on the optical properties of the material, the contributions of each component may dominate or be negligible. An important factor in determining this is the main free path length of the material. This is the average distance a photon travels in the material without scattering or absorption, and it is equal to the reciprocal of the sum of the scattering and absorption coefficients. The depth property is a multiple of the mean free path length. If a photon exceeds a distance (mean free path length × depth) from the surface of the material, it is then considered to contribute only to the Diffusion component; otherwise, it contributes only to the Multiple Scatter component. To put it simply, making this value higher will result in more light traveling inside the milk (Figure 5.26).

Next, increase the number of samples from 16 to 50. The Maximum Samples setting is the maximum number of samples evaluated by the single and multiple scatter components (Figure 5.27).

Finally, enlarge the number of Caustics to 100.000 and the GI Photons to 1.000.000, and start rendering (Figure 5.28).

Figure 5.27

Figure 5.28

Enlarge the number of Maximum Photons inside the SSS Physical shader setting to 4.000 and render again. This will result in a bit less color inside the milk (Figure 5.29).

Finally bring down the Transmission value, just a little bit (0,05 − 0,05 − 0,05) and render to get the result shown in the next image (Figure 5.30).

Figure 5.29

Figure 5.30

5.2.6 Glass Shader

The Glass shader accurately models the transparent and reflective properties of glass, including fresnel reflection and transparency shifts near the object's edges, and more. Again, remember that the Arch & Design material has a number of different presets for making glass too, but we will show you this shader so that you understand what the settings do. Open the file **Shader_glass.max** and render the scene (Figure 5.31).

We have used a standard Window and applied a Window Template material, which we renamed Window Glass lume parameters. All parts have been made yellowish and the Panel material (which represents the Glass) has been directed to use the Glass shader. For this, we have opened the mental ray Connection rollout and removed the lock for the Surface component. There, we have added the Glass shader (Figure 5.32).

Now move to the Glass shader level in the Material Editor to get an overview of all the rollouts that have become available (Figure 5.33).

If you close all the rollouts, you will see that there are seven available (actually, eight, but one is for the shaders). We will first explore the Glass (Lume) Parameters rollout (Figure 5.34).

Figure 5.31

Change the Surface Material Color swatch to a bright red and the Diffuse Color swatch to a bright yellow, and render the scene (Figure 5.35).

Figure 5.33

```
Window-Glass_lume_parameters ( Multi/Sub-Object )
   (1) : Material #17  ( Arch & Design (mi) )
   (2) : Material #17  ( Arch & Design (mi) )
   (3) : Panels  ( Standard )
         Surface: Glass_lume_parameters  ( Glass (lume) )
   (4) : Material #17  ( Arch & Design (mi) )
   (5) : Material #17  ( Arch & Design (mi) )
```

Figure 5.32

Figure 5.34

Figure 5.35

Figure 5.36 *Less reflection increases the influence of the surface material color*

Figure 5.37

5.38 *Transparency color set to yellow*

As you can see, there is no influence of the Surface Material option at present. What you can see very well are the reflection and transparency of the glass. Next, change the Reflectivity value to 0,2 and render the scene again (Figure 5.36).

The reflection is much less, and the Surface Color is now combined with the Diffuse Color. In other words, less reflectivity also makes the surface material less evident. If you were to adjust the Transparency value to 0, you would get a complete red window that would have lost all its transparency, so the biped behind the glass would no longer be visible.

The Index of Refraction speaks for itself—it controls the amount of refraction. With the Light option, you can select the lights that are to use the settings from this rollout. *None selected* means all the lights inside the scene will use the settings.

Now, we will move on to the next rollout: Transparency Tint. We have prepared the scene already with more windows and bipeds, so you just need to change the camera view to Camera Transparency Tint and move to the next material in the Material Editor, which I gave the same name as the camera so that you don't have to constantly reset the material (Figure 5.37).

The Transparency Tint option is on by default, as is the Use Diffuse option. This means that the Diffuse Color from the previous rollout is used by default as the color for the Transparency. If you want to use another color, turn on the Use Color option first and change the color swatch to a bright yellow, for example. Make sure you uncheck the Use Diffuse option, and render the scene (Figure 5.38).

Basically, this is the same type of image we had with the first rendering we made, with the Diffuse Color set to bright yellow.

Change the view to Camera Blur Transparency, which is the next rollout, and move to the next material in the Material Editor. I gave it the same name as the camera so that you do not have to constantly reset the material (Figure 5.39).

Figure 5.39

Figure 5.41

Check the option and change the Spread to 2. Make the number of Samples 10 and render the scene (Figure 5.40).

You can see that we now have created a kind of stained glass. In fact, this option influences the light rays that travel through the glass, blurring the objects behind the glass. Blur Transparency increases the number of rays, shooting each of them in a slightly different direction. The Spread option controls the spread of the extra rays (more spread

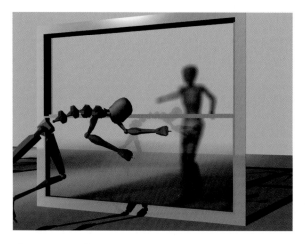

gives a more blurred image). The Samples option makes sure that the blur is of good quality; generally speaking, a larger value improves the quality of the blur. Be careful, though, because applying this option will increase the rendering time. Remember, these changes only blur the object behind the glass, not the reflection of the object in front of the glass.

Change to the next camera view, rollout, and material—Camera Blur Reflection—and move to the next material in the Material Editor (which I gave the same name as the camera so that you don't have to reset the material) (Figure 5.41).

Check this option and increase the Spread to 10. Set Samples to 50 and render the scene (Figures 5.42 and 4.43).

Figure 5.40 *Blur transparency turned on, keeps sharp reflections*

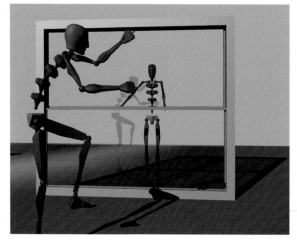

Figure 5.42 *Blur Reflection = off*

Figure 5.43 *Blur reflection = on*

We have placed one rendering with and one without the blur reflection next to each other so that you can see the difference. This is a subtle effect, even with relatively high values. Look at the shadow on the wall between the two bipeds, where the effect is the most obvious. We are now influencing the reflective rays. So, with this rollout, you can blur objects that reflect in the window. The Spread and Samples options work and interact in the same way as with the previous rollout.

Switch to the next camera and rollout, Edge Transparency, and move to the next material in the Material Editor (which I gave the same name as the camera) (Figure 5.44).

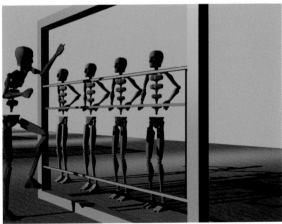

Without knowing it, we have been working with Edge Transparency already. As you can see, the Fresnel Effect option is set to *on*. This means that we have been rendering with a transparency effect based upon fresnel characteristics. In other words, the transparency has been influenced based on our viewing angle. This is what happens in real life. If you look straight through the glass, it is completely transparent. But if you look from an angle, it becomes less transparent (Figure 5.45 and 5.46).

Figure 5.44

Figure 5.45 *Edge Transparency = on*

Figure 5.46 *Edge Transparency = off*

We have placed both renderings side by side again. You will now notice two things. First, the reflection is completely gone in the right image. Second, if you look at the color of the bipeds behind the glass in the right image, they are all the same green, whereas the ones on the left have different colorings of green. In fact, we removed one of the physical properties of the glass by using the None option. At this point, the viewing angle doesn't

matter anymore. If you want to influence the viewing angle with a custom effect (meaning something other than the fresnel effect), you can do so by checking this option.

The next camera view is the camera edge shadow (Figure 5.47).

With the Edge Shadow option, you can influence the shadow effect. If you imagine a ball of glass, the shadow in the center is lighter than the shadows on the edges. This is exactly the type of effect you are able to achieve here. In the example we are using at present, this option can hardly be seen because we need a bigger mass of glass. Therefore, we will leave this option as it is and move on to the next rollout: Translucency.

Change to the Camera translucency view, and move to the next material in the Material Editor (which I gave the same name as the camera) (Figure 5.48).

Figure 5.47

The Translucency effect is basically the same as the Translucency shader. You can illuminate glass objects from behind—think of stained glass inside a door. To be able to see the effect more clearly, we have already adjusted the Diffuse Color in the Glass Parameters rollout to a bright red and the Transparency value to 0,5. Rendering the scene will create the result shown in the following image (Figure 5.49).

Figure 5.48

Next, check the Translucency Fixed option (uncheck None), and render again (Figure 5.50).

Now you are able to see the difference. It actually looks like the window is lit from the back, and it looks more realistic now. The effect is uniform over the total surface. To make the effect change over the surface, you could use the Scale option.

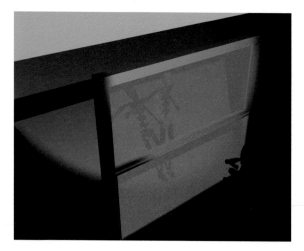

Figure 5.49

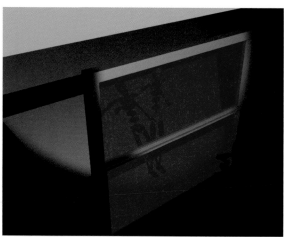

Figure 5.50

5.2.7 Landscape Shader

The Landscape shader is perfect for making landscapes (as you might expect from the name). But due to its flexibility, it is not limited to creating landscapes—you can use it for all kind of purposes where mixing of materials based upon geometry is relevant.

For this sample, you need to open the **Shader_Landscape.max** file and render the scene to see what we have here. The model isn't great, but it is a good example to show you what happens when you start playing with the settings (Figure 5.51).

Now open the Material Editor, and put the Landscape shader inside the Diffuse channel (Figure 5.52).

Figure 5.52

Figure 5.51

Leave everything at default settings; just render the scene to see what happens (Figure 5.53).

A mixed material has been applied. We will now start to play with the material and to explore the flexibility of this shader. Check the Material Editor and look at the first rollout, Landscape parameters (Figure 5.54).

The base color and overlay color have been applied, as you can see inside the rendering in a particular pattern. The amount of blur defines the blurring between the brown and green colors.

The position of the colors is influenced by two options: Relative to World and Relative to Object. Relative to World is used when you are using two planes next to each other, and you want the landscape pattern to move over correctly from one plane to the other. Relative to Object is used when you move the plane itself and you want the landscape pattern to follow. Since this effect

Figure 5.53

Figure 5.54

207

will only work when you use the vertical axes, you need the Plane Normal and Plane Distance options to point out which direction the vertical axes have and what the relative distance is from the origin of the coordinate system. All these options are only relevant when you make an animation, so we will leave them as they are for now since we are just making a static image.

The next rollout is the Texture rollout (Figure 5.55).

Figure 5.55

If you make this rollout Active and set the Influence to a higher value, such as 3, you will see that influence of the green color (overlay) is reduced. In other words, you can influence the overlay as a whole, or by the R, G, B or alpha component if you use the other options (Figure 5.56).

Figure 5.56

After rendering, reset the options to their defaults; that is, uncheck Active and set the Influence back to 1.

The next rollout is Height, which is on by default (Figure 5.57).

If we look at the original image, there were some abrupt changes in coloring, almost like sharp lines (see the image on the left) (Figures 5.58 and 5.59).

Figure 5.57

Figures 5.58 & 5.59 *Influence factor at 1 and influence factor at 3*

The Influence factor is actually responsible for these problem spots. By increasing the value to 3, you will see this more clearly. Parts of the geometry that are above a certain height will now gain influence.

The Upside Down option just flips the positions of the brown and the green colors, so we will leave that as it is.

The Height option actually controls the starting position of the darker green parts. If you increase it to 2.500, you will get the following image, where you can see the effect clearly (Figure 5.60).

The Spread option creates a smooth transition between the darker green and the brown color. Increasing it produces a smooth transition between the colors. So, increase this value to 2.500 and render the scene. You will note that the transitions have been smoothed out (Figure 5.61).

Figure 5.60 *Increased height value result*

Figure 5.61 *Smoothed out transitions*

Figure 5.62

The next setting is the Slope rollout (Figure 5.62).

Slope is responsible for the transition between low and high geometry, based upon the angle, which makes sense since it is called slope. For starters, let's decrease the Influence to 5 and render again (Figure 5.63).

Figure 5.63

This image illustrates the result. What happened is that the influence of the green color has been reduced for slopes that have an angle of less than 40 and it has been increased for those that are above this value. If you were to increase the angle to 70, even more green would be introduced.

Another rollout is Positional Noise (Figure 5.64).

Positional Noise is also on by default. We have assigned the Standard Landscape material again because we have been playing with settings so much that we are losing the overview of what we are doing.

So, starting from the original image, we are now increasing the Influence factor for Positional Noise to 25. Noise is introduced with bigger influence all over the landscape (Figure 5.65).

Figure 5.64

As you might have noticed, the noise increased the render time. High values like this give nice smooth noise. Increasing the scale option to 500 will increase the size of the noise and, as a side effect, will reduce the render time a lot (Figure 5.66).

Figure 5.65 *Positional noise at 25*

The Roughness value actually is at its roughest when using 0. If you increase it to 1, the roughness will smooth out again (Figure 5.67).

Figure 5.66 *Increased scale option for the positional noise*

Figure 5.67 *Result of roughness value at 1*

The Coverage has a range of −1 to 1. A value of −1 will leave almost no green, only the base color. A value of 1 will be almost completely green, no base color anymore. The next image was rendered with a value of 0,2, which reduced the presence of the brown color (Figure 5.68).

By increasing the vertical scale, the noise on the slopes is rescaled accordingly. The next picture illustrates what happens if you scale it up to 500 (Figure 5.69).

Figure 5.68 *Brown (base) color being pushed out by the coverage setting*

Figure 5.69 *Result of rescaling of the noise on the slopes*

Before moving on, turn off the positional noise option by unchecking Active.

The next rollout is the Shape Based Noise rollout, which is off by default (Figure 5.70).

Check it on and render the scene (Figure 5.71).

Shape Based Noise	
Active .. ☐	
Influence 2,0	
Scale 5,0	
Roughness 0,5	
Coverage 0,0	
Vertical Scale 1,0	

Figure 5.70

Figure 5.71 *The result of shape based noise introduced inside the landscape shader*

The effect is obvious. If you want more, just increase the value of the influence. The scale, roughness, coverage, and vertical scale work the same way as positional noise, so we will leave them as they are and briefly mention the next two rollouts, Shaders and Stain. The Shaders rollout just gives an overview of the different components in which shaders could be placed, and the Stain rollout only works in combination with stains, and we don't have them inside our scene.

5.2.8 Ambient/Reflective Occlusion Shader

As we have already talked about the Ambient Occlusion shader when we discussed the light-related shaders, we will now cover it a little bit less extensively. This time we will not use it as Light shader but as a Material shader.

It is important to remember that the new Arch & Design material has a built-in Ambient Occlusion option (see Chapter 4). In that material, it is mainly used to improve lighting effects where objects intersect so that you can get rid of the appearance of floating objects. The Ambient Occlusion inside the Arch & Design material uses faster and better techniques than this shader, so it will give a completely different result than the one we will achieve now. I will first show you the result of the Ambient Occlusion from the Arch & Design material, and then we will apply the separate Ambient/Reflective Occlusion shader.

Open the file **Shader_ambient_occlusion.max** and render the scene (Figure 5.72).

We have used only one material, which is an Arch & Design material with the preset Matte Finish. There are no lights inside the scene at all. Now let's add this Ambient Occlusion shader to the material.

Figure 5.72

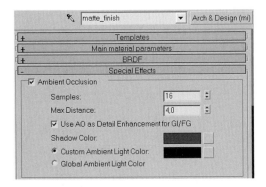

Figure 5.73

First, let me show you the built-in Ambient Occlusion option. Go to the Special Effect rollout of the Arch & Design material and check the Ambient Occlusion option. Just leave the settings as they are (Figure 5.73).

Render the scene (Figure 5.74).

Like we said in the beginning, this ambient occlusion is mainly intended for detail enhancement and

Figure 5.74

not for the ambient occlusion that we are after—the simulation of indirect light. So switch off this setting and move on to another rollout, the Special Purpose Maps rollout (Figure 5.75).

The Ambient Occlusion shader needs to go into the Additional Color/Self Illumination option. So, click the None button and select the Ambient/Reflective Occlusion shader from the Material/Map Browser. It will open directly inside the Material Editor (Figure 5.76).

As you can see, we have the exact same settings we had before when we connected this shader to a light source. Now for a nice image, increase the Samples to 256, render the scene, and get the result shown in the following image (Figure 5.77).

Figure 5.75

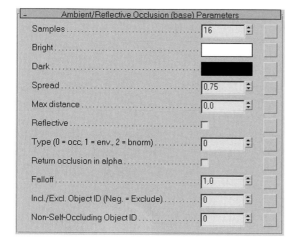

Figure 5.76

Figure 5.77

That was the effect we needed. Now it's a matter of fine-tuning the settings of the shader, which are already available inside the Material Editor. The settings are exactly the same as those met when we used this shader in the light source, so we will not discuss them here. Refer to Chapter 3 if you have forgotten how it works.

5.2.9 *Parti Volume and Parti Volume Photon Shaders*

Fog, clouds, and saltwater scatter the light that passes through them, that is, they contribute to the light transport. To simulate this effect you need a Parti Volume shader. (The abbreviation *Parti* means *participating*.) If the media inside the volume of another material are anything other than clean air or a vacuum, light scattering will take place. The scattering of the light is caused by the tiny particles inside the media.

To be able to calculate Volume Caustics and Global Illumination in the responsible media, these media need a so-called Volume Photon shader. Note that there is a corresponding Volume shader. The Parti Volume shader needs

to be placed within the Volume component of a mental ray material, and the Parti Volume Photon shader must be placed inside the Photon component (Of course, they can also placed inside the corresponding components inside the mental ray Connection rollout of each material definition that can be used inside 3ds Max.) (Figure 5.78).

If these shaders are used together, you will get a physically correct calculation of the light scattering. If they are not used together, you will not see the effect.

Since we discussed this shader under "mental ray and Camera shaders" in Chapter 2, I will just show you the sample file that I prepared. The biggest difference is that a shader used inside a material applies to just the material, whereas a shader used as a Camera shader applies to the whole scene.

Open the file **Shader_partivolume.max** and render the scene (Figure 5.79).

Inside this image, we created some pipes and tanks, where we have cut out materials to show you the gas that flows inside these objects. From left to right, we called them Volume 1 through Volume 3 (Figure 5.80).

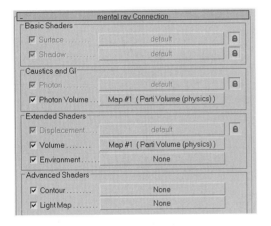

For Volume 1, we have not adjusted the mode, which means that the whole volume is filled. We changed the scatter color and decreased the extinction to make it less dense than the default value, and applied a different color. We introduced anisotropic reflection by putting in values for g1 and g2; the r value gives size to the particles.

For Volume 2, we used similar settings but with a small variation and a different color (Figure 5.81).

For Volume 3, we have applied the following settings (Figure 5.82).

Figure 5.78

Figure 5.79

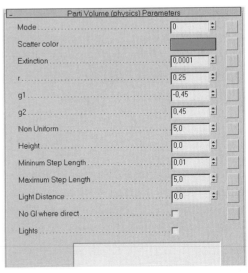

Figure 5.80 *Settings for volume 1*

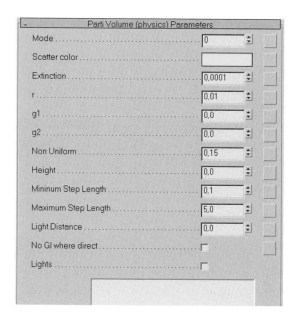

Figure 5.81 *Settings for volume 2*

Figure 5.82 *Settings for volume 3*

We have changed the Mode setting to 1 and introduced a Height setting of 1,81, which means the medium is filled with normal air up to that height; above that height, there is complete clean air or a vacuum, meaning that only the lower part of this tube will be filled with the colored air.

5.2.10 Translucency Shader

In reality, objects also receive light from the back side. Consider a lamp shade, a piece of paper, or stained glass. This is exactly the effect, light bleeding through from behind the object toward the front, that you are able to create with the Translucency shader. Again, this shader has been integrated inside the new Arch & Design material, which I showed you already, so I will show you how it works when using the old-school DGS material.

Open the file **Shader_translucency.max** and render the scene (Figure 5.83).

In the scene, we placed an Omni light and a Spot light, which is positioned behind the lighter. In real life, you would see some kind of indication of how full the lighter still is because this kind of plastic is usually translucent. This is the effect we will try to achieve now with the Translucency shader. Just follow these steps outlined next.

First open the Material Editor and activate the material named lighter body (the orange one). This is a DGS material. We now will add the

Figure 5.83

Figure 5.84

Translucency shader in the Transparency channel. Click on the small square to the right of the Transparency field, and Material/Map Browser will open; here you can select the Translucency shader (Figure 5.84).

Now check the parameters in the Material Editor (Figure 5.85).

Don't change anything yet; just render the scene (Figure 5.86).

You can see the influence of this shader. There is some indication of the amount of gas still available inside the lighter.

Now, let's look at the options in the shader. The Lights option in the shader gives you the possibility to assign the effect to specific lights in the scene. At present, all the lights are influenced by the shader.

The Diffuse Color is the color you should use in the Illumination shader, meaning we have to adjust this one to full orange. If you do this, nothing much will change in the scene—the orange will just become a little bit more evident.

The Transparency option has a range of 0 to 1, in which 1 is no translucency effect and 0 is the maximum effect. It is actually a multiplier that mixes the Surface material and the translucency effect. This means that if you modify the Surface material to full white and keep Transparency at the same level (0,5), the effect of translucency will increase as shown in the next image (Figure 5.87).

Figure 5.85

Figure 5.86 *The Translucency shader added to the material*

Figure 5.87

If you change the Surface material to full black and keep Transparency at 0,5, the translucency effect will disappear completely. This illustrates that the two options, Surface material and Transparency, work together. (Transparency is a multiplier that uses the Surface material and Translucency.) As long as you don't put the Surface material at full black, you will be able to play with the final effect by adjusting the color of the Surface material and the Transparency value.

If you copy a number of these lighters and play around with the settings we just talked about, you could get something like the following image (Figure 5.88).

Figure 5.88 *Different settings for the translucency shader*

5.2.11 Bump Shader

The Bump shader creates bump mapping. You can use the Bump shader directly inside the Bump component of a mental ray material or indirectly by using the Shader List option inside the Surface component in the mental ray Connection rollout of a 3ds Max material. I will now show you how this works. Again, this Bump option is directly available inside the new Arch & Design material, but if you are not using that material type, you need this kind of shader to be able to show bumps. In any case, we will use both materials inside this scene.

Open the file **Shader_bump.max** and render the scene (Figure 5.89).

This is a basic scene in which we will add bumps inside the wall and on the pavement. I will show you both the old and new ways. Let's start with the pavement. Select this object and open the Material Editor to see this material (Figure 5.90).

It is a very basic mental ray material, where we have used a DGS Surface shader to simulate the surface and a bitmap to create the concrete look. Now move to the Bump component and click on the gray None button to the right of it (Figure 5.91).

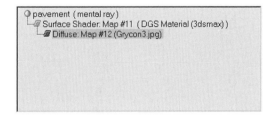

Figure 5.89

Figure 5.90

From the Material/Map Browser, select the Bump option (Figure 5.92).

In the Material Editor, you can now see the parameters of this shader (Figure 5.93).

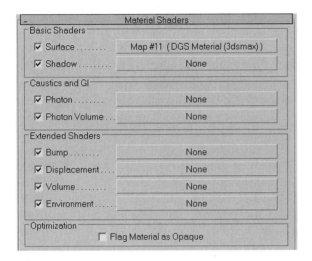

Figure 5.91

Figure 5.92

Figure 5.93

Click on the gray None button, select inside the Material/Map Browser for the bitmap option, and apply the image **bump_image.jpg**. Don't make any adjustments to this map, but move one level up in the material definition so that you get back to the options of the Bump shader. Don't change anything now; but if the rendering doesn't show enough bump effect, you could use the Multiplier option to change it to your liking (Figure 5.94).

Figure 5.94

This is the result—bump mapping with the Bump shader. Now select the Wall material, which is of the new type: Arch & Design. If you want to apply bumps inside this material, it is much easier. Just open the Special Purpose Maps rollout (Figure 5.95).

There is already a Bump component here. There is no need to apply the Bump shader anymore. You just need to select the bitmap you need, which is exactly what you were accustomed to doing with the standard materials. In this case, we have already done this step so you just need to check the option and render the scene again to get the two different Bump options in one rendering (Figure 5.96).

Figure 5.95

5.2.12 Environment Shader

The Environment shader gives you the ability to create an environment specifically for the material. It is comparable to the Environment option from the Rendering menu. The difference is that the regular Environment creates a background for the whole scene, whereas the Environment shader gives an environment specifically for a material for use in reflections and reflections (without using ray-tracing). Open the file **shader_environment.max** and render the scene (Figure 5.97).

Next we will apply the Environment shader to the material. Open the Material Editor and choose the material for the glass object. This material is an Arch & Design material, and we now have two options to apply the environment shader to this material. The first one is through the Special Purpose Maps rollout, where you will find an Environment option. Here you could directly apply the bitmap you want to use as a background. Since Arch & Design has the Environment shader built in, this is the easiest route. But there is another option — to use the specific Environment shader. This one needs to be added to the Environment slot inside the mental ray Connection rollout of the material (Figure 5.98).

Move to the Environment component and unlock it. After this, hit the None button; the Material/Map Browser will open (Figure 5.99).

Figure 5.99

Figure 5.96

Figure 5.97

Figure 5.98

Select the Environment shader, and you will get the parameters inside the Material Editor (Figure 5.100).

Next, use an image as environment. Click the None button to the right of Map option, and select the bitmap option from the Material/Map Browser (Figure 5.101).

Figure 5.100

Figure 5.101

Next select the image you want to use. I have used the Image **IMG0788.JPG**, which is on the DVD. In the Material Editor, you will see the regular parameters for bitmaps (Figure 5.102).

Open the Coordinates rollout, change the Texture option into Environment, and adjust the mapping to Spherical Environment. Finally, render the scene (Figure 5.103).

The Environment shader has used the image to create the reflection specifically for the object, and nothing has been added to the background.

Figure 5.102

Figure 5.103

5.2.13 Glow Shader

Glow is the shader that simulates light coming from within the object. You can use Glow in a light bulb to simulate the overexposure effect that you know from real cameras, but you can also use the Glow shader in a skylight, in which case, the effect will work as a lighting component. We will use both options inside the next sample.

Open the file **Shader_glow.max** and render the scene. During the rendering, you will use the Final Gather technique but not the Global Illumination option. One of the reasons for using Final Gather is that we are using a skylight in our scene. The other reason is more important: if there's no Final Gather, the Glow effect will not be visible, so it's use is mandatory (Figure 5.104).

We will now add the Glow shader to the scene. The light tubes near the ceiling will start to look like neon tubes, even though we have not assigned any kind of lights to them. The only lights in the scene are a skylight and an Omni light, which is responsible for the blue light coming from the right side of the image. First, open the Material Editor and look for the material called Light tubes. This is a ray-traced material. Now, open the Maps rollout and click on the gray None button to the right of the Luminosity option (Figure 5.105).

Figure 5.104

Figure 5.105

Next the Material/Map Browser will open, and you can select the Glow shader (Figure 5.106).

In the Material Editor, you will now see the Parameters rollout for the Glow shader (Figure 5.107).

In the previous image you can see the default settings. We have adjusted the Glow color to a light yellow. The Brightness is the brightness of the color we have just applied, which is the color that will be used to cause the object to glow. We have changed this value to 15. Now we are ready to render (Figure 5.108).

Figure 5.106

Figure 5.107

Figure 5.108

The image is perhaps a bit over the top, but this shows the effect very clearly; it even shows that it adds light to the scene. Glow adds the effect directly to the surface material color. With the Mix Diffuse option turned on, the light and dark parts in the Diffuse Color will be used to adjust the brightness of the Glow effect accordingly. The surface material is the input color that is used by the Illumination shader and then adjusted by the Glow Shader. Diffuse has the same color that is used for the Illumination shader. Transparency mixes the surface material color with the Glow effect. For instance, if we change the surface material into a bright blue, we would get the following result, once we have lowered the Brightness value to 3. Render the scene again (Figure 5.109).

If we were now to also change the Diffuse Color to a bright red, the final color of the tubes would be a mix of

blue and red—pink. When the Transparency value is set to 0, you get a full mix of the surface material and Diffuse Color. If the value is set to 1, you just get the surface material color.

The influence is very clear, I would say. The light tubes start to glow and even slightly illuminate the concrete beam. In addition, you can see the color influence we just discussed.

The next thing we will do is use the Glow shader within the skylight. For this, just select Skylight and go to the Modify panel. Down in the Skylight Parameters rollout, click within the Sky color group on the gray None button (Figure 5.110).

Figure 5.109

Figure 5.110

Figure 5.111

From the Material/Map Browser that opens, select the Glow shader again. Drag and drop the shader from the Skylight parameters into an empty slot of the Material Editor, and adjust the settings to a light yellow for the Glow option and increase the Brightness to 5 (Figure 5.111).

Now render the scene again (Figure 5.112).

Again, the effect is very obvious.

5.2.14 Material to Shader

Flower models provided by Ronald Zeilstra, www.zndesign.nl

The name of the Material to Shader more or less speaks for itself. With this shader, you can use a 3ds Max material as a shader. mental ray will select the proper Material component depending on which component you have applied this shader to. For instance, if you want the Surface component of a mental ray material to look like a material you have made in the past, then you need to use the Material to Shader option in this component. This is exactly what we will do now.

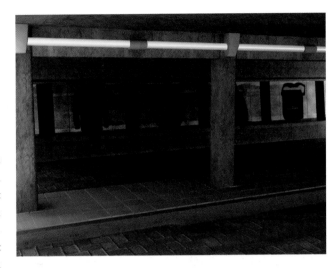

Figure 5.112

Open the file **Shader_material_to_Shader.max** and render the scene (Figure 5.113).

Now open the Material Editor and have a look at the materials we have used inside this scene. There are a number of standard material definitions and some architectural materials too. We can now reuse all these materials as a mental ray material. Just select an empty sample slot in the Material Editor, and select the mental ray material as a material definition (Figure 5.114).

The next step is to go to the Parameter rollout and click on the gray None button to the right

Figure 5.113

Figure 5.114

of Surface component. In the Material/Map Browser that will open, select the Material to Shader option (Figure 5.115).

Open the Parameters rollout (Figure 5.116).

You can now either hit the None button to apply a material or alternatively do the following: drag and drop the first material (flower1 flower) from the Material Editor Sample slot to the None button in the Parameters rollout. Just select the Instance or Copy option, according to your need (Figure 5.117).

Figure 5.115

Figure 5.116

Figure 5.117

You can see that the material has now been added to the Material option and is thus part of the Surface component of the mental ray material we are creating. mental ray now knows which parts of the architectural material it should use inside the Surface component (Figure 5.118).

Finally, assign this new mental ray material to the flower1 flower object. Follow this procedure for all the different materials, and render again to see the result.

Since I have already done this for you, so you could also switch scene state and select the Material to Shader state (right click the mouse in the scene and use the option as shown) (Figure 5.119).

Figure 5.118

Figure 5.119

This scene state needs to be loaded now. Be patient because it takes some time owing to the large amount of geometry involved (Figure 5.120).

The rendering is almost the same, but there is no more light passing through the glass material. This is because we are now using a mental ray material and we have assigned the Architectural Glass material to only the Surface component. mental ray now distills the surface information from this original material and uses it. So the fact that light passes through is not taken from the original information.

The solution for this is to select the glass object and check the mental ray material that has now been added to this object. Do this by selecting the glass and opening the Material Editor. Then use the Get Material option and in the Material/Map Browser to choose the material you've assigned so that this material will be the only one showing up. Now double click it, and it will become available in the Material Editor. Open the mental ray glass material and assign a copy of the Material to Shader option also to the Shadow component (Figure 5.121).

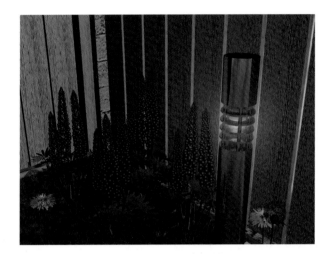

Figure 5.120

Figure 5.121

Now render again (Figure 5.122).

This is exactly the same image we had in the beginning.

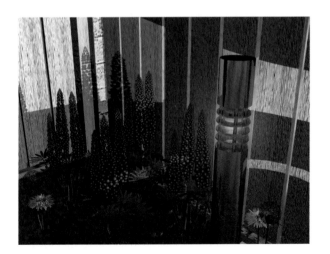

Figure 5.122

5.2.15 Shader List Shader

Flower models provided by Ronald Zeilstra, www. zndesign.nl

The Shader List shader gives you the ability to create a list of shaders. The result of the first shader in the Shader List is used as the input for the next shader in the list. The final result is then the result of all the different shaders you have used inside the Shader List. This option is found not only with materials but also in the Camera Shader group of the Renderer panel, for example.

Open the file **Shader_Shaderlist.max** and render the scene (Figure 5.123).

We will change the standard DGS material that has been used for the wall since we need an image to represent a wall, plus a bump effect to make it complete. So open the Material Editor and select the material named Wall. The problem we are facing is that there is no extra slot where we can place the bump effect. For this, we will need the Shader List option. With Shader List, we can add an image to this component and also to the bump effect. So click on the gray square to the right of the Diffuse Color swatch (Figure 5.124).

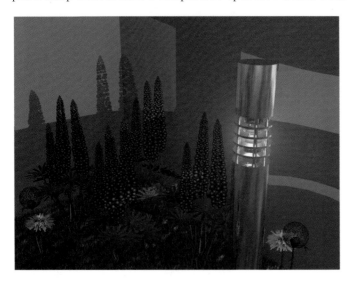

The Material/Map Browser will open. You should select the Shader List option (Figure 5.125).

The options for this shader will be displayed in the Material Editor (Figure 5.126).

Now choose the Add Shader option and select the bitmap option from the Material/ Map Browser; then select the bitmap **Masonry.Stone.Ashler.patterned.jpg**. Make sure you change the tiling to U = 2,5 and V = 1,5. Next, move back to the start of the Shader List option and you will see that the bitmap has been added (Figure 5.127).

Figure 5.123

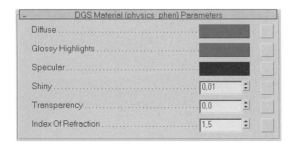

Figure 5.124

Figure 5.125

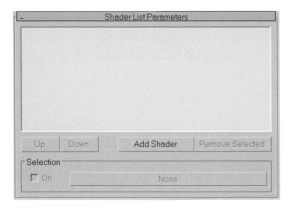

Figure 5.126

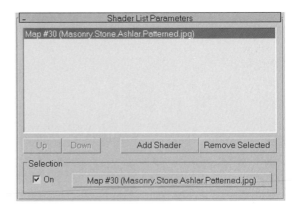

Figure 5.127

Repeat the Add Shader process again, but now select the Bump option from the Material/Map Browser (Figure 5.128).

You will get the parameters of this shader in the Material Editor (Figure 5.129).

Click on the gray None button and select the bitmap option. Make sure you select the image (**Masonry.Stone. Ashlar.Patterned.Bump**). Change the tiling to 2,5 and 1,5 (which is the same as for the bitmap) and move up two levels in the material definition. The Shader Parameters rollout now looks like the next image (Figure 5.130).

Figure 5.128

Figure 5.129

Figure 5.130

Now render the scene (Figure 5.131).

You can clearly see the effect of the Shader List. First, this shader uses the image to make it visible on the wall. Then it uses the image to create the bump effect. So, we have now used two shaders inside one component (Diffuse) of the DGS material. The Shader List option works the same way everywhere it is available inside mental ray, so whenever you need to combine certain shaders, you can use Shader List as I have shown you.

Figure 5.131

5.2.16 Transmat Shaders

Officially, the Transmat shader should be used in combination with a helper object. Helper objects are used for volume effects, but are not visible themselves. Unfortunately, you are not able to assign a material to the standard Max helper objects. But we can do this with the aid of a shader. We need shaders that create an invisible object, the so-called Transmat shaders (Figure 5.132).

The good news is that none of these shaders has any kind of parameters, so you just need to assign them to the proper component.

Figure 5.132

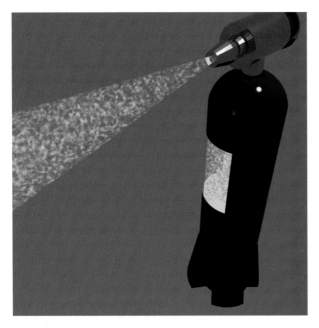

Open the file **Shader_transmat.max** and render the scene (Figure 5.133).

We have already set up this scene with the material inside. Obviously, it is the gas that is inside of the bottle and the beam of air it releases. These materials are made up in the manner shown in the next image (Figure 5.134).

We are using a mental ray material in which the Parti Volume has been placed in both the Volume and the Photon Volume components, as I showed you already.

```
Gas_volume ( mental ray )
  ─── Surface Shader: Map #31  ( Transmat (physics) )
  ─── Shadow Shader: Map #33  ( Transmat (physics) )
  ─── Volume Shader: Map #29  ( Parti Volume (physics) )
  ─── Photon Shader: Map #32  ( Transmat Photon (physics) )
  ─── Photon Volume Shader: Map #29  ( Parti Volume (physics) )
```

Figure 5.133 **Figure 5.134**

To make the two objects (spray beam and gas volume) invisible, we have used a Transmat shader inside the surface component. We did the same inside the Shadow component, and by doing so, we ensured that the rays would pass through the object. Finally, we also used this one inside the Photon component to exclude the objects from the photons dancing around inside the scene. These photons will now pass through the objects as if they weren't there.

5.2.17 Photon Basic Shader

The Photon Basic shader supports diffuse and specular reflection plus transmission and refraction for photons. I have prepared a scene in which to show you how you can use this shader to your advantage.

Open the file **Shader_Photonbasic.max** and render the scene (Figure 5.135).

In the scene, we are using an IES Sun, but we have extensive color bleed inside our scene. The color of the floor is appearing all over the wall and ceiling. We will now use this Photon Basic shader to illuminate this scene and to make sure that the walls and ceiling are more realistic.

Select the Wooden floor material and open the mental ray Connection rollout. Remove the lock to the right of the Photon option and, as by magic, a Photon Basic shader will be applied to this component. (Actually I prepared it, to save some clicks.) (Figure 5.136)

Now render the scene again, and you will see an amazing difference (Figure 5.137).

Go back to the Material Editor and select the Photon Basic shader, and let's review the options (Figure 5.138).

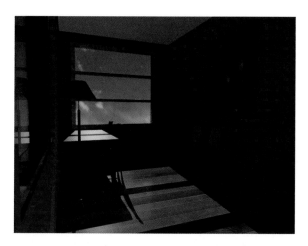

Figure 5.135 *Color bleeding from the floor to the walls and ceiling*

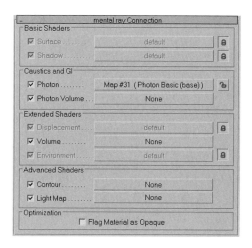

Figure 5.136

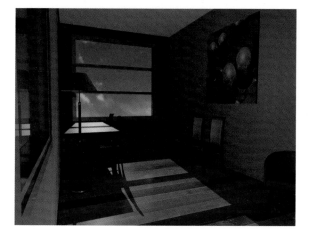

Figure 5.137

Figure 5.138

Figure 5.139

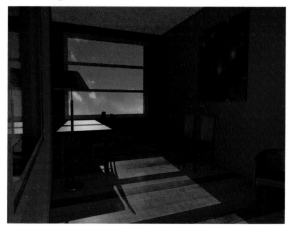

Figure 5.140

Since the floor material is not transparent, we need to leave Transparency black, which means no transparency. Index of Refraction is of no use for our material, either. The only thing we adjusted here is the color of the Specular component; we made it the same color as the Diffuse Color swatch, just to enhance the effect. Just for fun, we will change the colors for Diffuse and Specular into red (Figure 5.139).

Now render again and you will see how you can influence the behavior of photons independent of the material, if needed (Figure 5.140).

This shader can also be used in the material that you apply to a sphere that surrounds your scene completely (with normals facing inward). The material should be a transparent material with the Photon Basic shader applied. This material collects the photons that are shot into space and that are not returned to the photon map because they do not hit any more objects. The Photon shader collects these lost photons, thereby decreasing the rendering time and increasing the predictability of the photon-emitting process.

5.3 Water-Related Shaders

Inside mental ray are a number of shaders available that have an influence on water materials, in some way or another. For example, they can simulate the surface or waves. But some more specific shaders deal with the way shadows behave inside the water or the way that water behaves when you look into it, or they simulate looking from below the water surface up to the sky.

We will now do an exercise in which most of these shaders will be applied. Just to remind you, with the new Arch & Design material, there is an easy way to create realistic water. Since we have talked about Arch & Design already, we will use a mental ray material for this exercise.

5.3.1 Water Surface Shader

Everything starts with the water surface. If you look at a water surface, you will see changes in reflection and trans-

parency, depending on the direction. If you look from below the water up to the sky, this effect is even stronger. The Water Surface shader allows you to create these types of effects. So, open the file **shader_watersurface_ocean.max** and render the scene (Figure 5.141).

I have created a kind of typical water scene in which I have used the mr Daylight system as the source of the light. I added the draft preset for Final Gather to get some indirect light inside the scene to make it a bit more realistic. Then, I used a simple plane as the water surface, which now has a standard gray material assigned to it.

The first thing to do is to start adjusting the material for the water surface. To accomplish this, change the material from a standard material into a mental ray material. As you know already, you must put a shader in the Surface parameter; otherwise, the material doesn't work. Since we are creating water, it is logical to use the Water Surface shader for this component (Figure 5.142).

Don't change any of the settings of the Water Surface shader yet. Just render the scene so that you can see what happens step by step (Figure 5.143).

Figure 5.141

Figure 5.142

Figure 5.144

Figure 5.143 *Water surface shader added*

The Water Surface shader effect is clear to see, the water is already reflecting the environment as real water would do.

Now look at the parameters of the Water Surface shader (Figure 5.144).

The first color swatch, surface material, will allow you to change the basic color of the water. The Transparency Color swatch controls the transparency, based upon the color, black or white, in which white is totally transparent and black is opaque.

The Index of Refraction is by default set correctly for water 1,33.

The option to look into or out of the water depends on the position of the camera. For this scene, we need to look into the water.

Stain underneath is also on by default. This will make the Water Surface shader act like the Stain shader. This will only work with the Water Surface shader when a material in the scene has been assigned the Wet–Dry Mixer shader. We will do this when we will discuss the Wet–Dry Mixer shader at the end of this water chapter.

We have adjusted the settings for the Water Surface shader so a little bit more green-blue is added to the water, and to add some extra transparency (Figure 5.145).

And we have rendered the scene again (Figure 5.146).

Figure 5.145

Figure 5.146

5.3.2 Water Surface Shadow Shader

If you look at the last image, which was the result of the Water Surface shader, you'll see we were missing an important factor: the light didn't cast any shadows upon the ground plane underneath the water. For this to happen, we need the Water Surface Shadow shader. Open the Shadow component of the water material and apply the Water Surface Shadow shader to it (Figure 5.147).

The settings for this shader have the following options (Figure 5.148).

Figure 5.147

The Surface material is the color that we have adjusted to be the same as the color inside the Water Surface shader. The Transparency has also been adjusted to the same as the Water Surface shader. Of course, we checked the Look In option, and we also checked the Stain option because we will need this later when we will apply the Wet–Dry Mixer shader.

Figure 5.148

We have introduced transparency. First, the Transparency was completely white, which means completely transparent, from the top plane to the bottom plane. If you change this option to light gray, for example, the strength of the shadow cast remains the same, but the color that is projected on the bottom plane is influenced by this setting. So by introducing transparency, we influence the color on the plane that is receiving the shadow, just like with real water. If the water is completely clear, the color at the bottom is the color of the water; if the water is murky, the color at the bottom changes.

Now when we render, the shadows from the objects that are in the water will start casting shadows upon the ground plane, and the color of the water itself will be adjusted just a little bit. Render the scene to see it yourself (Figure 5.149).

Figure 5.149 *Water surface shadow shader added to the water*

5.3.3 Submerge Shader

As light moves through water, it is scattered by the small particles in the water. This causes the water to get a slight glowing effect. This glowing effect varies, depending on whether the water is deep or shallow. Deeper waters

glow less since the light loses intensity when it is scattered. This is the effect the Submerge shader simulates. If the camera is under water, use the Submerge Shader as a Camera Volume shader. If the camera is above water, use it as the Water Surface Object's Volume shader. So, in our case, we need to open the Volume component and apply the Submerge shader (Figure 5.150).

The Water Color speaks for itself—it is the color of the water. We changed it to a slightly darker color than we have been using in the other shaders.

Figure 5.150

The Vertical Gradation controls how quickly the water becomes dark. Lower values cause the water to be nearly uniform in color, while higher values cause an abrupt change in water color, from the lighter areas toward the surface to the darker regions below. I changed this value into 0,7 so that you can see the effect better.

Density controls how murky the water is, that is, how quickly objects disappear as they become more distant. The submerge effect applies only on a vertical axis. Use Base Plane Normal and Base Plane Distance to specify the vertical axis direction and distance relative to the world coordinate system origin. I had to change the plane distance to 75 for this scene (Figure 5.151).

You can clearly see the effect if you look at the water plants, which have almost disappeared now.

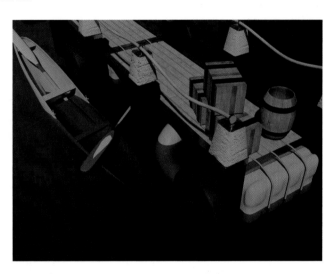

Figure 5.151 *Submerge shader added to the water*

5.3.4 Wet–Dry Mixer Shader

Objects that are wet look totally different than when they are dry. This is exactly what the Wet–Dry Mixer shader will do for you—create the difference in appearance between an object that is wet and the same one when dry. We will now apply this shader to the boat material. Select this material (named Boat material), which is an Arch & Design material. Now click on the mapping option in the Diffuse group, Color component, and select from the Material/Map Browser the Wet–Dry Mixer shader (Figure 5.152).

Figure 5.152

Look at the settings that now have become available (Figure 5.153).

The Dry Color is the color for the material when it is dry. (I just copied the original Diffuse Color and pasted it here.) The Wet Color is the color for the material when it is wet. I just used a yellow color to better show what happens, and rendered the scene again (Figure 5.154).

As you can see, nothing changed on the dry section of the boat, but the part of the boat that is underneath the water surface now has a completely different color.

5.3.5 Ocean Shader

Finally, we will start adding waves. Currently, you can see the best possible view of the influence of all the shaders we have used up to this point, but now we need waves. For this, we use the Ocean shader. We will put this one in the Bump component of the mental ray material. The Ocean shader creates realistic waves, and you can control a wave's height, roughness, speed, direction, and so on (Figure 5.155).

Hit the gray None button to the right of the Bump component; the Material/Map Browser will open (Figure 5.156).

Select the Ocean shader, and you will get the parameters of this shader available in the Material Editor. Leave all the settings as they are, and just render the scene (Figure 5.157).

Figure 5.153

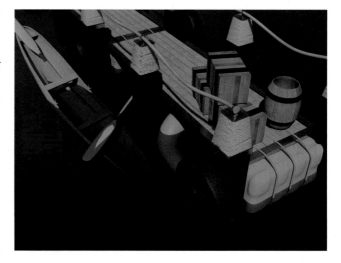

5.154 *Wet–dry mixer shader added to the water*

Figure 5.155

Figure 5.156

Figure 5.157 *Ocean shader added to the water*

Now we have completed the water surface.

As for the settings and options (Figure 5.158):

The first group determines the size of the waves. Largest and smallest are the two choices here, and should be obvious. Quantity represents the number of steps between the smallest and the biggest waves. The Steepness value gives you influence on the roughness of the water surface. Small values will produce calm water; higher values will make the water rougher (Figure 5.159).

Figure 5.158

We have changed the values to Largest = 150, Smallest = 2, Quantity = 15, and Steepness = 2 to get this rendering.

The second group involves the position of the waves (Figure 5.160).

Figure 5.159

The position of the waves is influenced by two options: Relative to World and Relative to Object. Relative to World is used when you are using two planes next to each other, and you want the wave pattern to move over correctly from one plane to the other. Relative to Object is used when you move the plane itself and you want the wave pattern to follow. Since this effect will only work when you use the vertical axes, you need the Plane Normal and Plane Distance options to point out the direction for the vertical axis and the relative distance from the origin of the coordinate system. All these options are only relevant when you make an animation. We will leave them as they are for now since we are just making a static image.

The Directed option is relevant for static images and animations. Without this option on, you get an ocean without any wind blowing on it. The waves are not moving in any kind of direction, but are static. To see the result, check this option and change the Direction angle to 90 degrees. You will see that the pattern of the waves changes accordingly (Figure 5.161).

The next set of options is also for animation purposes (Figure 5.162).

Wave speed is the speed of the movement of the water. Loop animation does exactly what it says, and the Loop Frames option defines the length of the loop.

The next group gives you influence on how the waves are arranged inside the water surface. As you can see, we are actually using this already since this option is checked on by default (Figure 5.163).

Figure 5.160

Figure 5.161

Figure 5.162

Figure 5.163

In reality, a water surface is a mix of movement and size of waves because the wind is not blowing in the same way and force over the total water area. The Flats option generates this effect. The Size and Variation options give you fine-tuning capabilities for this kind of effect.

The final option is Bump (Figure 5.164).

With this option, we get the result we have now. If you were to turn it off, the result would be similar to the image at the beginning, when we started without the Ocean shader. This option is only relevant if you start using the Ocean shader inside the Displacement component, meaning that you start to add real geometry. If you use Displacement, turn off the Bump option.

Putting the Ocean shader inside the Displacement component is, in fact, a good solution if you want to create small and big physical waves to enhance realism. If you want to do this, just add an extra Ocean shader inside the Displacement component, and use the following settings (Figure 5.165).

Figure 5.164

Figure 5.165

Figure 5.166

Uncheck the Bump option in this Ocean shader. In addition, uncheck the whole Bump component inside the Extended Shaders group of the mental ray material. Render the scene. Since we will be using Displacement, the render time will increase. But the realism will be enhanced since we are now actually displacing geometry physically instead of simulating this with the Bump shading technique (Figure 5.166).

Index

TERM

This Agreement will remain in effect until terminated pursuant to the terms of this Agreement. You may terminate this Agreement at any time by removing from Your system and destroying the CD-ROM Product. Unauthorized copying of the CD-ROM Product, including without limitation, the Proprietary Material and documentation, or otherwise failing to comply with the terms and conditions of this Agreement shall result in automatic termination of this license and will make available to Elsevier Science legal remedies. Upon termination of this Agreement, the license granted herein will terminate and You must immediately destroy the CD-ROM Product and accompanying documentation. All provisions relating to proprietary rights shall survive termination of this Agreement.

LIMITED WARRANTY AND LIMITATION OF LIABILITY

NEITHER ELSEVIER SCIENCE NOR ITS LICENSORS REPRESENT OR WARRANT THAT THE INFORMATION CONTAINED IN THE PROPRIETARY MATERIALS IS COMPLETE OR FREE FROM ERROR, AND NEITHER ASSUMES, AND BOTH EXPRESSLY DISCLAIM, ANY LIABILITY TO ANY PERSON FOR ANY LOSS OR DAMAGE CAUSED BY ERRORS OR OMISSIONS IN THE PROPRIETARY MATERIAL, WHETHER SUCH ERRORS OR OMISSIONS RESULT FROM NEGLIGENCE, ACCIDENT, OR ANY OTHER CAUSE. IN ADDITION, NEITHER ELSEVIER SCIENCE NOR ITS LICENSORS MAKE ANY REPRESENTATIONS OR WARRANTIES, EITHER EXPRESS OR IMPLIED, REGARDING THE PERFORMANCE OF YOUR NETWORK OR COMPUTER SYSTEM WHEN USED IN CONJUNCTION WITH THE CD-ROM PRODUCT.

If this CD-ROM Product is defective, Elsevier Science will replace it at no charge if the defective CD-ROM Product is returned to Elsevier Science within sixty (60) days (or the greatest period allowable by applicable law) from the date of shipment.

Elsevier Science warrants that the software embodied in this CD-ROM Product will perform in substantial compliance with the documentation supplied in this CD-ROM Product. If You report significant defect in performance in writing to Elsevier Science, and Elsevier Science is not able to correct same within sixty (60) days after its receipt of Your notification, You may return this CD-ROM Product, including all copies and documentation, to Elsevier Science and Elsevier Science will refund Your money.

YOU UNDERSTAND THAT, EXCEPT FOR THE 60-DAY LIMITED WARRANTY RECITED ABOVE, ELSEVIER SCIENCE, ITS AFFILIATES, LICENSORS, SUPPLIERS AND AGENTS, MAKE NO WARRANTIES, EXPRESSED OR IMPLIED, WITH RESPECT TO THE CD-ROM PRODUCT, INCLUDING, WITHOUT LIMITATION THE PROPRIETARY MATERIAL, AND SPECIFICALLY DISCLAIM ANY WARRANTY OF MERCHANTABILITY OR FITNESS FOR A PARTICULAR PURPOSE.

If the information provided on this CD-ROM contains medical or health sciences information, it is intended for professional use within the medical field. Information about medical treatment or drug dosages is intended strictly for professional use, and because of rapid advances in the medical sciences, independent verification of diagnosis and drug dosages should be made.

IN NO EVENT WILL ELSEVIER SCIENCE, ITS AFFILIATES, LICENSORS, SUPPLIERS OR AGENTS, BE LIABLE TO YOU FOR ANY DAMAGES, INCLUDING, WITHOUT LIMITATION, ANY LOST PROFITS, LOST SAVINGS OR OTHER INCIDENTAL OR CONSEQUENTIAL DAMAGES, ARISING OUT OF YOUR USE OR INABILITY TO USE THE CD-ROM PRODUCT REGARDLESS OF WHETHER SUCH DAMAGES ARE FORESEEABLE OR WHETHER SUCH DAMAGES ARE DEEMED TO RESULT FROM THE FAILURE OR INADEQUACY OF ANY EXCLUSIVE OR OTHER REMEDY.

U.S. GOVERNMENT RESTRICTED RIGHTS

The CD-ROM Product and documentation are provided with restricted rights. Use, duplication or disclosure by the U.S. Government is subject to restrictions as set forth in subparagraphs (a) through (d) of the Commercial Computer Restricted Rights clause at FAR 52.22719 or in subparagraph (c)(1)(ii) of the Rights in Technical Data and Computer Software clause at DFARS 252.2277013, or at 252.2117015, as applicable. Contractor/Manufacturer is Elsevier Science Inc., 655 Avenue of the Americas, New York, NY 10010-5107, USA.

GOVERNING LAW

This Agreement shall be governed by the laws of the State of New York, USA. In any dispute arising out of this Agreement, you and Elsevier Science each consent to the exclusive personal jurisdiction and venue in the state and federal courts within New York County, New York, USA.